THE EMERGENCY
IN COLOUR

IRELAND IN WARTIME

JOHN O'BYRNE
MICHAEL B. BARRY

GILL BOOKS

Gill Books
Hume Avenue
Park West
Dublin 12
www.gillbooks.ie

Gill Books is an imprint of M.H. Gill and Co.

THE EMERGENCY IN COLOUR, IRELAND IN WARTIME
ISBN 9781804580677

By Michael B. Barry:
Across Deep Waters, Bridges of Ireland
Restoring a Victorian House
Through the Cities: the Revolution in Light Rail
Tales of the Permanent Way: Stories from the Heart of Ireland's Railways
Fifty Things to do in Dublin
Dublin's Strangest Tales (with Patrick Sammon)
Bridges of Dublin: the Remarkable Story of Dublin's Liffey Bridges (with Annette Black)
Victorian Dublin Revealed, the Remarkable Legacy of Nineteenth-Century Dublin
Beyond the Chaos: the Remarkable Heritage of Syria
Homage to al-Andalus: the Rise and Fall of Islamic Spain
The Alhambra Revealed: the Remarkable Story of the Kingdom of Granada
Málaga, a Guide and Souvenir
Hispania: the Romans in Spain and Portugal
Courage Boys, We are Winning: an Illustrated History of the 1916 Rising
The Green Divide: an Illustrated History of the Irish Civil War
An Illustrated History of the Irish Revolution 1916-1923
Fake News and the Irish War of Independence
The Fight for Irish Freedom: an Illustrated History of the War of Independence
The Irish Civil War in Colour (with John O'Byrne)
A Nation is Born (with John O'Byrne)
1588, the Spanish Armada and the 24 ships lost on Ireland's shores

The paper used in this book comes from the wood pulp of sustainably managed forests.

A CIP catalogue record for this book is available from the British Library.

Colourising of photographs by John O'Byrne.
Book design by Michael B. Barry.
Printed and bound by L.E.G.O. SpA, Italy.

CONTENTS

CHRONOLOGY

1939

12 January	The IRA issues a demand to the British government to withdraw from Northern Ireland, and days later begins a bombing campaign in Britain.
25 August	An IRA bomb kills five people in Coventry.
1 September	Germany invades Poland.
2 September	The taoiseach receives support from a hastily convened Dáil for Irish neutrality in the event of war. The Emergency Powers Act is passed.
3 September	France and Britain declare war on Germany.
August–September	The Marine and Coast Watching Service is established to monitor and guard Irish territorial waters. In due course some old ships, along with MTBs, are acquired.
October	The first petrol rationing is introduced.
9 October	The government introduces a compulsory tillage requirement for farmers.
23 December	IRA members raid the Magazine Fort and make off with 13 tonnes of ammunition. Over the course of the Emergency, around 2,000 IRA members pass through the internment camp at the Curragh.

1940

3 January	A Garda is shot dead in Cork by the IRA. Legislation is amended which helps allow suppression of the organisation.
7 February	Barnes and McCormack are hanged in Birmingham for involvement in the Coventry bombing.
25 February	IRA prisoners begin a hunger strike.
9 April	Germany invades Denmark and Norway.
19 April	The IRA hunger strike is called off after two men die.
May	The Irish Defence Force strength is 13,350 – half of which are reservists. A national recruitment drive gets underway.
5 May	Abwehr agent Hermann Goertz lands by parachute in Co. Meath.
10 May	Churchill is appointed British prime minister, after Chamberlain resigns.
24 May	A Local Security Force (LSF) is formed under Garda control. In January 1941 most members are transferred to the Local Defence Force (LDF), now under army control.
26 May	As the German Army sweeps through northern France, British forces begin evacuation from Dunkirk.
17 June	British envoy Malcolm MacDonald is sent to Dublin with an offer to end partition if Ireland enters the war against Germany and Italy. Some time later, de Valera rejects the offer of unity.
22 June	France capitulates to Germany.
June	British develop the 'W' Plan, where a British expeditionary force in Northern Ireland would move across the border into Éire, to repel a German landing.
26 August	German bombs are dropped at Campile, Co. Wexford, killing three women.
August	Internment Camp No. 2 is built at the Curragh to house airmen, from the belligerent nations, who landed in Ireland (divided into B, British and G, Germans). Camp No. 1 was built for IRA Internees.
August	The German Army prepares Operation Green, plans for an invasion of Ireland, a subset of Operation Sealion, the invasion of Britain.
6 September	Two IRA members are executed. Over the course of the Emergency, a total of six IRA men were executed, while five Gardaí were shot dead.
24 November	Lord Craigavon (James Craig) dies and is replaced by J.M. Andrews as Northern Ireland prime minister.

1941

1–3 January	German bombs are dropped accidentally across many counties in Éire. Three people are killed in Co. Carlow.
2 January	Britain decides to restrict export of essential materials to Ireland. Shortages ensue and rationing is introduced in due course.
13 January	James Joyce dies in Zurich.
25 January	Coal rationing introduced. In March, local authorities are given powers to cut and harvest turf.
21 March	Irish Shipping Ltd is formed. It acquires, with difficulty, over a dozen poor-quality ships.
7 April–6 May	The Luftwaffe bomb Belfast. Over several weeks, around 1,100 are killed and 2,000 injured. Fire engines are sent from Éire to assist.
April	Between now and the end of March 1945, there are over 6,600 desertions from the Irish Army, many of whom enlist in the British forces.
May	Seán Russell, a senior member of the IRA, travels to Berlin to secure support. He dies aboard a German submarine on the return journey to Ireland.
31 May	German bombing at North Strand in Dublin results in 28 deaths and 90 people injured.

22 June	Germany launches Operation Barbarossa, the invasion of the USSR.
July	Colonel Dan Bryan is appointed to head the G2 Branch of the Irish Army, and directs the intelligence effort in Éire.
November	Hermann Goertz, a German agent, is arrested.
7 December	Japanese planes attack the US fleet at Pearl Harbour. President Roosevelt declares war on Japan the following day.

1942

26 January	The first American troops arrive in Northern Ireland. Over the course of the war, a total of 300,000 US military personnel will pass through the Six Counties.
January	Cooperation between the British forces in Northern Ireland and the Irish Defence Forces is accelerated, with reciprocal visits by senior officers.
January	From the beginning of the year, Éire begins to discreetly release Allied internees, while retaining the German internees.
May	Non-essential travel by private motor vehicles is banned in Éire.
1–13 September	A major exercise is carried out by the Irish Army at the River Blackwater, Co. Cork, which simulates the repelling of an invasion of the southern coast.

1943

24 February	35 girls are killed in a fire at St Joseph's Orphanage, Cavan.
22 June	In the general election Labour increases its share and a new farmers' party, Clann na Talmhan, wins 10 seats. Despite losing seats, Éamon de Valera is able to form a minority government.
1 May	Prime Minister J.M. Andrews is ousted by the Unionist Party who replace him with Sir Basil Brooke.

1944

21 February	David Gray, US envoy, issues a note to de Valera insisting on the removal of Axis diplomats from Dublin. The taoiseach refuses and puts the Irish Defence Forces on alert.
30 May	After losing a Dáil vote, de Valera calls a snap general election. His party, Fianna Fáil, regains its majority.
3 June	Weather reports from Blacksod Bay are sent on to the Allies, and these help to set the date for the D-Day landings, which begin on 6 June.

1945

January–April	Concentration camps including Auschwitz, Bergen-Belsen and Dachau are liberated.
30 April	Hitler commits suicide.
2 May	De Valera visits the German envoy's residence to extend official condolences on the death of Hitler.
8 May	VE Day – Allied victory in Europe.
13 May	In a victory broadcast, Churchill strongly criticises Irish neutrality during the war. Three days later de Valera makes a reasoned reply to Churchill.
25 June	Seán T. O'Kelly succeeds Douglas Hyde as president.
5 August	US drops an atomic bomb on Hiroshima, followed by another on Nagasaki three days later.
15 August	Japan surrenders.

1946

29 August	The USSR vetoes Ireland's application for UN membership. Ireland has to wait until December 1955 to become a member.

1947

24 January	The Big Freeze starts, with continuing sub-zero temperatures. Blizzards sweep the country and there is widespread disruption.
6 February	Due to shortages, British government announces a ban on exports of coal from north-eastern ports – which affects Ireland.
June	The Marshall Plan, American aid to Europe, begins. Éire is granted a $128m loan. However, as Ireland's neutrality still rankles with the Americans, they only give $18m in grant aid, the second smallest grant awarded to any country under the plan.

1948

4 February	A general election is held. Fianna Fáil lose seats and an 'inter-party' coalition government, led by John A. Costello of Fine Gael, is formed.
5 July	The National Health Service is introduced in Northern Ireland.
7 September	Taoiseach John A. Costello, visiting Canada, announces government plans to repeal the External Relations Act and leave the Commonwealth.
17 September	W.B. Yeats' remains are brought back from France by a naval corvette and landed at Galway to be brought to Sligo for burial.

1949

8 February	Ireland declines to join NATO due to difficulties posed by the fact that 'six of her north-eastern counties are occupied by British forces against the will of the overwhelming majority of the Irish people'.
18 April	Ireland officially leaves the Commonwealth and becomes a republic.

ACKNOWLEDGEMENTS

This work benefitted from the help, insights and scholarship of many kind people. Thanks are due especially to: Dr Brian Kirby, Irish Capuchin Provincial Archives; Commandant Daniel Ayiotis, Aislinn Mohan, Lisa Dolan, Hugh Beckett and Noelle Grothier, Military Archives, Cathal Brugha Barracks; Berni Metcalfe, Glenn Dunne, National Library of Ireland; Eibhlin Colgan, Guinness Archives; Daniel Breen, Dara MacGrath, Cork Public Museum; Liam O'Reilly of the Public Record Office of Northern Ireland; Thomas Hall, Fiona Looney, An Garda Síochána Museum & Archives; Jill Craig, Washington County Free Library; Tanya Keyes, Jim Dunleavy, ESB Archives. Ciaran Cooney, who curates the image library of that great institution, the Irish Railway Record Society, kindly gave many historic photographs.

Special thanks are due to Jim Coughlan and the *Irish Examiner* who generously furnished many exceptional images from their outstanding photographic archive.

The following were very helpful: Barry O'Kelly, Foynes Flyingboat Museum; Barry Whelan; Ciara Long, Aer Lingus; Colum O'Riordan; Dennis Burke; Éanna O'Keefe, DLR Local Studies; Eric Mineault, Library and Archives Canada; Gerard Burroughs; Guy Warner; Jim Herlihy; Jimmy Laffey, Joe Maxwell; Jonathan Beaumont; Justin Horgan; Las Fallon; Lynda O'Keffe, *Irish Times*; Jonathan Beaumont; Marta López, Lar Joye, Dublin Port Archive; Michael Fewer; Michelle Bourke, Whyte's; Natasha Serne, RDS; Paddy Sammon; Paul and Carl Murray; Stephen Boylan, Gate Theatre and Trevor White.

The team at Gill Books gave great encouragement and support: Patrick O'Donoghue with Iollann Ó Murchú, Margaret Farrelly, Liam Maguire, Sarah-Louise Deazley and Kristen Olsen.

Last but not least, the authors are greatly appreciative of the support and help of, respectively: Paddy and Patricia O'Byrne, and Veronica Barry.

INTRODUCTION

This book tells the story of the momentous events that affected Ireland over the period 1939 to 1945. This was during WWII, a time that has been euphemistically called 'The Emergency'. Given that the effects of the war rolled on for some years, we decided to also include the years up to 1949, the seminal year when the Irish state shook off any remaining imperial ties and made the unequivocal declaration of a republic. This volume is the logical continuation of our previous two books, *The Irish Civil War in Colour* and *A Nation is Born*.

Chapter 1 tells of the months leading up to the war, including how the IRA mounted a vicious, but pointless, bombing campaign in Britain. September 1939 brought the outbreak of war and Ireland's decision to remain neutral. Chapter 2 begins with the period of the 'Phoney War', until reality hit after Germany swept through Belgium and France. Britain was at its most vulnerable after Dunkirk, and as U-boat sinkings increased in the North Atlantic, Churchill's eyes turned towards the Irish Treaty Ports. Panicked by wild tales of fifth columnists, consideration was given to invading this Achilles-heel of an island to the west. The Germans, in developing their plan to invade Britain, also included a sub-plan to land on the south-east Irish coast. In time, the danger of invasion dissipated: the Germans were diverted by their invasion of the USSR and the British found that they could fight U-boats in the Atlantic from bases in Northern Ireland. They were also receiving quiet cooperation from the Irish Army intelligence service G2. After the fall of France, the Luftwaffe were able to establish air bases along the coast, which allowed them to reach more distant locations, as Belfast found out with the devastating air raids of April–May 1941. A few weeks later, Dublin also had a rude awakening to the dangers of war (albeit on a miniscule scale compared to Belfast) when German bombs were dropped at North Strand.

In the meantime, the Irish Army, underfunded and neglected for decades, was endeavouring to expand and meet the challenge. It was woefully ill-equipped, possessing only light weaponry, some WWI artillery and armoured cars. The Air Corps had a potpourri of obsolete planes. A Marine Service had been reinvented at the outbreak of war and furnished with two pre-WWI ships and a few motor torpedo boats. Re-arming proved difficult, as the hostile Allies refused to sell any meaningful equipment. 1941 ended with the bombing of Pearl Harbour and the entry of the USA into the war. Chapter 3 tells of how an almost unlimited quantity of US war matériel and men began to flow across the Atlantic with, in many cases, the first stop being Northern Ireland. This became a giant US military base and its factories hummed, churning out aircraft and other military equipment. To the south, in stark contrast, was the under-equipped Irish Army. In September 1942 the army mounted what for it was a huge effort – the Blackwater Exercises. In these, each of the two army divisions played, respectively, the parts of defender and invader on the southern coast. This chapter also pulls together the story of the planes downed in Éire and the internment of belligerent airmen and sailors over the entire war period.

The ordinary citizens of Éire survived as best they could, despite rationing. Any concept of *sinn féin* (ourselves alone) proved somewhat threadbare, as during the war, it became fully apparent that Ireland depended on imports to maintain the basic essentials of modern life. The government had to scour the world and purchase a fleet of superannuated ships to form the basis of Irish Shipping. Shortages of petrol and coal affected road and rail transport. A massive turf campaign was initiated so that households could keep warm during the winter.

Chapter 4 starts with the continuing flow of advanced ships and aircrafts to Northern Ireland as preparation for the planned landings in France got underway. The Allies now knew they were going to win, which gave the American envoy, David Gray (his consistently unfriendly attitude regarding neutral Éire merely reflected that of the Anglophile President Roosevelt), an opportunity to put the taoiseach, Éamon de Valera, on the spot by demanding the expulsion of the Axis legations from Dublin. De Valera refused to do so, to widespread domestic support, but it gave an opportunity to blacken neutral Éire in the American press. The Allies continued with their military campaign and duly invaded France (with the landing date determined by helpful weather data

from Blacksod Bay). The Germans were eventually defeated, with Hitler committing suicide at the end of April 1945. The taoiseach, a stickler for diplomatic niceties, went to the German envoy's residence to offer condolences (as he had done with David Gray weeks before, after Roosevelt's death). This brought down a storm of anger in Allied countries. Eleven days later, in his victory speech, Churchill accused the Irish government of frolicking with Axis representatives and said how his restraint had been tested on the issue of invading Éire. It brought a dignified and reasoned reply by de Valera, acknowledging that the British prime minister had successfully resisted the temptation to invade, noting that it was 'indeed, hard for the strong to be just to the weak'.

Chapter 5 covers the post-war period, a period where shortages and rationing continued for some time. As the years went by, a new Ireland was beginning to emerge, and there were new connections to the world via Dublin and Shannon airports. The tired Fianna Fáil government was ejected in the 1948 general election and a new government came into place, supported by variegated parties of the right and left. It is remembered chiefly for its declaration of the Republic and, less favourably, for the Mother and Child debacle.

Heavy censorship was imposed on the press at the time and it did cut off Éire from the world. However, the declaration by the eminent historian F.S.L. Lyons that its people were in 'Plato's cave' with 'their backs to the fire of life and deriving their only knowledge of the outside from the flickering shadows thrown on the wall by the men and women who passed to and fro behind them' was a touch overblown. Reflecting his class and upbringing, he was referring to the dreadfulness of being cut off from the Anglo-Saxon world.

Irish neutrality was multilayered. In September 1939, British Prime Minister Neville Chamberlain had declared war, rightly concerned about thwarting German aggression and its threatened hegemony. This resulted in Britain becoming embroiled in a long and existential struggle for survival. The relations between Britain and its island neighbour were complex. It had engaged in a brutal war in Ireland 18 years previously and a unilateral act of its parliament had partitioned Ireland. And yet, for Ireland, Britain was practically its only trading partner – it offered an advantageous market for Irish goods. British ships were battling through U-boat-infested seas to bring goods back to Britain, a few of which, desperately needed in Éire, were re-exported there.

However, it is a fact, that after WWII broke out, no neutral country declared war of its own volition and, United States included, only went to war after being attacked. In other words, every country did what was best for itself, not for any general moral cause. It is difficult to class WWII exclusively as a struggle for democracy, given that Germany was on one side and the USSR on the other. It was only towards the end of the war that the true evil of the Nazi regime became fully apparent to the world, when news filtered out after the liberation of Belsen and other extermination camps of the German atrocities there.

In the first years of the war, the Irish 26-county state was in mortal danger of being invaded, either by the Germans or the British. If that happened, there is no doubt that an invading army would have rapidly smashed through Irish defences and taken over the country. Who knows where that would have led us to? If it had been by the British, we might have returned, to be once again part of the United Kingdom. If the Germans had carried out the invasion we might have become a remote and irrelevant quiescent state of a confederated Reich.

In my view the taoiseach, in choosing neutrality, made the correct decision for the 26 counties. It is a credit to Éamon de Valera that he managed to steer the neutral boat of Éire, albeit sometimes leaky, between the dangerous rocks and reefs of the belligerents.

This book is the third in the series of books. Once again, the black and white photographs have been colourised, again by hand, not by AI – we hope you can see this in the resulting quality and depth of the colour. Once again, we have endeavoured to tell the story in a linear fashion, using captions which were sometimes limited by space, but where we have tried to impart the essential information, with all its nuances. In summary, we hope that you will enjoy this story of the Emergency years and beyond, brought to life by the colourised photographs.

Michael B. Barry

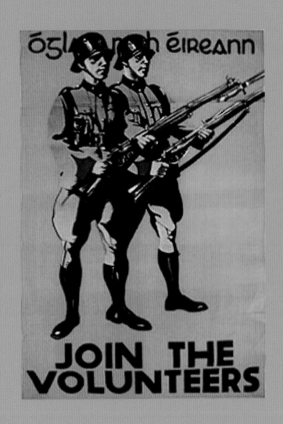

1. EMERGENCY
1939

A sentry stands guard at Spike Island in Cork Harbour. Taoiseach Éamon de Valera had gained a diplomatic triumph when the British handed over the Treaty Ports in the second half of 1938.

As the storm clouds grew darker over Europe, thought was increasingly given to improving Ireland's defences. When budget percentages spent on defence were examined, it turned out that other neutral countries were spending four to five times the Irish amount. In January 1939, the Minister for Finance, Seán MacEntee, argued against increased defence spending. He said that in the unlikely event Ireland was attacked by Britain, resistance would be futile; if British enemies attacked Ireland, Britain (out of self-interest) would defend Ireland. The Defence Forces continued in their run-down holding pattern.

When weapons were eventually sought by Ireland from Britain and the US, it turned out to be too late. Against a background where arms production was prioritised for their own defence needs, these countries saw no need to send weapons to neutral Ireland.

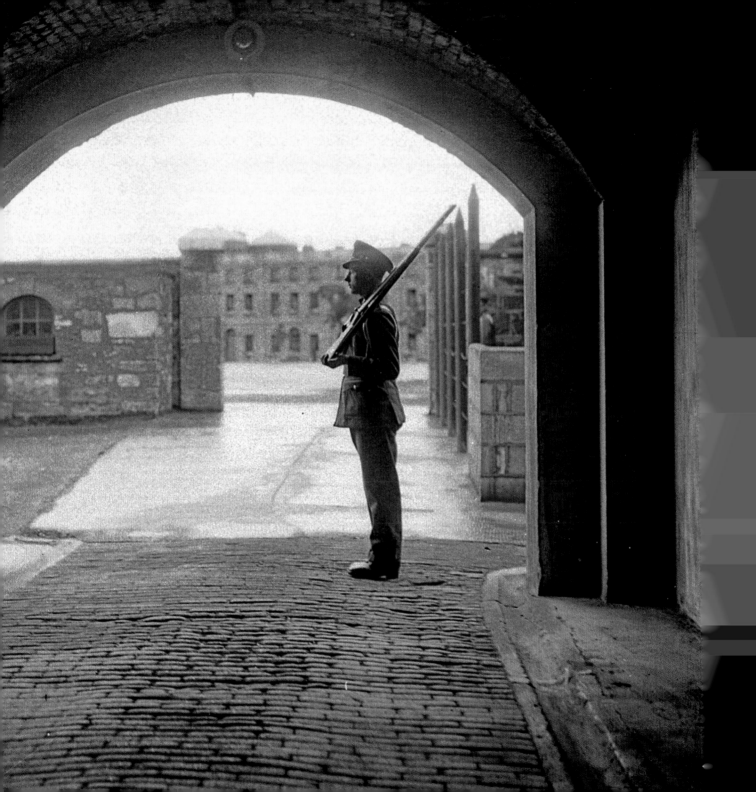

The German training ship, the *Schlesian*, sailed into Cork Harbour for a courtesy visit at the end of February 1939. Built in 1906, the ship was a Deutschland-class pre-dreadnought battleship. During WWI it had fought in the Battle of Jutland. The Treaty of Versailles had permitted Germany to keep eight obsolete battleships, of which she was one. In 1935 she had been converted into a training ship for cadets.

During the visit to Cork, there was an incident when the Cork Lord Mayor, James Hickey, refused to extend the normal courtesies to the captain and crew. He was protesting against the pressure on the Catholic church in Germany, as well as a slight by the German News Agency to the memory of Pope Pius XI who had just died (the agency was said to have called Pius a 'political adventurer').

The veteran battleship was brought back into active service when war broke out in September 1939 and was used to bombard Polish artillery positions near Gdansk. The *Schlesian* spent most of the war engaged in miscellaneous guard duties in the Baltic. On 3 May 1945, as she sailed out of Swinemünde (now Świnoujście, Poland) she struck a mine and was towed to sink in shallow water.

The visit to Cork Harbour, a Treaty Port, by this imposing, albeit veteran, capital ship was a manifestation of the risen power of Germany, then asserting its might across Europe. To any Irish citizen that cared, it could also be taken as a reminder that Ireland had no navy and of the meagre state of the country's defences.

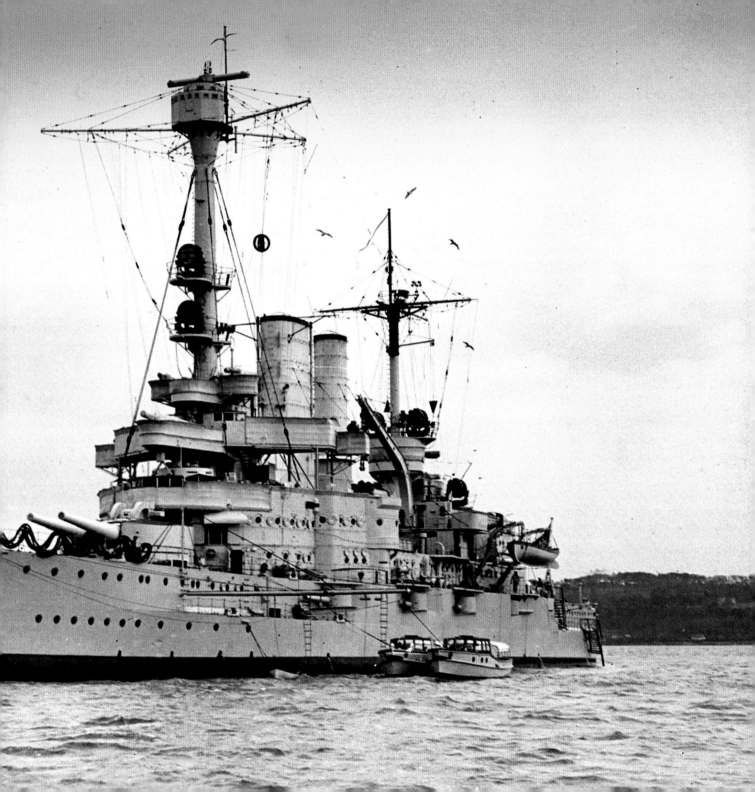

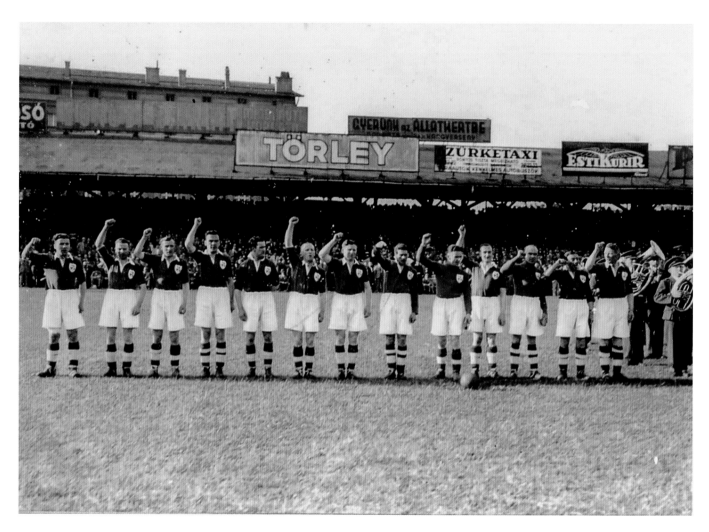

Innocents abroad? On 18 May 1939 Ireland met Hungary in Budapest for an international friendly soccer match – they drew. Here, the Irish team gives the raised right fist salute, as used by the fascist Arrow Cross Party. At the time, Hungary, smarting at the loss of 70 per cent of its territory under the Treaty of Trianon after WWI, was ruled by a regent, the ultra-conservative Admiral Horthy. Horthy was fiercely anti-communist and had allied with Hitler's Germany in an attempt to reverse the Treaty of Trianon, but Hungary was not a fascist state. In the May 1939 elections, the Arrow Cross Party became the second most popular party. It was suppressed after WWII broke out, but in 1944 was approved by the collaborationist government after Hungary's occupation by Germany.

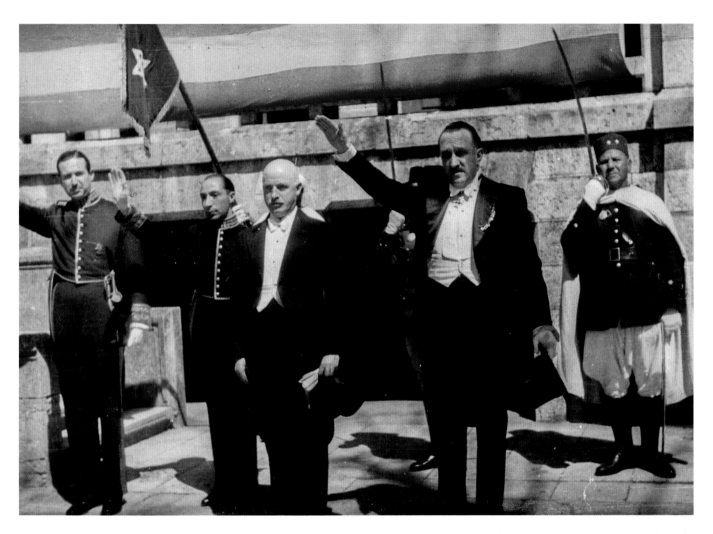

The one who did not give the fascist salute – Leopold Kerney at Burgos on 10 April 1939 in the course of presenting his credentials as Irish envoy to General Franco. In 1926 he had been the representative in Paris for the anti-Treaty republicans. After de Valera came to power he was posted as Irish commercial secretary to Paris. In August 1935 he was appointed minister plenipotentiary to Spain. When the Civil War broke out, Kerney, cut off from Madrid, set up a consular office in Saint-Jean-de-Luz, accredited to the legitimate republican government. After the capture of Barcelona by the right-wing rebel forces in January 1939 (thus decisively winning the Civil War), Éire decided to recognise Franco's regime. In July 1940, Kerney worked in securing the release of Frank Ryan, the Irish republican leader, from Burgos prison, who was then transferred into the custody of the German Abwehr.

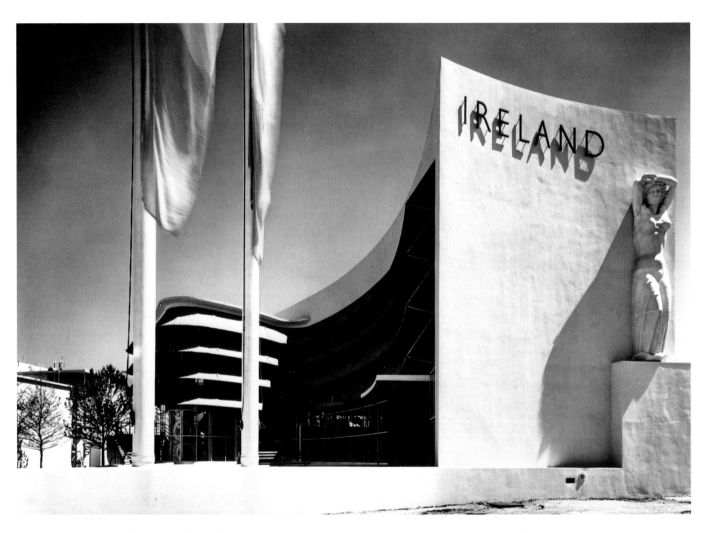

The Irish Pavilion at the New York World Fair, 1939. It was Ireland's first appearance as an independent country at an international fair. Ireland managed to secure one of the best sites in the fair, despite pressure from the British who wanted it sited within a block representing the British Empire as a whole. The design was by Michael Scott and was adorned with an external statue of a young woman emerging from the sea, inspired by Yeats line: 'Your mother Éire is always young'. It was intended that Éamon de Valera would officially open it, but with the worsening situation in Europe, he could not attend. In his stead, Tánaiste Seán T. O'Kelly officiated at the opening on 13 May 1939. The pavilion was selected by an international jury as the best building in the fair.

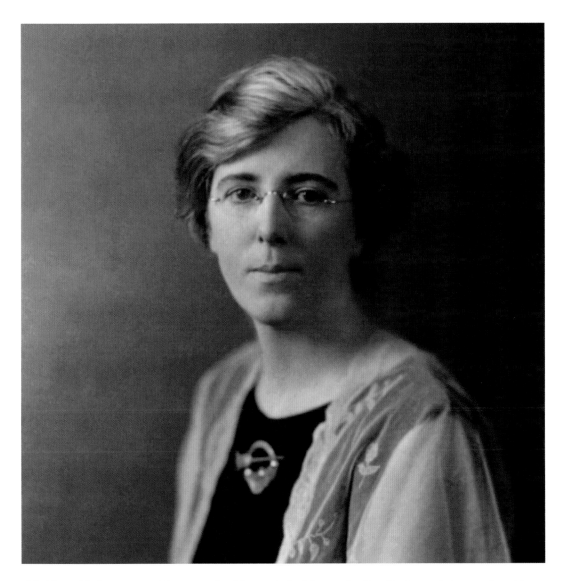

Kathleen Clarke was republican royalty. Her uncle had been a leading Fenian and she was the widow of Tom Clarke, the executed 1916 leader. Her brother, Ned Daly, had also been executed. She was a founder member of Cumann na mBan and served on Sinn Féin's Executive. Elected a TD, she took the anti-Treaty side in 1922 and was later a founder member of Fianna Fáil. Kathleen Clarke became the first woman lord mayor of Dublin in 1939. When she died in 1972, she was given a state funeral.

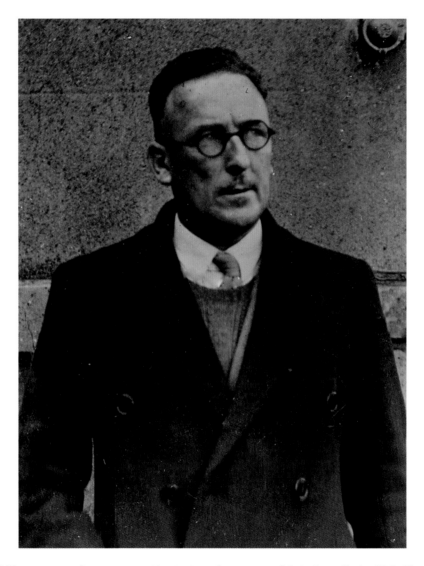

Seamus O'Donovan, explosives expert. In 1938, at the request of Seán Russell, the IRA Chief of Staff, O'Donovan prepared a sabotage plan against Britain. An ultimatum was sent to the British demanding the withdrawal of their forces from Northern Ireland. On 15 January 1939, receiving no reply, the IRA began a campaign setting off bombs in British cities, specifically attacking infrastructure. There were over 300 incidents, resulting in 10 fatalities with around 100 people injured.

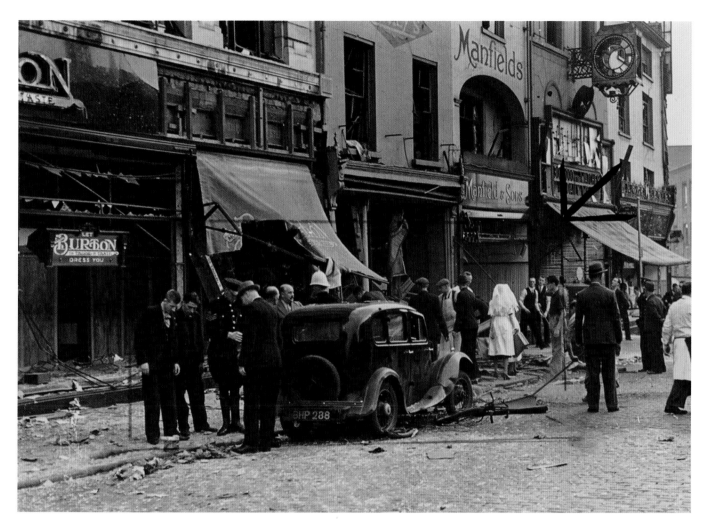

The aftermath at Coventry. On the afternoon of 25 August, a carrier-cycle with a pre-fused bomb in the basket was left against a wall in the busy Broadgate area of Coventry by an IRA volunteer, who had panicked after losing his way – the target is thought to have been a power station. Five people were killed and 60 injured. IRA men Peter Barnes and James McCormack were found guilty in a swift trial and sentenced to death. There were widespread protests in Ireland against the sentence and the Irish government appealed for clemency. The request was dismissed and on 7 February 1940, the two men were hanged at Winson Green Prison in Birmingham.

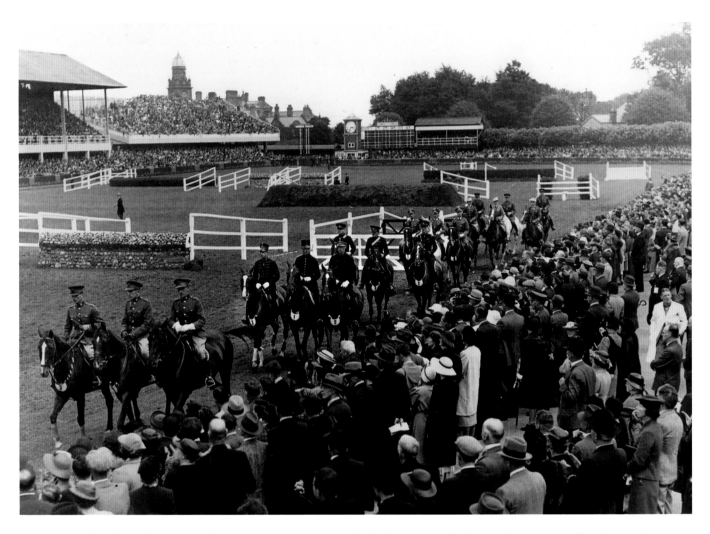

The Dublin Horse Show was held in August 1939, attended by both President Hyde and the taoiseach. The Nations Cup international jumping event took place in what turned out to be one of the last sporting competitions between the future belligerents before the outbreak of war three weeks later. Taking part were teams made up of military officers from Éire, England, France and Germany, together with those from the neutral nations of Switzerland and Belgium. France won.

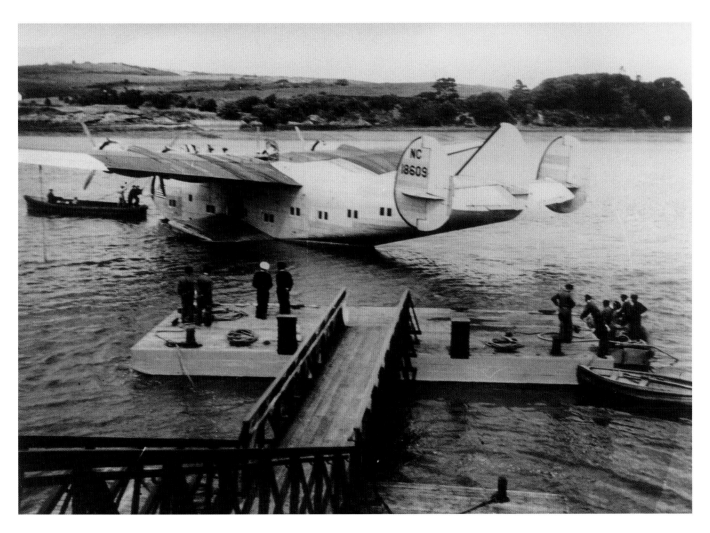

Large, luxurious and reliable, and with a range of 5,600km, a Pan American Yankee Clipper is moored at Foynes, Co. Limerick on the south side of the Shannon Estuary. In 1935, Britain, the USA and Canada, along with Éire, had agreed that eastward transatlantic flights would land at Foynes. On 11 April 1939, the first commercially viable flying boat, a Pan American Boeing B.314 Yankee Clipper, landed at Foynes. After the outbreak of war, the flying boat terminal, despite being located in neutral Éire (and with the tacit approval of the Irish government) became an important hub for the Allies, allowing military and other important officials to travel between Britain and North America, as well as to British colonies in Africa.

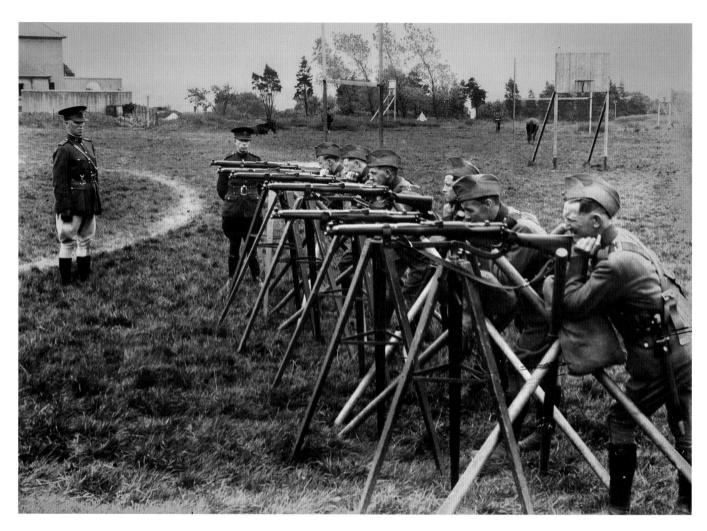

Basic training. The Volunteer Force with Lee Enfield rifles. Despite many strategic analyses by the Defence Forces over the late 1930s that the state had no ability to mount a credible defence of its territory, the government continued to neglect defence policy. In 1937, de Valera had fatalistically stated that 'we can have no real plan of defence of this country so long as there are parts of our territory [occupied] by the British'. As European war became likely, military expenditure began to minimally increase, but by then it became practically impossible to source military equipment.

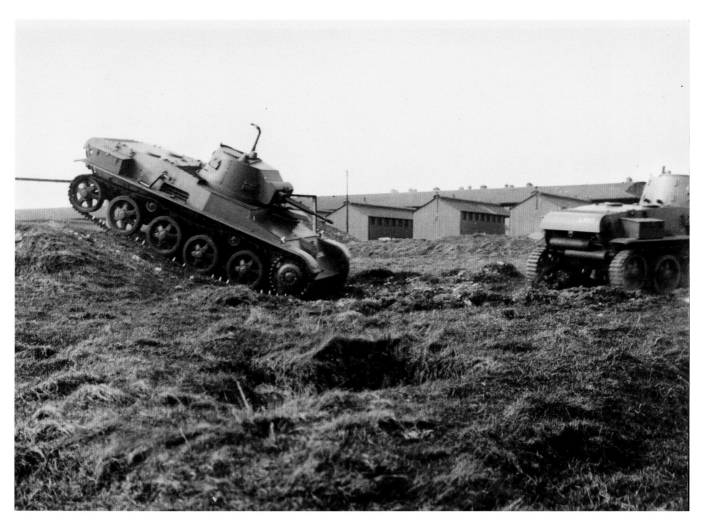

Landsverk L-60 light tanks on exercise at the Curragh, Co. Kildare. In the mid-1930s the Defence Forces had taken delivery of these two Swedish-made tanks. They joined the only other tank in Irish service, the obsolete Vickers Mk.D medium tank, which had been delivered in 1929. As the historian Eunan O'Halpin has written, when WWII broke out, the army remained 'diminutive, undertrained and underequipped to varying degrees in almost everything'.

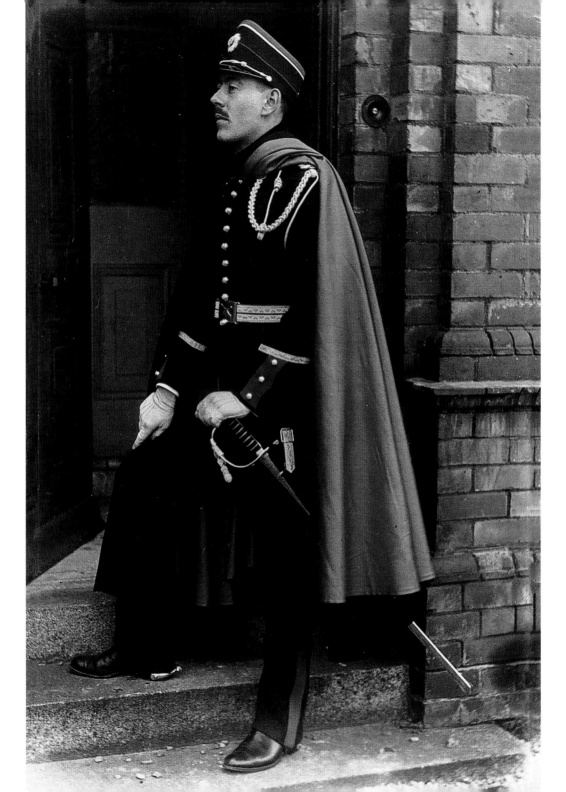

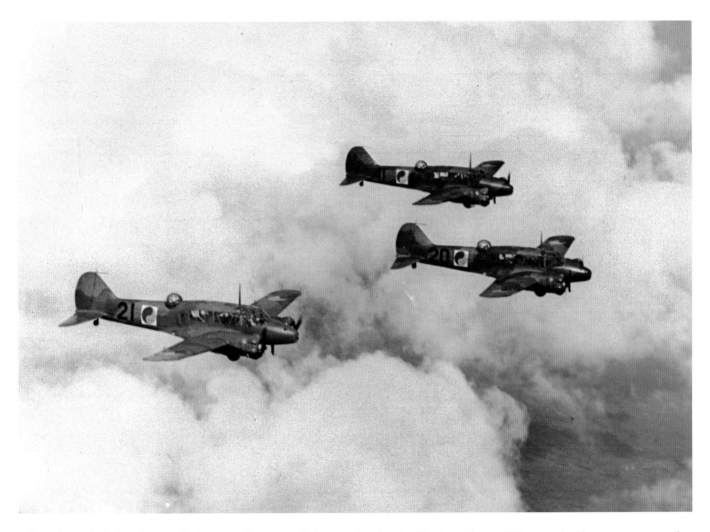

Avro Anson light bombers in flight, part of a group of nine acquired by the Air Corps from 1937 onwards. They were soon made obsolete and were instead used for coastal reconnaissance after war broke out.

Left: an Irish Army officer in the full dress uniform that applied from the mid-1930s. It is a tribute to Defence Forces personnel that despite continual shortages of equipment and manpower over the decades, problems that persist up to today, they have always managed to maintain an *esprit de corps* and continue to operate a professional army.

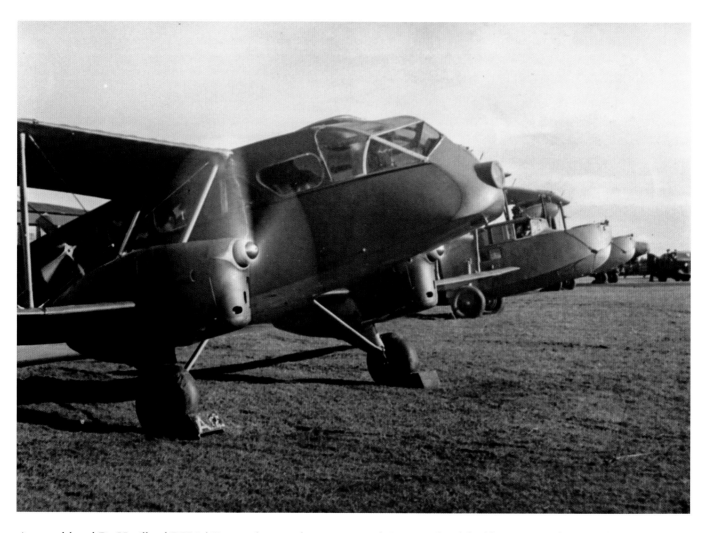

A second-hand De Havilland DH.84 Dragon (previously in service with Jersey Airlines) had been acquired in March 1937, to serve as a target tug for firing practice. It was the first twin-engined aircraft to enter service with the Air Corps. Coincidentally, in May of the previous year, a similar DH.84 aircraft, *Iolar*, had flown from Baldonnel Aerodrome to Whitchurch Airport in Bristol, marking the inaugural flight of the Irish national airline, Aer Lingus.

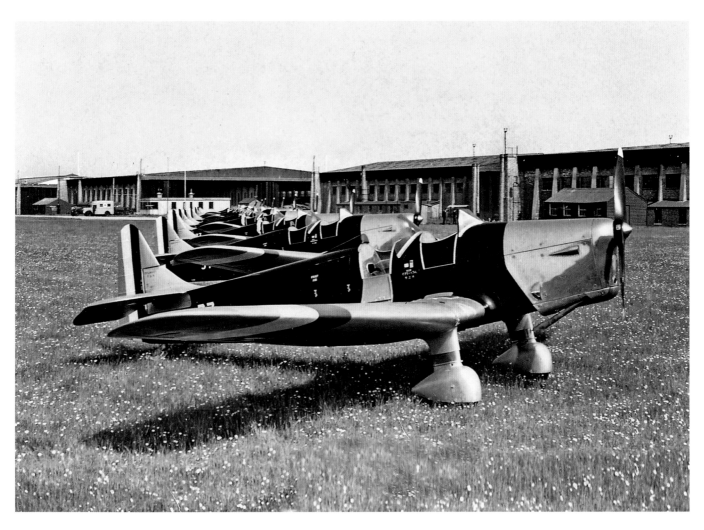

Reflecting the need to recruit and train short-service officer pilots, ten Miles M.14a Magister elementary trainers were delivered to Baldonnel in early 1939. With low wings, all-wood construction and twin cockpits with dual controls, these were the first monoplane training aircraft to be operated by the Air Corps.

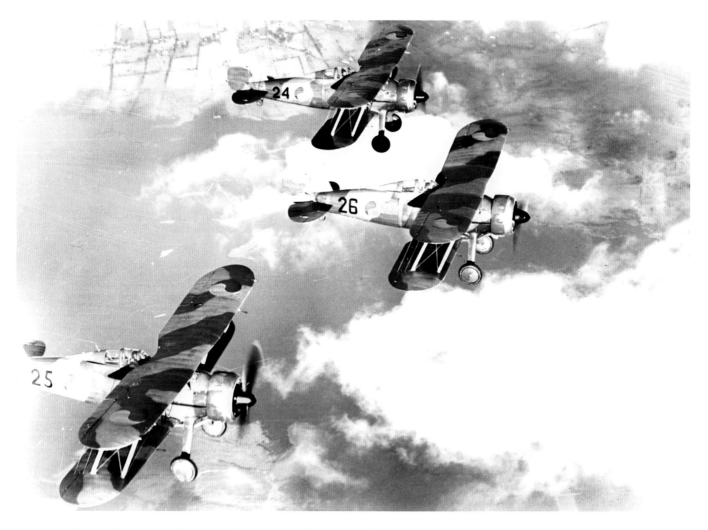

Four Gloster Gladiator single-engine fighters were delivered to Baldonnel in March 1938. The Department of Defence later attempted to order four more of these biplanes with no success, as by that stage the aircraft company's production was committed to the Royal Air Force.

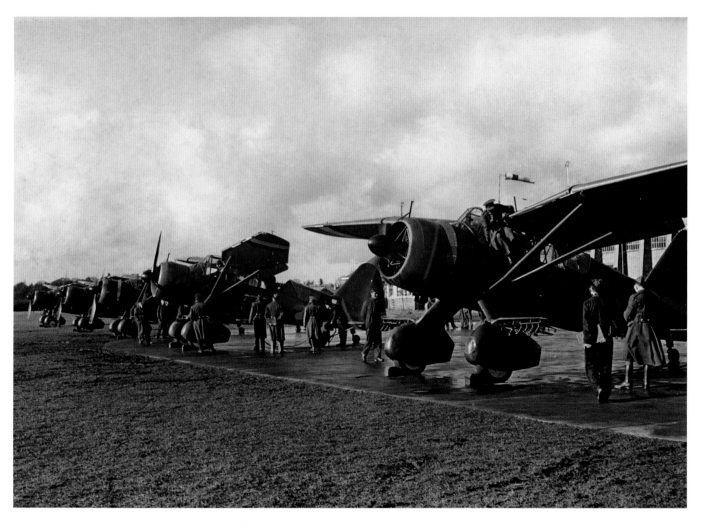

A line up of Lysander IIs. Ordered in 1938 from Westland Aircraft Limited by the Department of Defence, six of these two-seater army-cooperation aircraft were delivered to the Air Corps in June 1939.

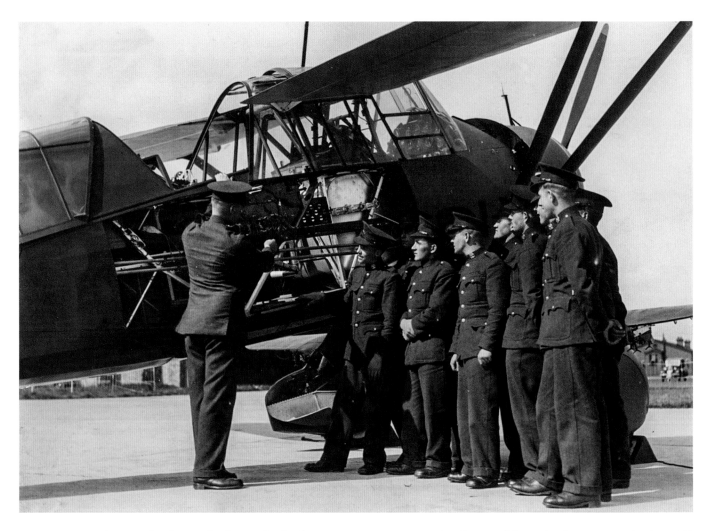

Demonstrating the innards of a Westland Lysander fuselage to young apprentices. Accidents and heavy landings meant that by 1943 there were only three of these aircraft type left in service.

Right: An Irish naval rating. Ireland had no navy up to the end of the 1930s. It was belatedly realised that a neutral nation needed to protect its territorial waters from use by belligerent forces. A small Marine and Coast Watching Service was established in September 1939. In mid-1940 the old Royal Navy shipyard at Haulbowline Island was adopted as the HQ of the Marine Service.

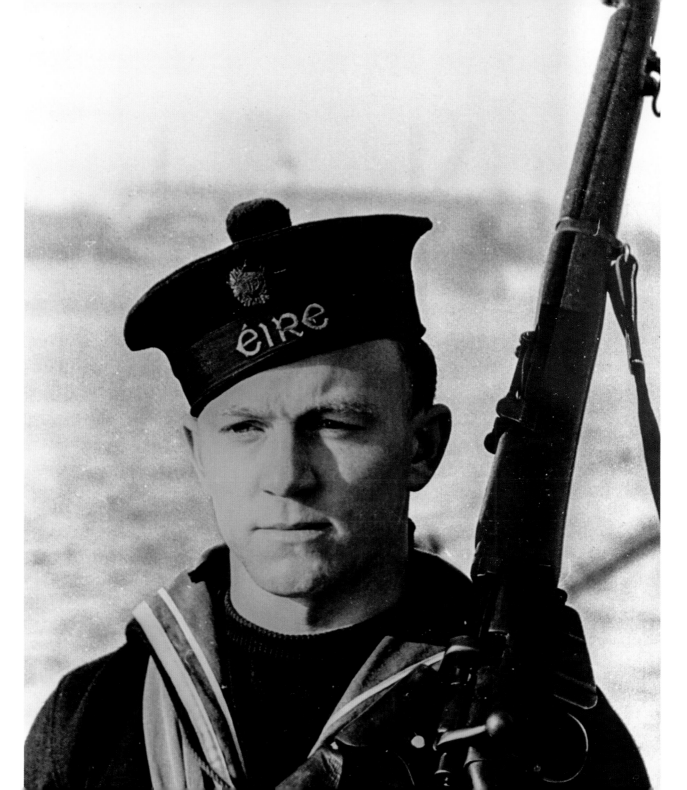

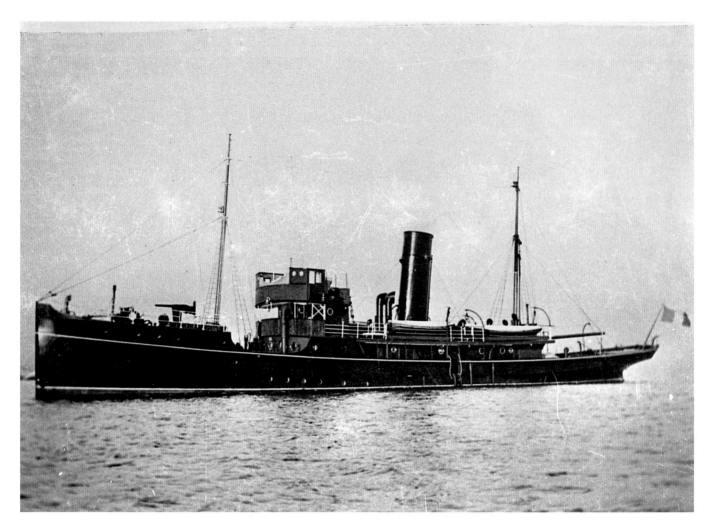

Once more, the *Muirchú* was brought back for military service, and was converted for deployment in the new Marine Service. A ship with many lives, she had been built in 1908 in the Liffey Dockyard as the *Helga*, a fishery research and protection vessel. After the outbreak of WWI, she operated as a naval armed yacht. In April 1916, during the Easter Rising, she famously bombarded Liberty Hall. During the Civil War she was commandeered for use in operations against anti-Treaty forces. Incorporated into Free State service, she was renamed the *Muirchú*. With the Civil War won, the government promptly closed down their short-lived navy in August 1923, and the ship was given to the Department of Agriculture for, once again, fishery protection duties.

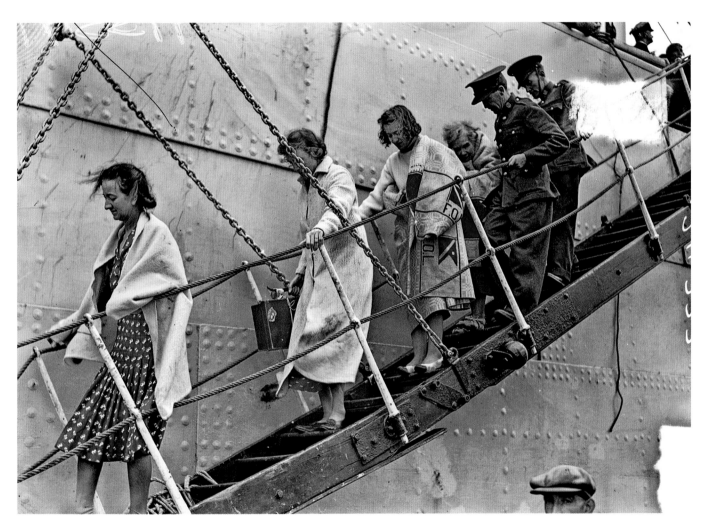

The realities of a world war were quickly brought home here at Galway when survivors from the SS *Athenia* came ashore after being rescued by a Norwegian ship. On 3 September 1939 the Donaldson Atlantic Line passenger liner was bound for Montreal, having left Liverpool the previous day. She was around 370km northwest of Ireland when she was struck by a torpedo fired by a German submarine, the *U-30*; little over eight hours after Britain had declared war on Germany. Around 120 were killed in the sinking, but the rest on board were rescued, including the 450 who were landed at Galway. The SS *Athenia* was the first British ship to be sunk by a German submarine during WWII. The German Navy did not believe that they had a U-boat in the area at that time and thus immediately denied responsibility. Later, after Hitler was informed of the correct story, he decided to keep it quiet.

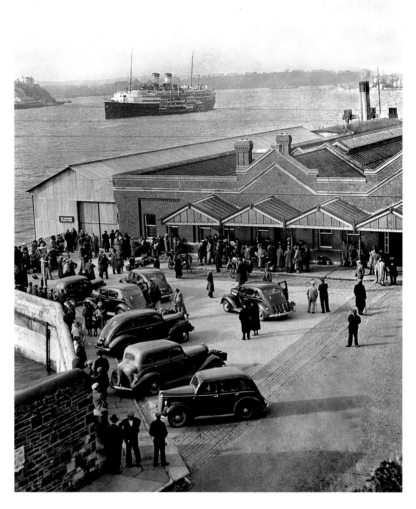

The scene at Cobh Railway Station on 4 September 1939, as hundreds of American tourists, who had been stranded in neutral Ireland at the outbreak of war, prepare to embark on the specially chartered SS *Iroquois* (seen in the background). Earlier, on 2 September in Dublin, the Dáil had met and unanimously passed an extensive Emergency Powers Bill – with the session concluding at 5:00 a.m. the following morning. The Emergency, as the war years came to be known in Ireland, had begun.

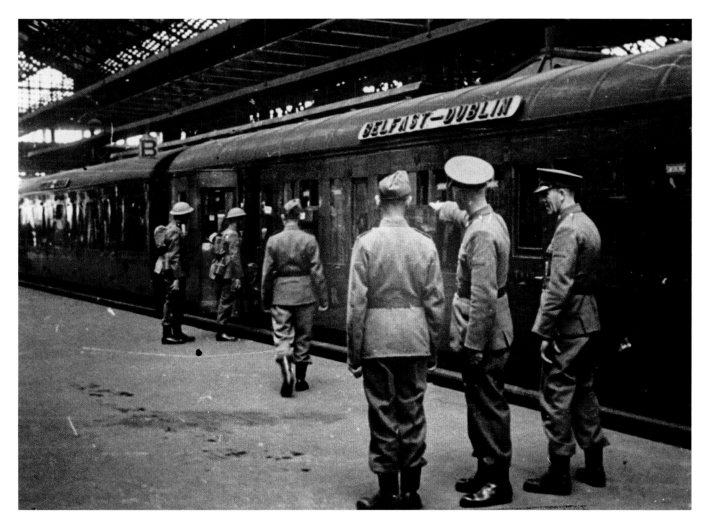

Pictured at Amiens Street Railway Station, Dublin, during the Emergency – soldiers inspect the Belfast–Dublin Express. At the outbreak of war, the Common Travel Area was suspended and travel restrictions were imposed between the United Kingdom and Éire. As shortages began to bite, rationed commodities (particularly foods such as eggs and sugar) that were in relative abundance in Éire were smuggled across the border into Northern Ireland. In turn, products like tea and petrol went south.

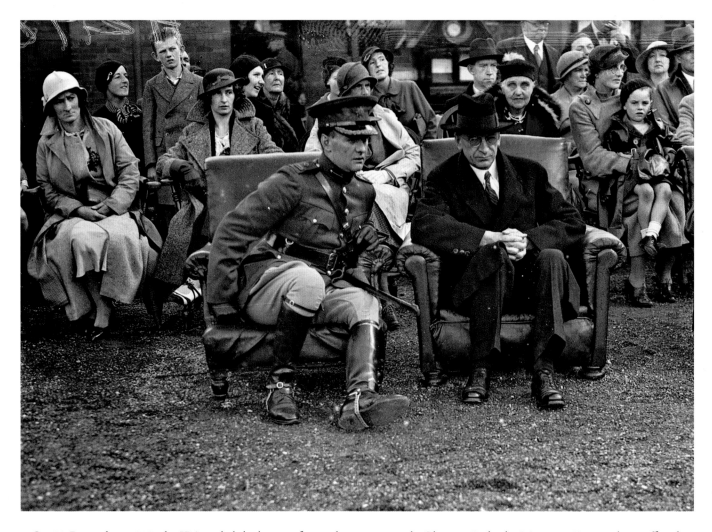

On 23 December, 1939, the IRA raided the bastion fort and magazine in the Phoenix Park, the Magazine Fort, making off with most of the army's reserves of ammunition and a quantity of Thompson submachine guns. Despite the fact that most of the missing material was soon recovered, it was a massive shock – it was an 'Irish Pearl Harbour', as Colonel Dan Bryan remembered later. The army Chief of Staff, Lieutenant-General Michael Brennan (seen here some years earlier at a commissioning ceremony with Éamon de Valera) retired shortly afterwards and was replaced by Major-General Daniel McKenna in January 1940.

ARKS JACK MAC MANUS

this land is yours
for the keeping—

HELP TO KEEP IT

2. EMERGENCY
1940-41

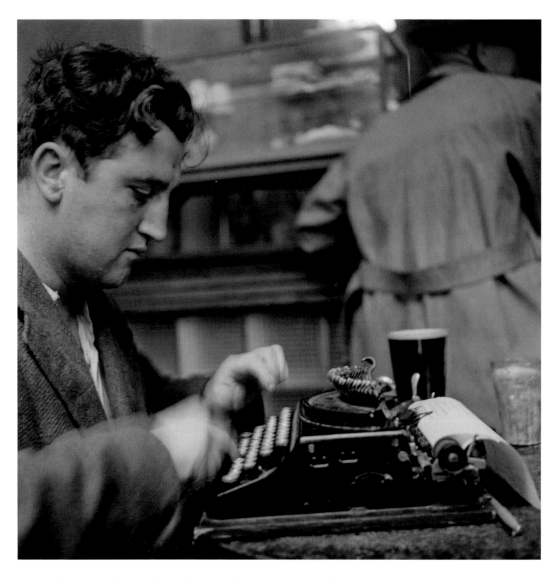

In February 1940, Brendan Behan, aged 16, was sentenced at Liverpool's Assizes to three years in Borstal (the basis of his 1958 masterpiece *Borstal Boy*). A member of the IRA, he had travelled to Liverpool on his own initiative to bomb the docks there, but was quickly arrested. Deported to Ireland in November 1941, he was later arrested and sentenced for the attempted murder of Garda detectives and was to spend the rest of the Emergency in confinement.

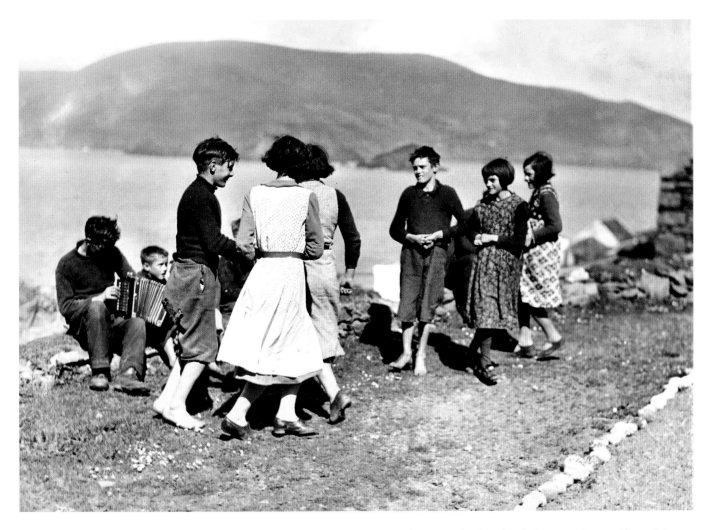

Simple pleasures. Young people dance to the sound of an accordion on the Aran Islands. Already living a plain and basic life, the inhabitants of the islands off Ireland's Atlantic coast were little touched by the war during its early years. Traditional music continued to be played in gatherings across the country, a way for folk to meet, socialise and enjoy their cultural heritage.

Sitting in the kitchen around the turf fire, Mícheál Ó hÉanaigh, *seanchaí* (storyteller-cum-historian), enthralls a gathering at Teelin, in the Donegal Gaeltacht. *Seancaithe* were inheritors of a millennia-long Gaelic storytelling tradition. It may be difficult to comprehend now in the era of television, internet and mobile devices, but during the 1940s, life was more social and there was a greater sense of community.

Friends and neighbours in the Irish countryside used to entertain themselves at home with storytelling events like this. There was also a large variety of activities such as impromptu music sessions, traditional dancing, card games like poker and whist, listening to a radio at a friend's house – or simply conversing by the fireside.

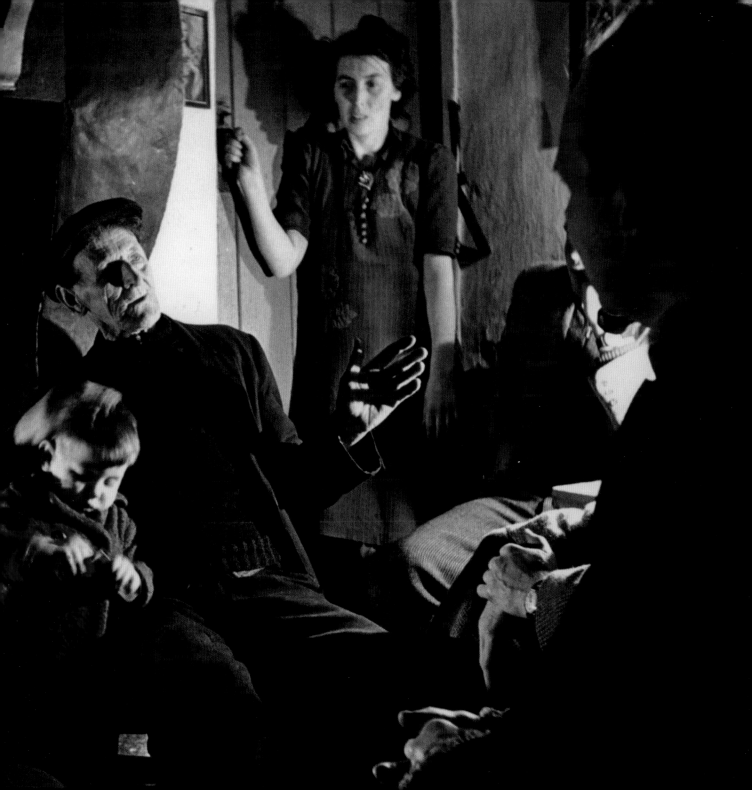

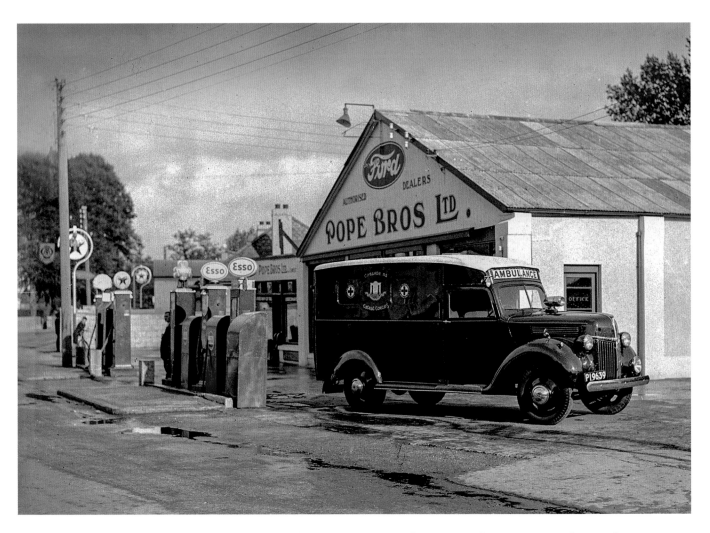

An ambulance parked in front of the petrol pumps at the Victoria Cross, Cork, premises of Pope Bros in 1940. Petrol rationing was introduced in Éire at the outbreak of war. The initial ration of 10 gallons per month for a private motorist was relatively generous – twice the amount allowed in Britain. The allowance was lowered after December 1940 when, with their attitude to neutral Ireland hardening, the British government announced that the delivery of petrol supplies would be reduced.

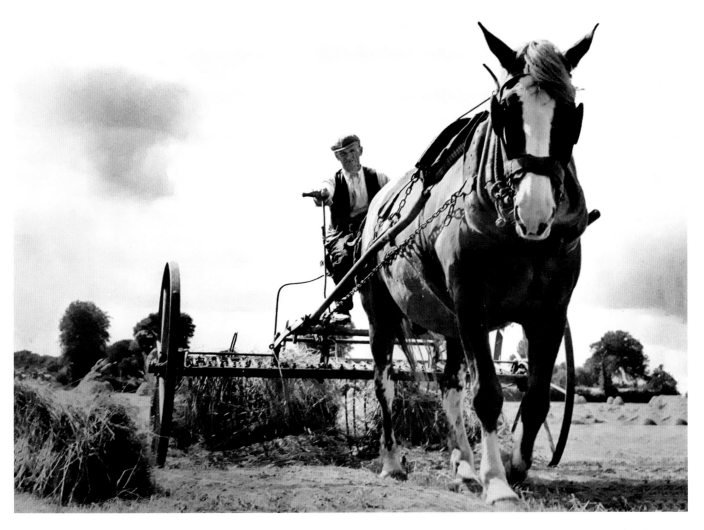

Cutting hay using horsepower – no petrol required. The Fianna Fáil government had always been committed to a self-sufficient Ireland and wanted to reduce the substantial imports of wheat and animal feedstuff. They wished to promote tillage as opposed to the prevalent practice of dairy and beef farming. The government introduced an obligation for the 1940 growing season that all farmers with more than ten acres were to till one-eighth of their acreage (with exemptions for unsuitable land like bog). There was opposition to this measure with many dairy and cattle farmers being reluctant to plough up their rich grassland.

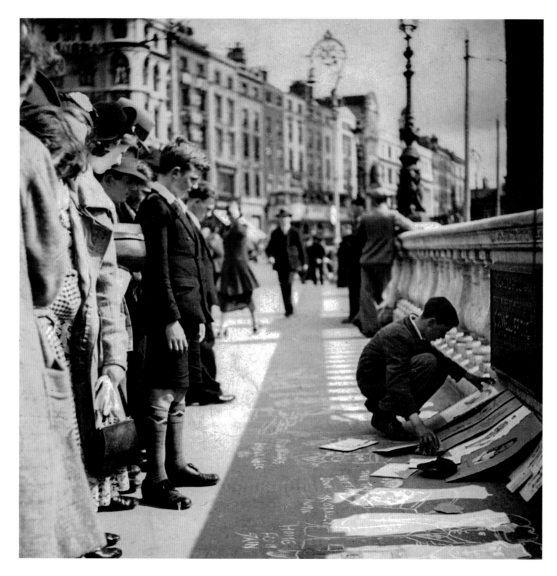

Passersby inspect paintings on display at O'Connell Bridge in Dublin. Cultural life continued in Ireland during the war, albeit in a muted form. Novels were published. Visual artists carried on and there were exhibitions in the Royal Hibernian Academy. In the field of classical music, there were new works by composers such as Frederick May and Aloys Fleischman. Despite resource shortages, there were professional and amateur theatrical performances across the country.

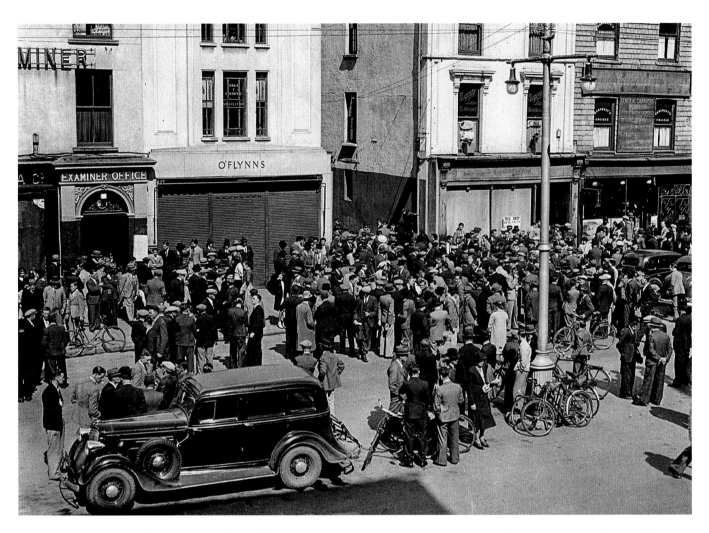

In May 1940, people mill outside the offices of the *Cork Examiner* as they seek news about the German invasion of neutral Belgium and the Netherlands. The 'Phoney War', where both sides had been generally content to remain behind their defences, was over. Departing from his strict neutrality, de Valera made a speech criticising the invasion by the Germans: 'Today these two nations [Holland and Belgium] are fighting for their lives, and I think I would be unworthy of this small nation if on an occasion like this, I did not utter a protest against the cruel wrong which has been done them.'

A crew prepares to fire a 9.2 inch gun at Fort Davis (previously Fort Carlisle), part of the Treaty Port installations in Cork Harbour. The gun could hurl a shell weighing 170kg for a distance of around 20km.

After Dunkirk and the fall of France, Britain's survival was in doubt. As Churchill succeeded Chamberlain, British eyes turned to the neutral country next door. Fuelled by alarmist intelligence reports, they became obsessed by the danger of an imminent invasion of Éire by the Germans. Malcolm MacDonald, previously the Colonial Secretary, was given the unenviable task of trying to persuade de Valera that Éire should join the war. In June 1940, MacDonald made two visits to Dublin which were inconclusive. He returned once again on 26 June and made a startling offer to the taoiseach – Britain would make a declaration accepting the principle of a united Ireland. The terms to be worked out: Éire would enter the war on the side of Britain and its allies and would allow the British Navy to use its ports, with the stationing of the British Army and Air Force at locations to be agreed. In a later discussion, MacDonald undertook to revise the offer to one where Éire could maintain its non-belligerency, but where it would allow British forces to enter its territory to assist in its defence in the event of a German invasion.

De Valera immediately pointed out the difficulties – while Éire was to enter the war immediately, 'a united Ireland was to be a deferred payment'. On 5 July the British offer was formally rejected.

A fundamental flaw in the British proposal was that Viscount Craigavon in Northern Ireland had only been informed of its contents on the same day as it was presented to de Valera. Craigavon was having none of it and sent off a telegram to London: 'Am profoundly shocked and disgusted by your letter making suggestions so far reaching behind my back …' The Viscount later sent off a telegraph saying that: 'De Valera under German dictation … Strongly advocate immediate naval occupation of harbours and military advance south.'

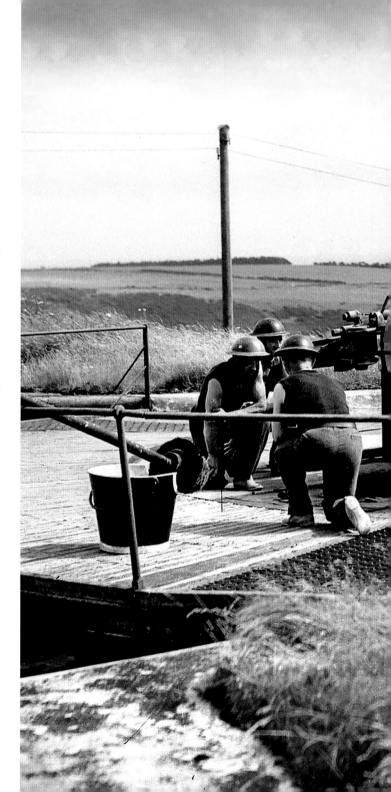

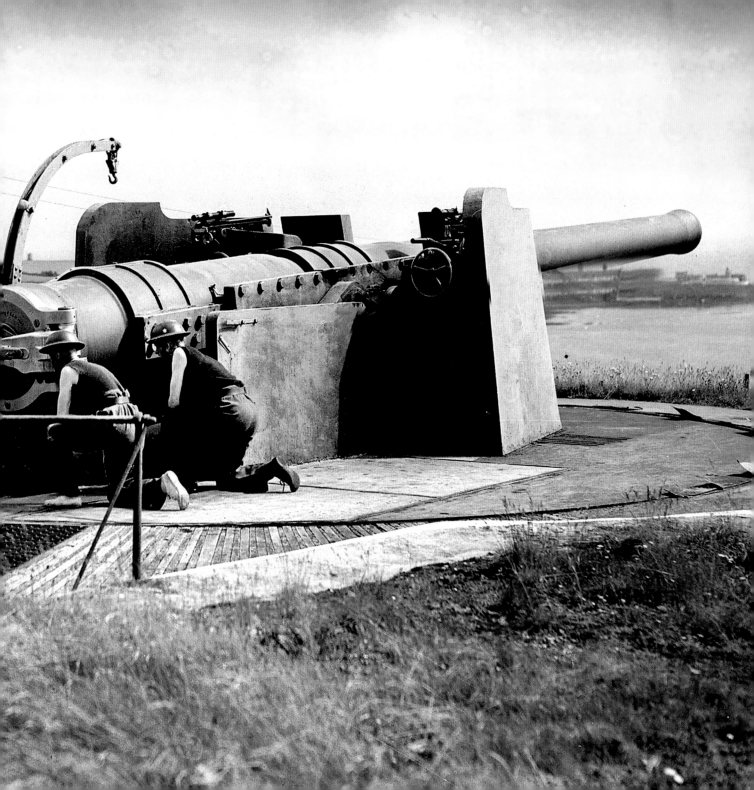

July 1940 – the army are on manoeuvres near Ballincollig, Co. Cork. A member of the Cavalry Corps, in a Rolls Royce armoured car (of 1922 vintage) receives directions from an infantryman. The latter is wearing the standard-issue Stalhlem-style helmet, which was procured in 1927 by the army from the British engineering company, Vickers.

Despite its British manufacture, the optics of soldiers wearing German-type helmets did not look good in the neutral Ireland of that time. Over the course of 1940, this helmet was replaced by the British MK II Brodie helmet. A number of the withdrawn helmets were later distributed to various emergency services, now painted white.

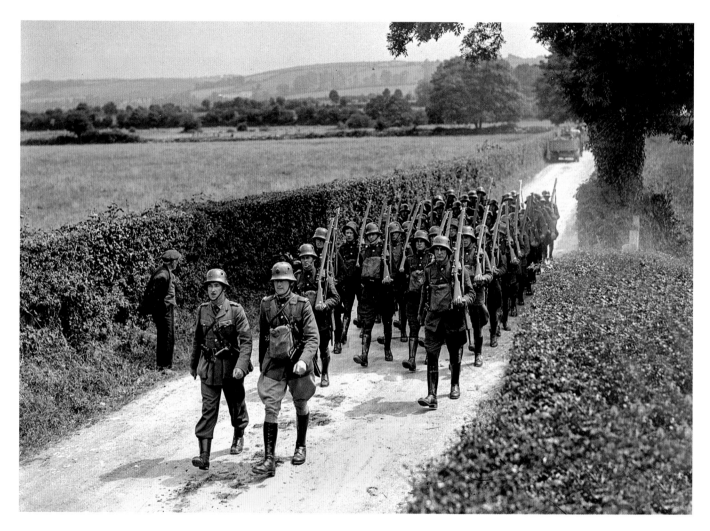

A unit marches at Ballincollig. At the outbreak of the war, the government had ordered the full mobilisation of the Defence Forces, including reservists. By May 1940 their establishment amounted to a mere 13,000 men under arms. In June, de Valera, supported by opposition party leaders, issued a 'call to arms'. A vigorous recruitment campaign resulted in an increase of numbers to 41,000 by the following March.

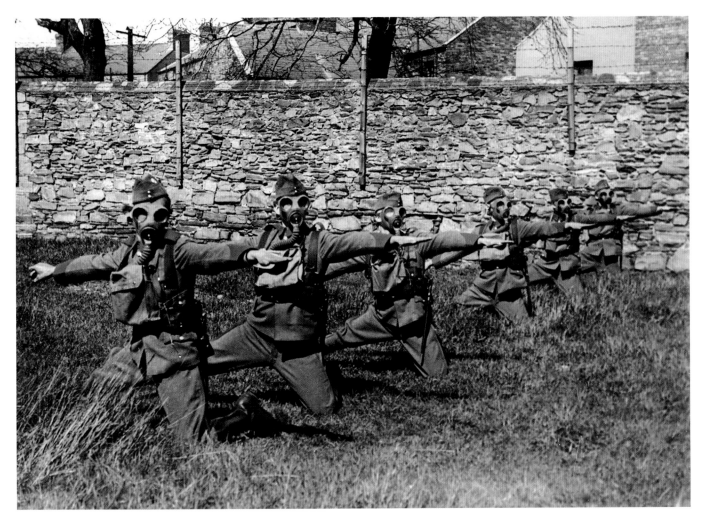

Members of the Volunteer Force in training at Portobello (now Cathal Brugha) Barracks. After mid-1940, Irish military planning was based on the assumption of the equal possibility of an invasion by Britain (coming south across the border) or by Germany on the southern coast. A two-division structure was adapted. One of these divisions was to focus on defence of the border, the other was to secure the southern ports and the coastline. An independent brigade was kept in reserve as a mobile strike force, to be deployed where needed.

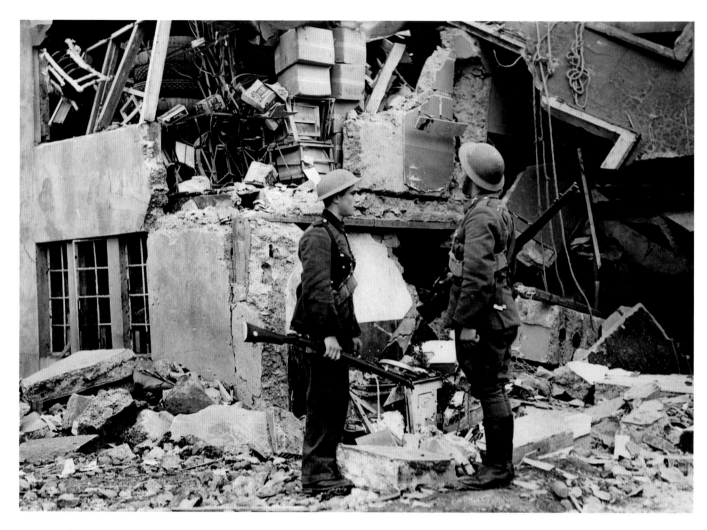

On the afternoon of 26 August 1940, a quiet part of neutral Ireland was brought face-to-face with the cruel reality of modern aerial bombardment. A German Heinkel HE 111 dropped four bombs at Campile, Co. Wexford, a small village located on the Waterford to Rosslare railway line. The railway track was damaged and there was a direct hit on the Shelbourne Co-Operative – three young women working there were killed. It was a clear day and there have been dark suggestions that the bombing was deliberate. Nonetheless, the most plausible explanation is that a lost German pilot thought he was bombing a facility by a railway in Wales.

A civilian volunteer in a local defence unit training with a wooden replica of a Lewis machine gun. Measures like this had to be adopted due to the severe shortage of equipment.

Local Security Force (LSF) volunteers demonstrate a replica wooden field gun to the taoiseach. Recruitment for the LSF, a form of home guard, began in May 1940 after the invasion of France. The uniform was of brown (initially blue) denim, and a consignment of Springfield rifles, recently obtained from the US, were among the weapons issued.

Originally the volunteers were under the control of An Garda Síochána, but in January 1941 most of the force was transferred to army control, to become the Local Defence Force (LDF). The original brown uniform was of poor quality and was christened, 'The Habit'. In 1942 a green battledress-style uniform of better quality was issued. The number of volunteers reached a peak of over 100,000 in 1942.

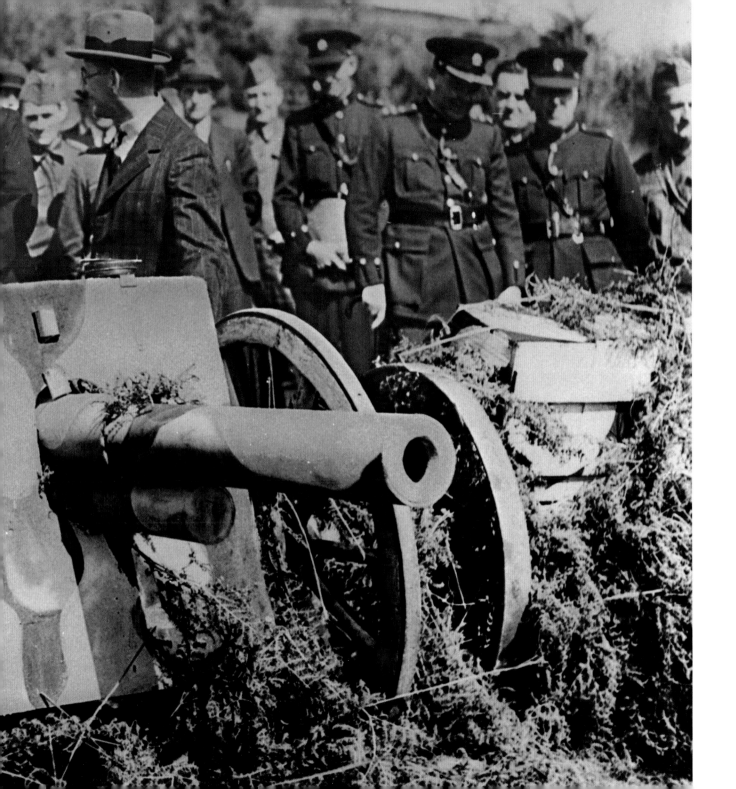

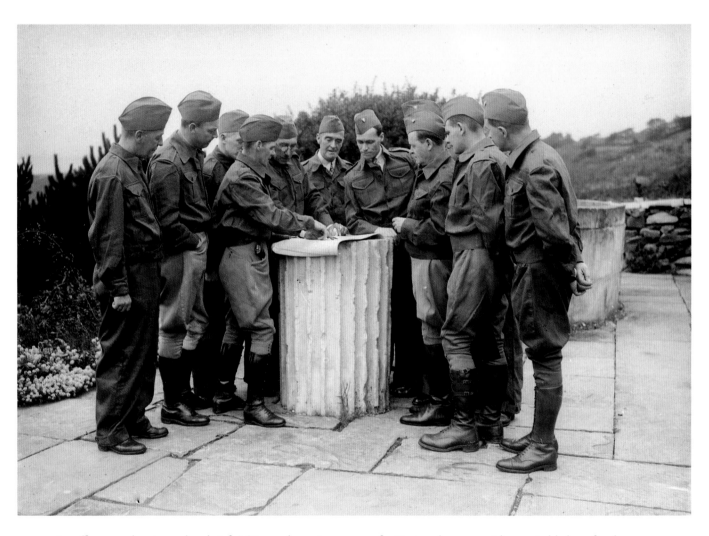

An officer, revolver in pocket, briefs LSF members. A segment of a Doric column provides a suitable base for the map.

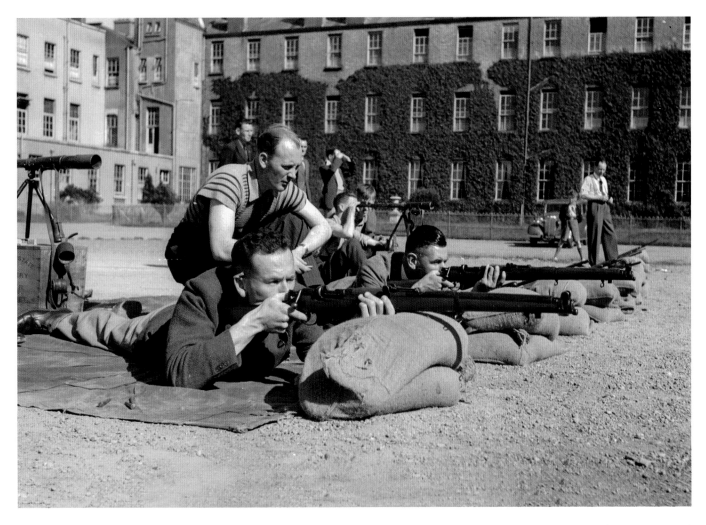

How to aim: instruction on how to fire a Lee-Enfield rifle. As well as weapons training, instruction was given in such topics as squad drills, patrol duties, traffic control, aerial observation, Air Raid Precautions (ARP), attendance at fires and first aid.

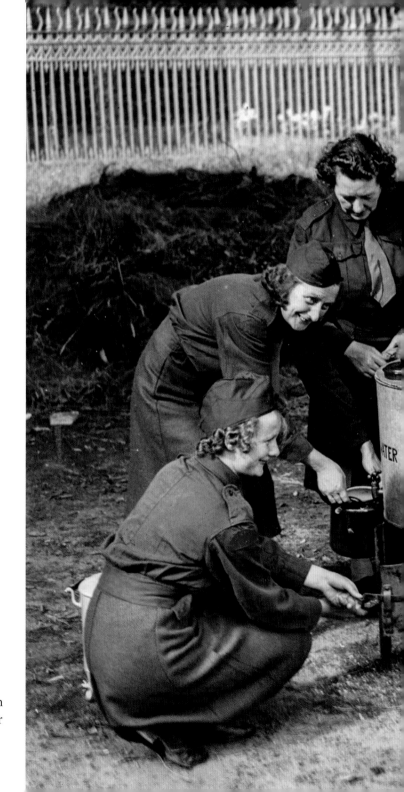

Time for tea? Male and female members of the LSF with an Air Raid Precaution warden gathered around a water boiler.

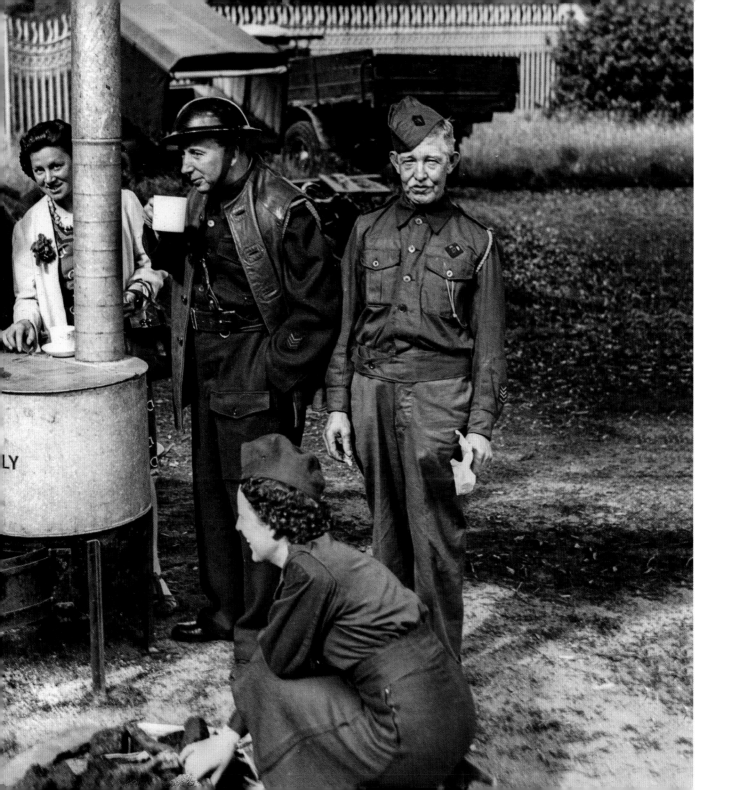

The task of the LSF was to guard their local areas and defend them in the event of an invasion. Here, an LSF man watches the coast while his colleague reports their observations.

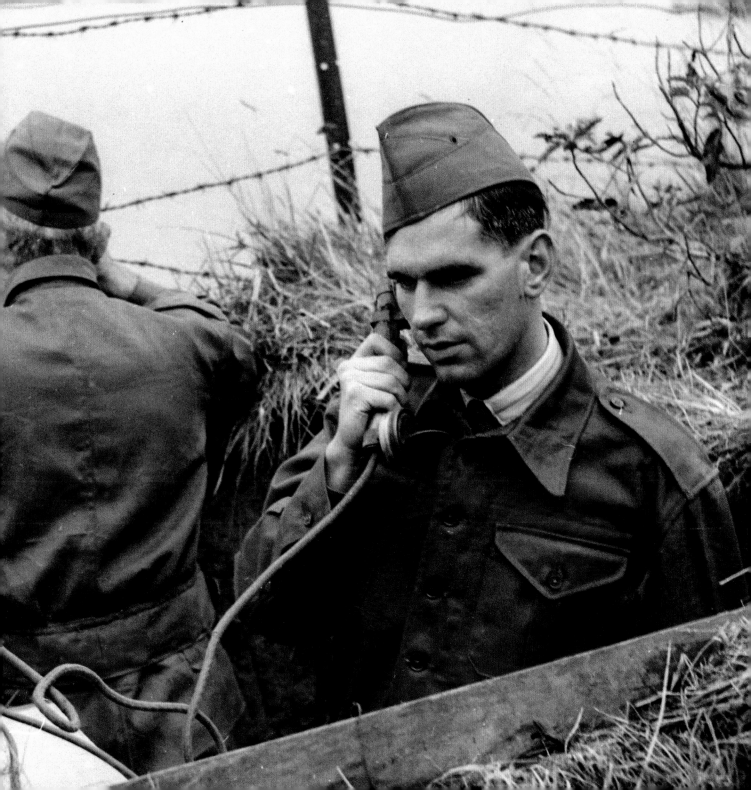

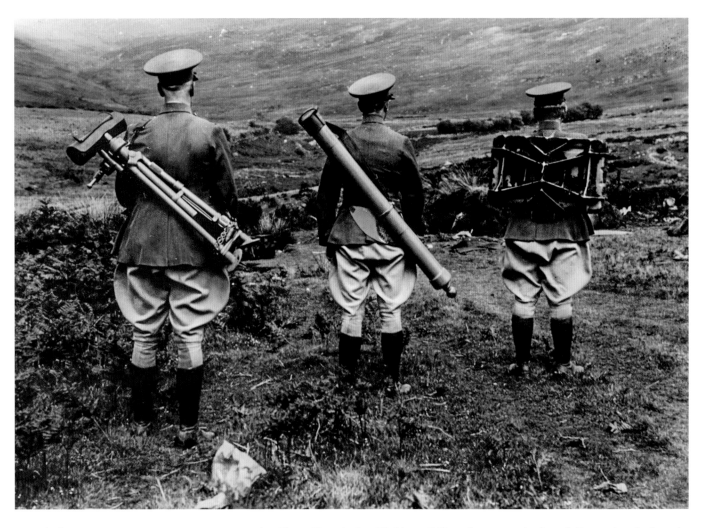

Ready for an army mortar training exercise at the Glen of Imaal, Co. Wicklow. Officers line up with, from left to right, the bipod legs, barrel and base plate of a Brandt 81mm mortar slung on their backs.

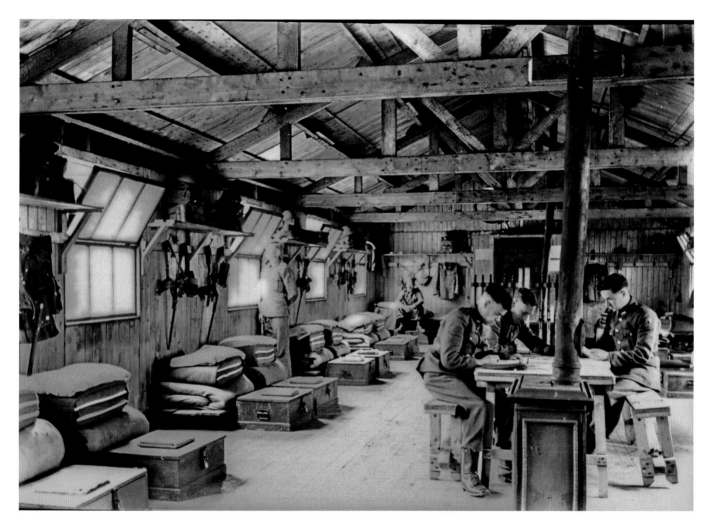

Recruits, hair recently shorn, sit at a central table. Their Brodie helmets and personal kit are stowed on the walls. Hundreds of timber huts like this were constructed across the country to accommodate the increased army numbers.

Whoever could that be? A barracks jape during training at the Curragh. The influx of new recruits meant an enormous amount of basic, tactical and physical training had to be organised, all to mould the army into a functioning corps. A fundamental problem with the rapid expansion was the lack of trained and experienced NCOs and officers.

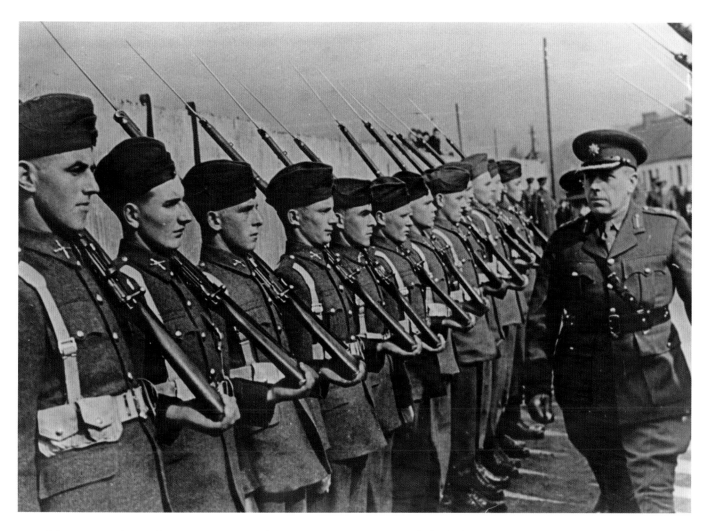

Major-General Daniel McKenna inspects the troops. On 29 January 1940 he had been appointed as Chief of Staff of the Defence Forces in preference to more senior officers – his energy and professionalism had impressed the government. Promoted to Lieutenant-General in 1941, this forceful officer, originally from Co. Derry, worked hard to rectify the weaknesses of an army woefully short of almost every requirement.

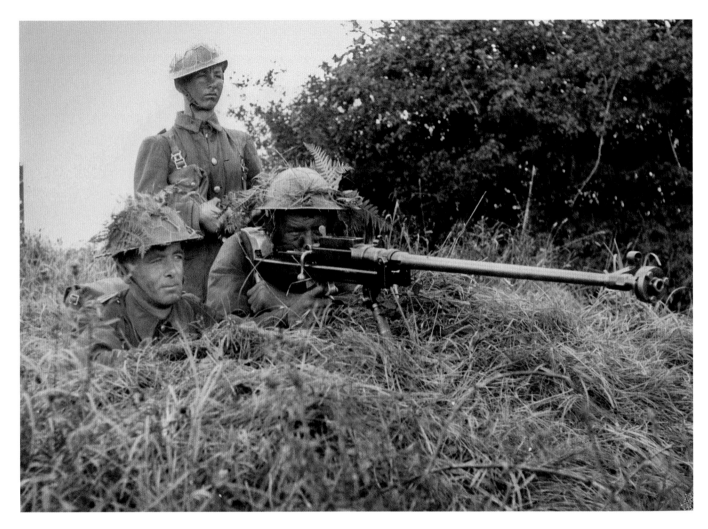

Soldiers pose with the Boys 55 inch anti-tank rifle. Procured from Britain in the late 1930s, a total of 141 were deployed in the army. It was adequate against light armour, but was not able to penetrate the heavy armour of modern battle tanks.

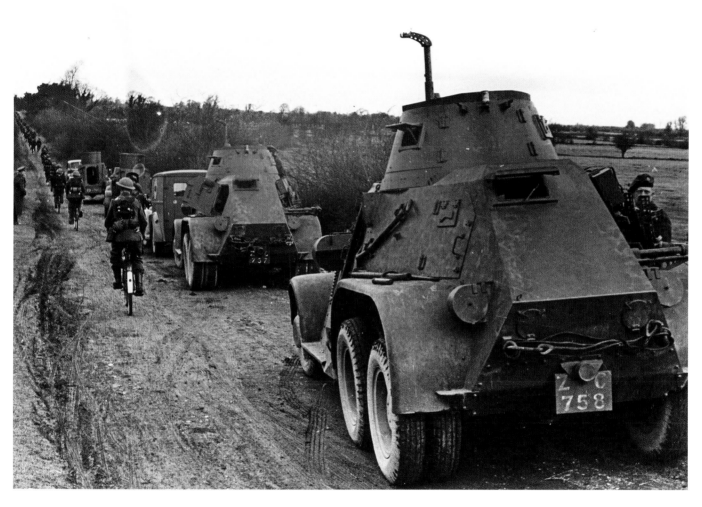

The Irish Army on the move. A cyclist unit passes a group of military vehicles. In the distance are two Ford Mk V armoured cars (built by Thompson & Son, Carlow). These were fitted with turrets armed with Hotchkiss machine guns that had been recycled from 1922-era Peerless armoured cars. In between is an ambulance, and nearest the camera are two Landsverk L180 armoured cars. A total of eight of these were delivered from Sweden in the late 1930s. Five more had been ordered but couldn't be delivered due to the outbreak of war.

Demonstrating a Universal Carrier (generally known as a 'Bren Gun Carrier') as it ploughs through the Irish winter mud down a steep slope. The first batch of 26 were part of a small consignment of military equipment supplied to the Irish Army by Britain in Autumn 1940. Around 200 more were eventually procured.

These light and tracked vehicles were versatile. With a maximum speed of just under 50kph, they could tow a light field gun or transport soldiers with weapons such as mortars or machine guns over rough ground.

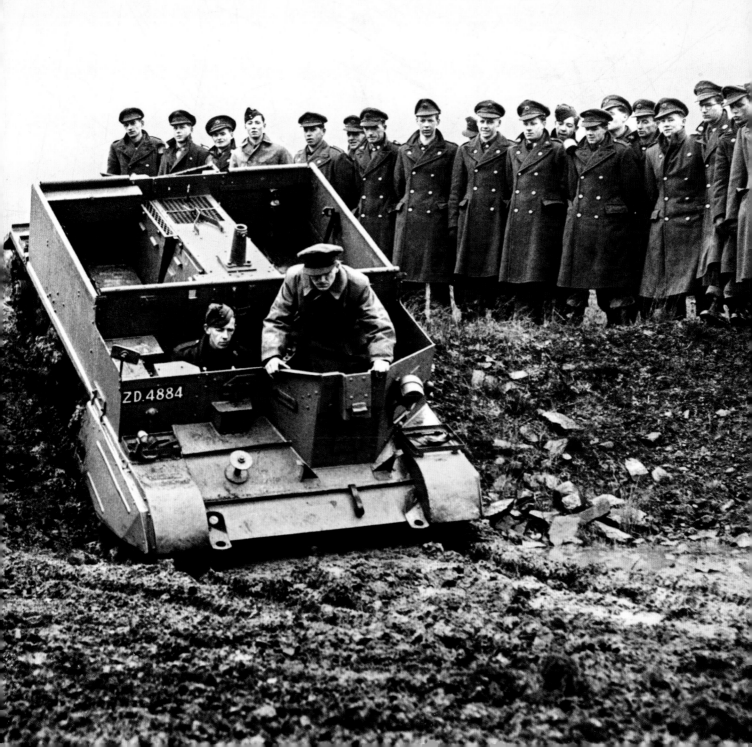

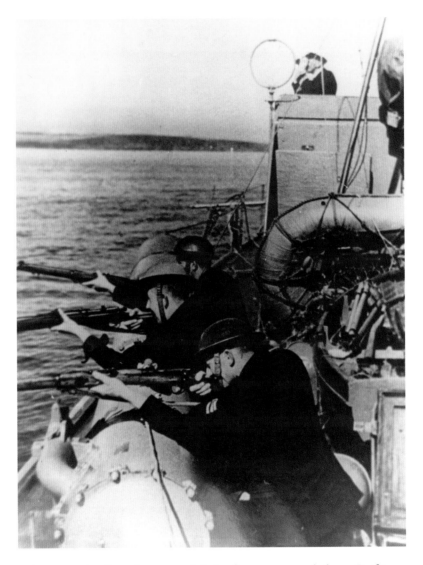

Careful aim is taken at a mine from the cramped deck of a motor torpedo boat. Drifting sea mines were a frequent menace during the war years in Irish waters.

Right: Sailors clamber on board a merchant vessel. An important duty during the Emergency for the Marine and Coastwatching Service was to inspect all vessels entering Irish ports.

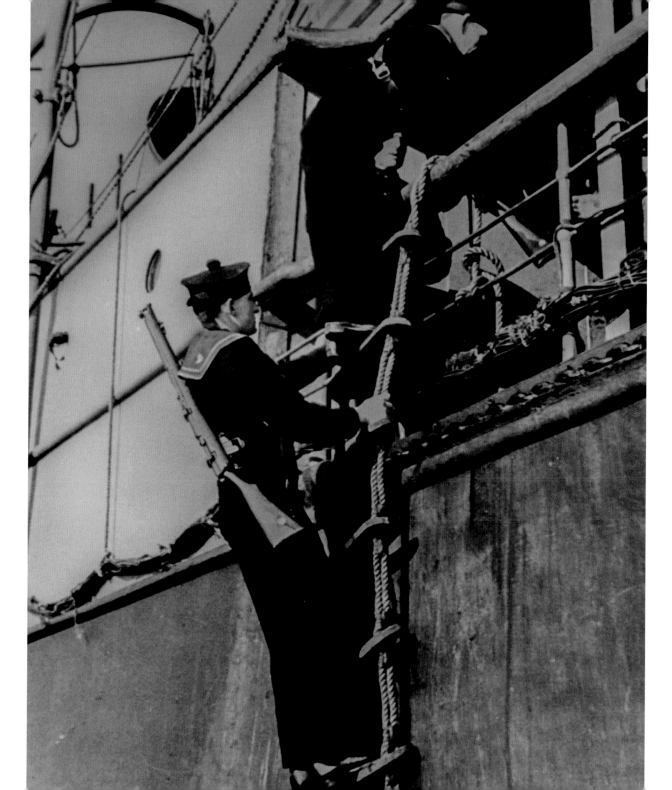

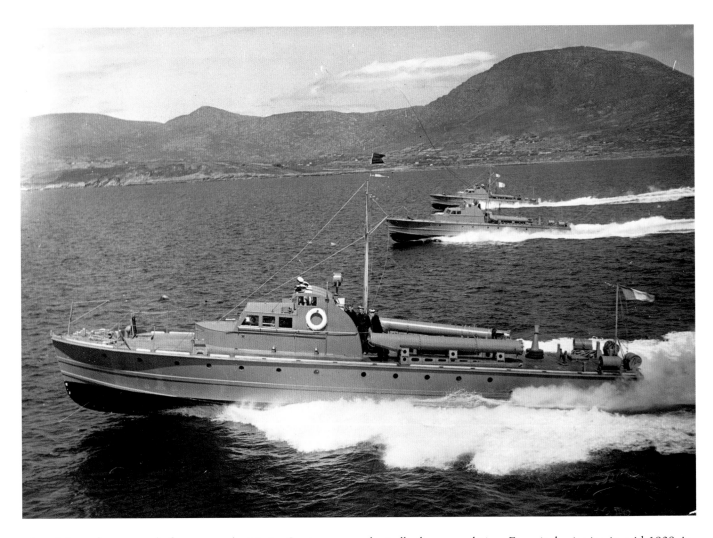

In a defence force starved of resources, the Marine Service was emphatically the poor relation. From its beginning in mid-1939, it had to make do with two ageing vessels which were converted for military use. From January 1940 onwards, the service received a total of six motor torpedo boats (MTBs), built by the British firm Thorneycroft. Several of these had been destined for the navies of Estonia and Latvia, but delivery could not be made due to the war. The MTBs carried 18-inch torpedo tubes and depth charges. In the event, the MTBs were not suited for the rough Atlantic waters and were better used in harbours.

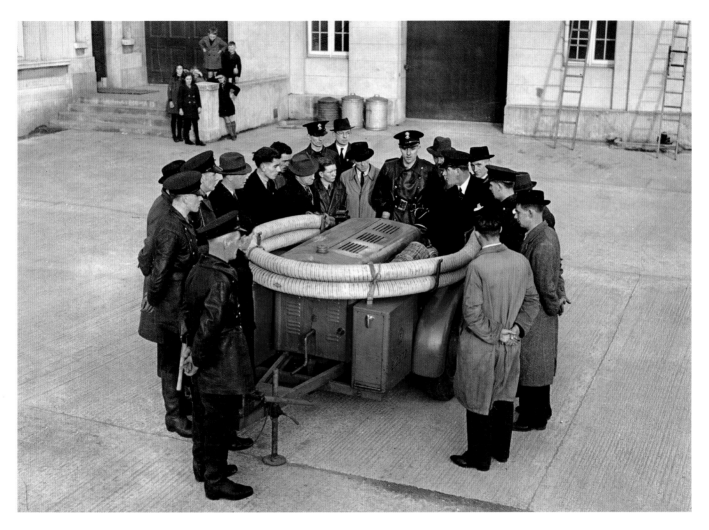

Displaying auxiliary fire service equipment at City Hall, Cork in 1940. Awareness of the vulnerabilities of Ireland to aerial bombing had taken some time to develop. In mid-1939, legislation was passed where local authorities were charged with developing air-raid precautionary measures, such as first-aid posts, shelters, air-raid sirens and auxiliary fire services.

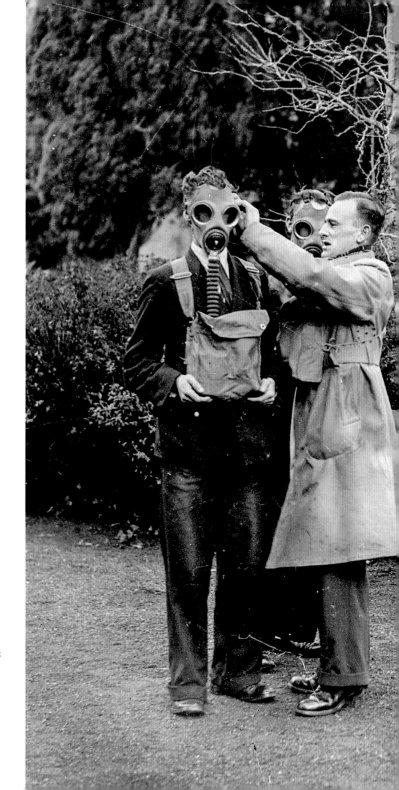

A demonstration of gas masks at Fitzgerald Park in Cork. There was a fear that gas bombs or shells would be used, like they had been in WWI. Gas masks were a ubiquitous sight during the Emergency, issued to protect the wearer from inhaling toxic gases. In the event, none of the belligerents used poison gas in combat during WWII, although the Germans used gas in extermination camps during the Holocaust.

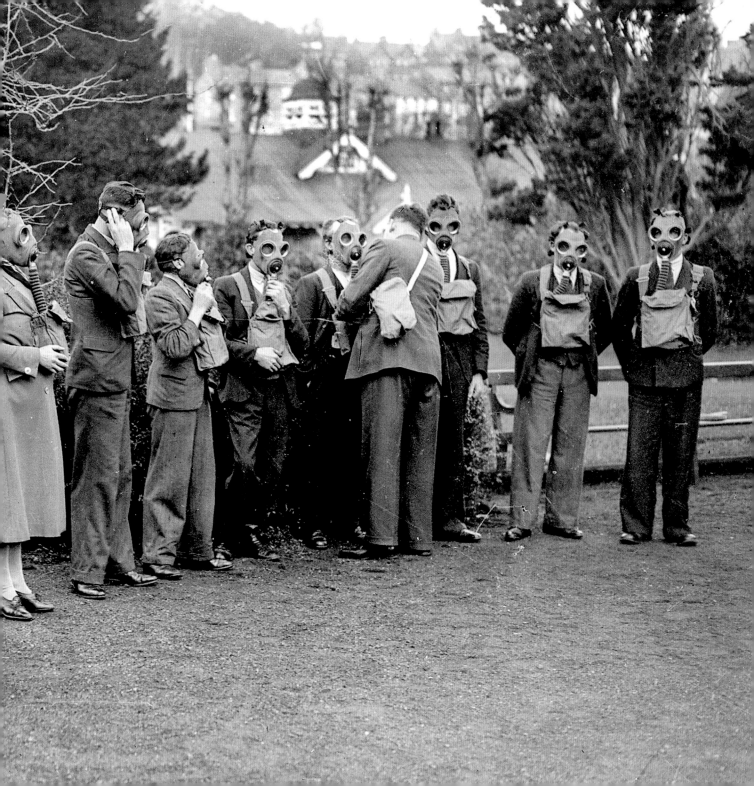

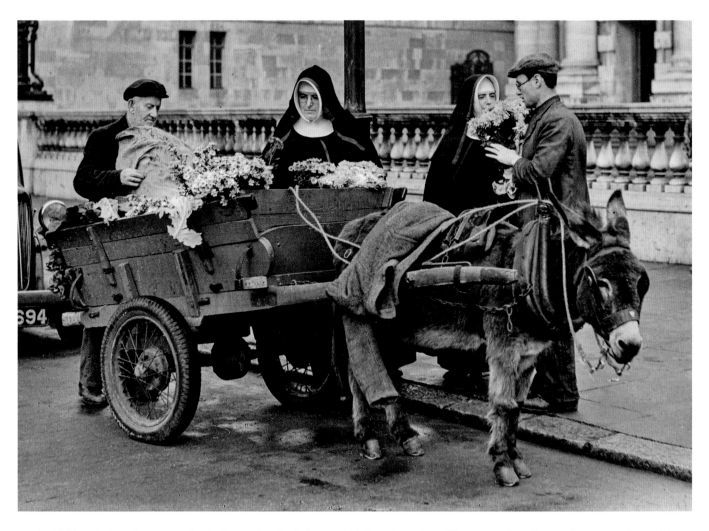

As 1940 ended, ordinary people tried to maintain their normal life and routines. Here, nuns buy flowers from a vendor, as his donkey waits patiently.

Christmas holiday season or not, the war once again came visiting, this time to just south of Dublin. On 20 December 1940 at around 7:30 in the evening, two German bombs fell on Glasthule (near Dún Laoghaire), injuring three people. Pictured is the crater at the junction of Rosmeen Park and Summerhill Road.

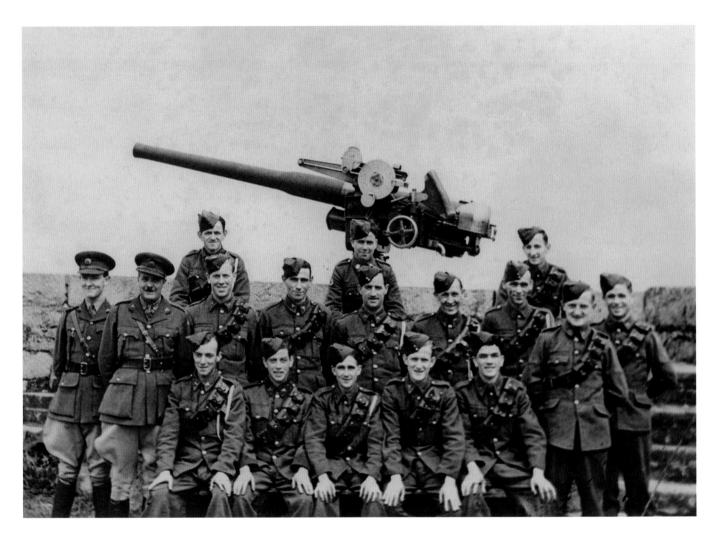

The Defence Forces did their best during the Emergency to deploy anti-aircraft batteries, but there was never a sufficient quantity of modern guns. Here, the anti-aircraft battery at Sandycove pose in front of their 12-pounder. Like in many other cases, the army had to adapt what it had. This type of weapon was originally a naval gun, but was modified to have a higher angle of elevation to allow it to fire on aircraft.

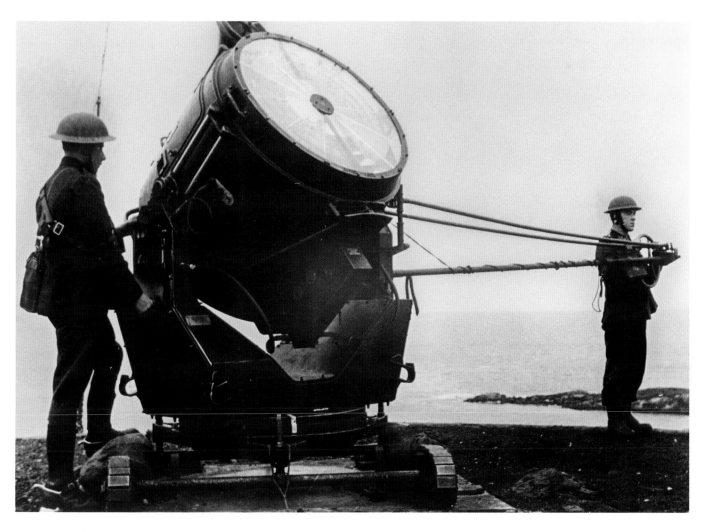

Searchlights were deployed to help track bombers at night, with the intention of indicating targets to anti-aircraft guns.

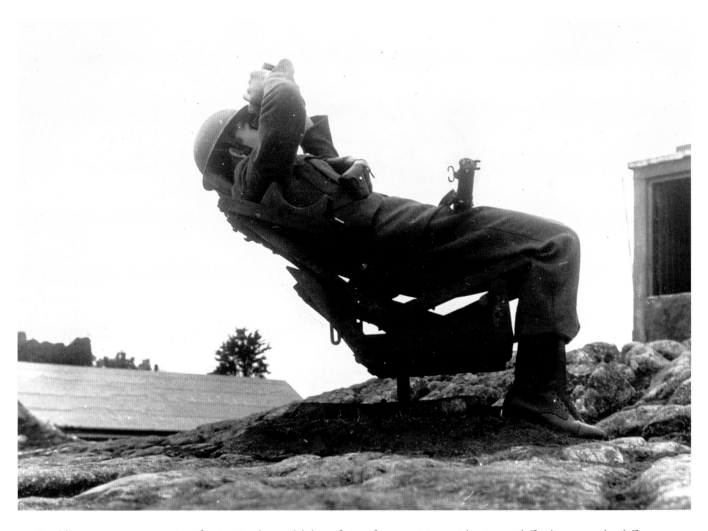

A soldier attempts to spot aircraft. Despite the availability of aircraft-recognition guides, it was difficult to spot the differences between the planes of the belligerents at high altitude.

Right: Operating a rangefinder at the anti-aircraft battery at Ringsend Park in Dublin. In the background is one of the Vickers 3.7 inch heavy anti-aircraft guns. One of the few modern guns acquired by the Defence Forces, it could fire ten rounds a minute. During the North Strand bombing of May 1941, the batteries at Ringsend Park and Fairview opened fire on the German bombers.

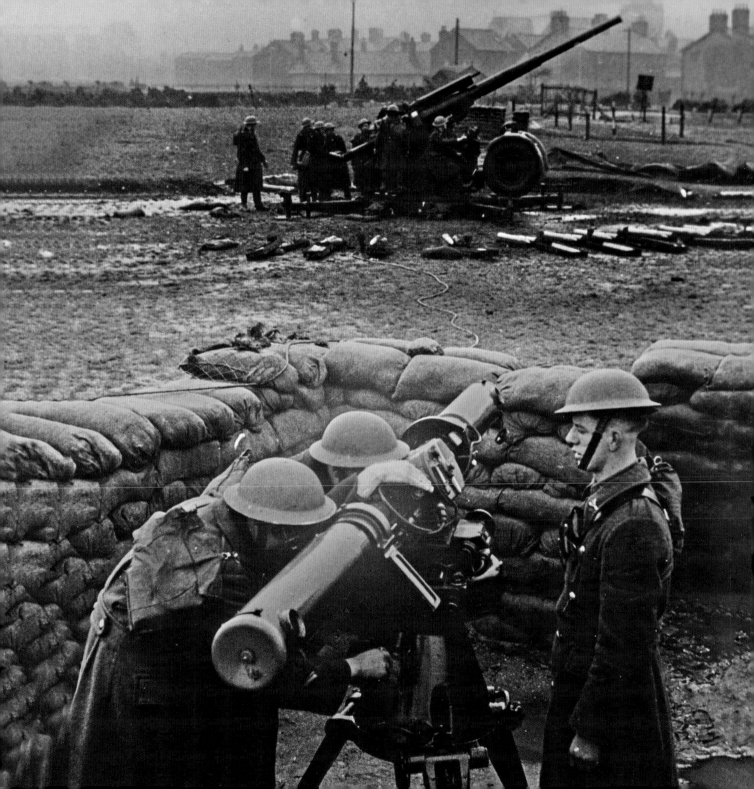

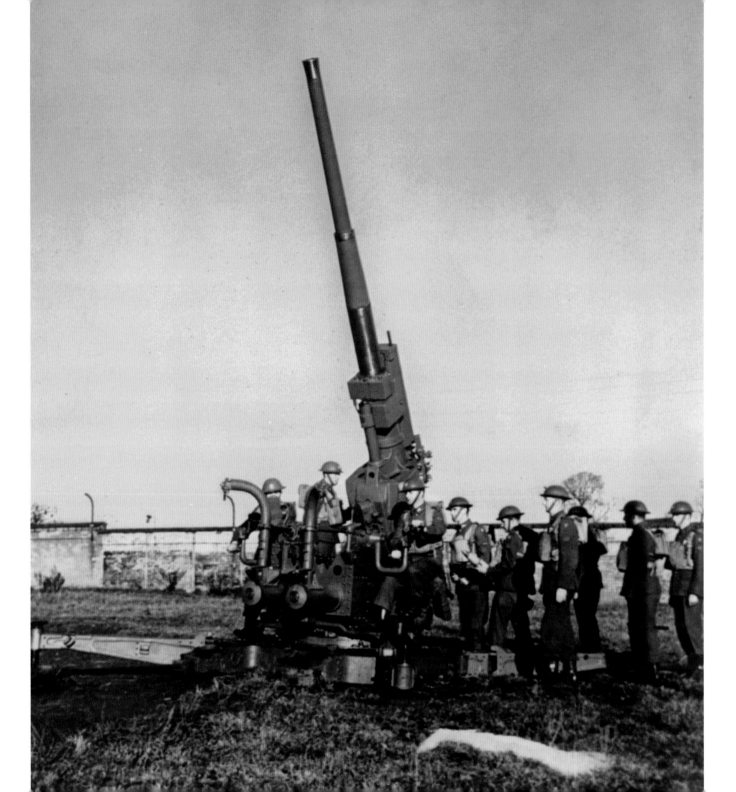

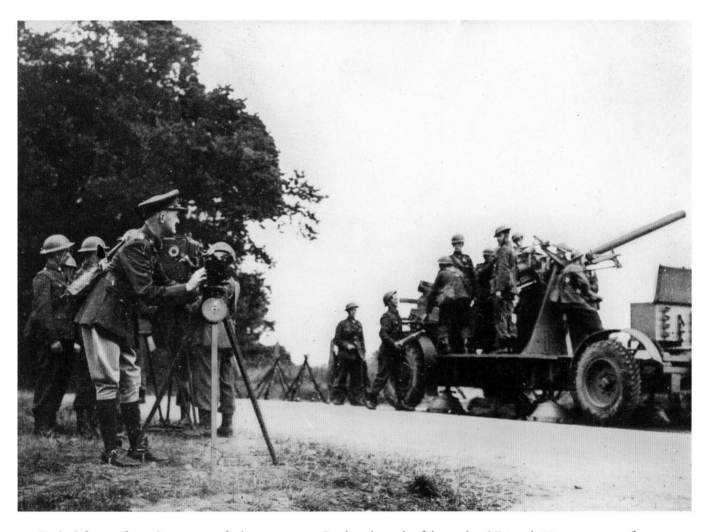

To the left, an officer adjusts a rangefinder instrument. On the other side of the road, a QF 3-inch 20 cwt anti-aircraft gun is mounted on a trailer. These mobile guns could fire at a rate of 25 rounds per minute. However, they had been developed during WWI and were obsolete by 1939, being gradually replaced by more modern weapons.

Left: A firing drill is underway with a 3.7 inch heavy anti-aircraft gun, set at maximum elevation. The gun is in a fixed location, with its cruciform stabilisers extended.

The Gloster Gladiators at Baldonnel – propellers spinning and getting ready to roll. From May to July of 1941, three Gladiators, all that were serviceable at the time, were based at a temporary airstrip near Navan in Co. Meath. Their mission was to provide support for the army division that was on alert for a possible British invasion across the border from the North.

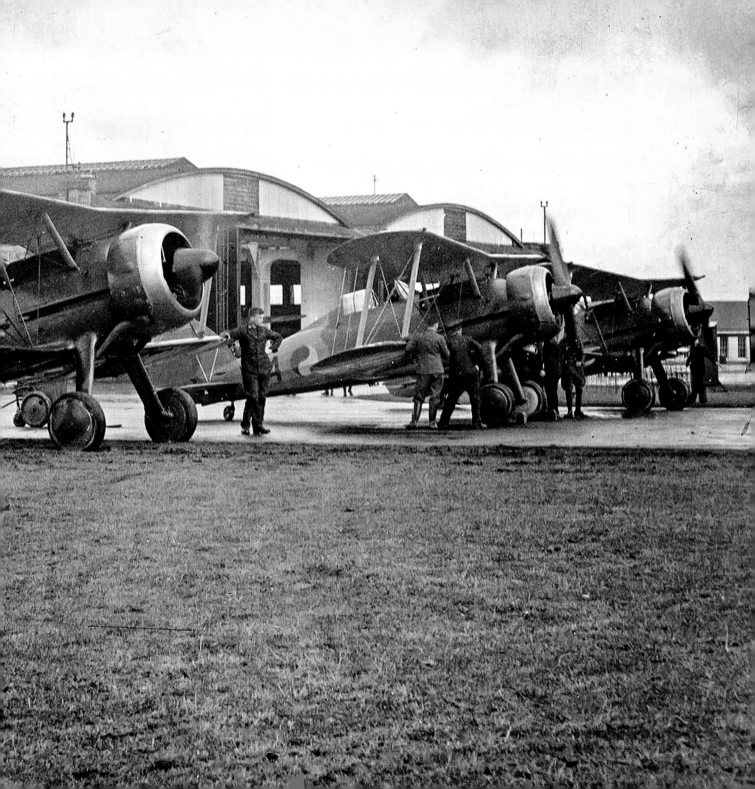

Festooned with bandoleers of bullets, Air Corps air-gunners stride out, with a Gloster Gladiator in the background. The Gladiators had been acquired in 1938, but by the start of the war they were obsolete. The aircraft had its moment of glory in British service in the Mediterranean, operating against the Italian Air Force during the defence of Malta. However, for the Air Corps, their experience with the Gladiator showed that it was not capable of intercepting any of the modern planes of the belligerents that ventured into Irish airspace.

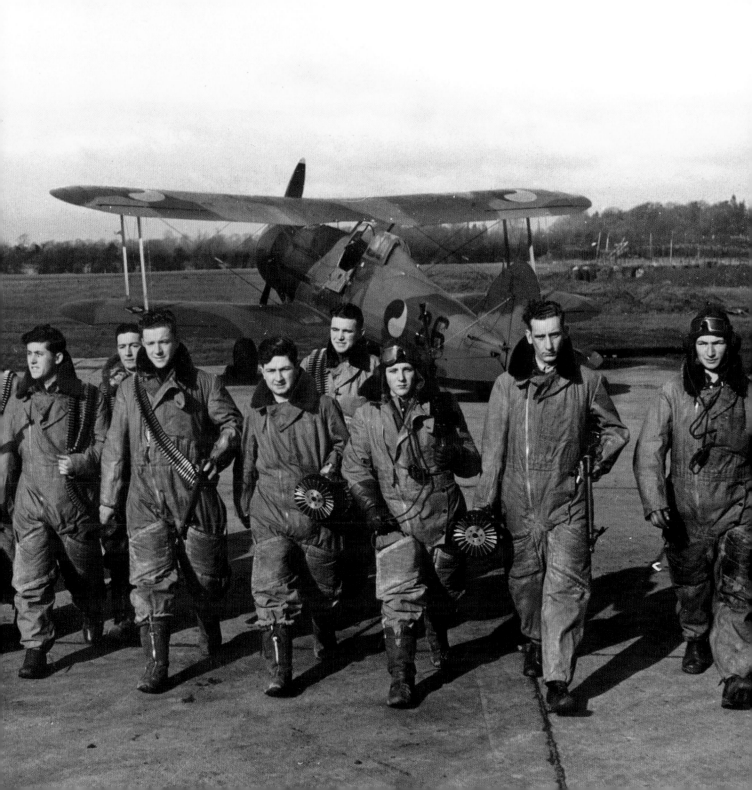

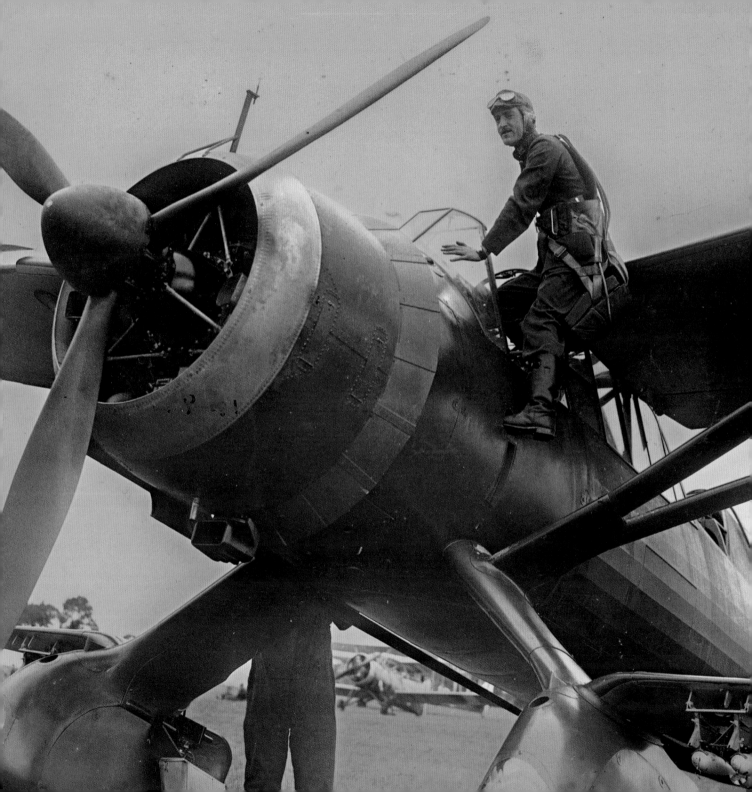

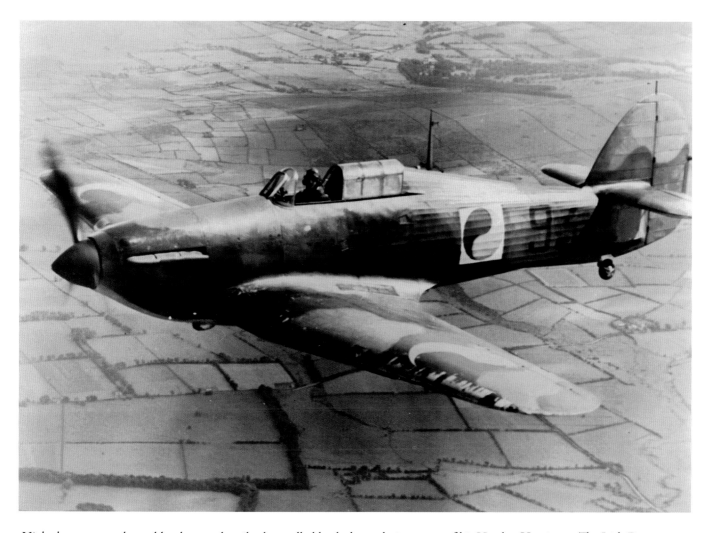

High above a snow-bound landscape, the pilot has pulled back the cockpit canopy of his Hawker Hurricane. The Irish Department of Defence tried to order 13 of these aircraft at the outbreak of WWII, but could not obtain any. During the Emergency, three Hurricanes force landed in Ireland over the course of three years. After being recovered, these were subsequently purchased from the British for Air Corps service.

Left: Captain D.K. Johnston climbs into the cockpit of his Westland Lysander at Gormanston airfield, with small practice bombs slung under stub wings. Six of these cooperation and reconnaissance planes had been delivered to the Air Corps in July 1939.

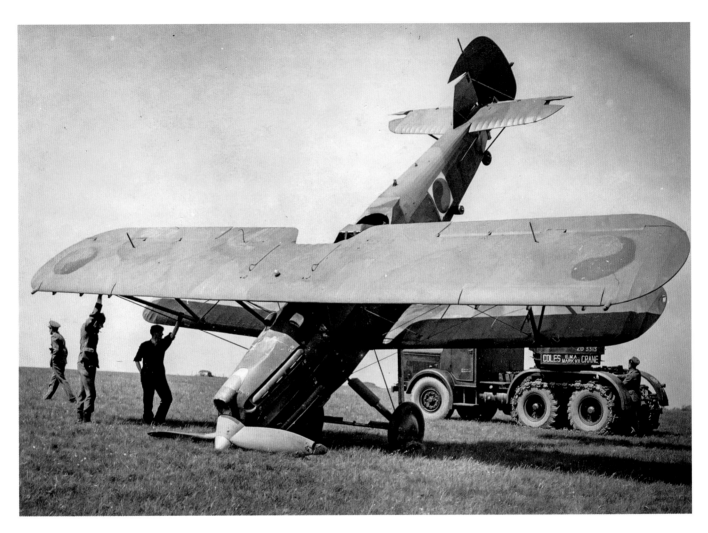

Recovery is underway for this Hawker Hector which has gone nose over on soft ground. This aircraft type had been developed in the mid-1930s for army cooperation duties. In May 1941, 10 of these, then surplus to RAF requirements, were delivered to the Air Corps. Mainly used for training, they were withdrawn from service after the delivery of Miles Master trainers in 1943.

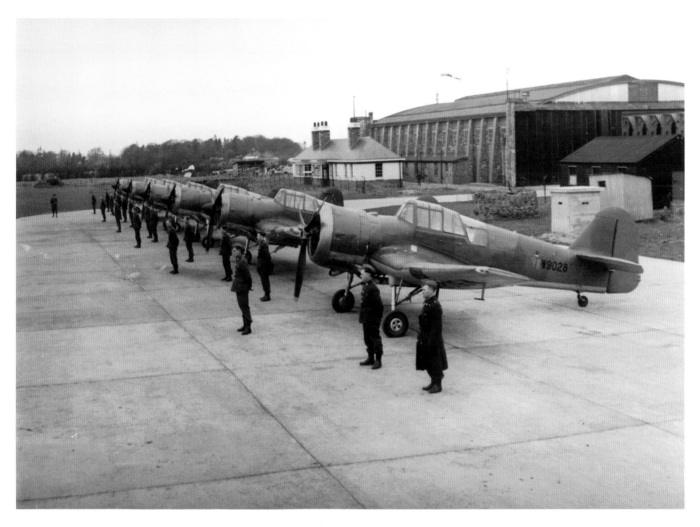

Miles Master IIs at Baldonnel. These were two-seat monoplane advanced trainers, intended to train pilots to fly Hawker Hurricanes. This batch of six was delivered in early 1943.

Frank Aiken was seen off by the taoiseach at Dublin Airport in April 1941, en route to the United States on a mission to obtain arms. When Aiken met the president, it was an encounter between an east-coast Anglophile Brahmin and a strong-willed man from South Armagh. After Roosevelt ventured that Éire should fear 'German aggression', Aiken added 'or British aggression'. 'Preposterous,' shouted the president, and he pulled the tablecloth, sending the crockery flying.

At the outbreak of hostilities in Europe, the government applied censorship over all media, the strictest application in any neutral country. The events of the war had to be reported in impartial terms, without any analysis or moral judgement. Bertie Smyllie, seen here, was editor of the *Irish Times* which sympathised with the Allied side and frequently clashed with the censor. On VE day in May 1945, Smyllie arranged that the front page carry photos of Allied leaders, made up in a 'V' (for victory).

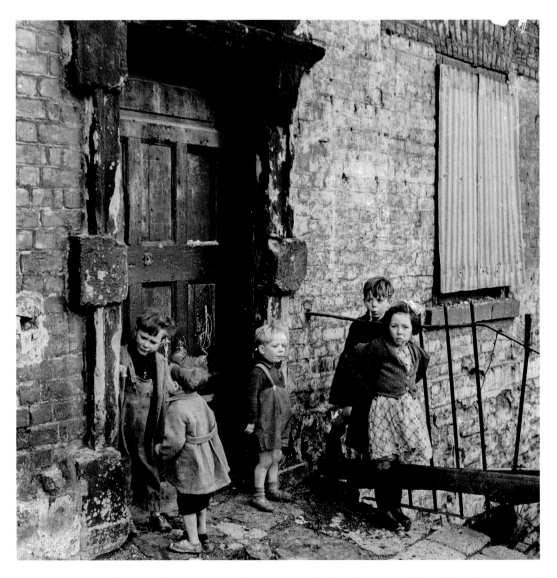

Children in front of a dilapidated tenement house on Cumberland Street, Dublin. The achievement of Irish independence had been of little benefit to the poor. Poverty continued to be endemic across the country, from those in urban slums, to the rural labouring classes. With the advent of the Emergency, and the sharp rise in the cost of living, the poor were plunged even deeper into hardship.

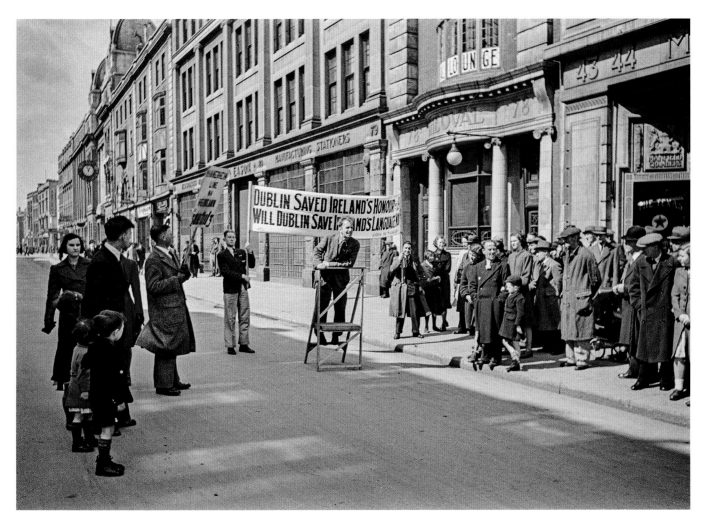

'Will Dublin Save Ireland's Language?' Here we see in May 1941 a demonstration at Middle Abbey Street, Dublin, by a group promoting Irish language revival. A splinter branch of the Gaelic League, *Craobh na h-Aiséirí*, was founded in September 1940 by those who wanted to bring a new energy to gaelicisation. In the summer of 1942, the leading activist, Gearóid Ó Cuinneagáin, split away from the branch to found the pro-Axis and fascist *Ailtirí na h-Aiséirí* ('Architects of the Resurrection'), whose goals included a Christian Gaelic Ireland. As well as the abolition of the English language, the North would be reconquered by an expanded Irish Army. The party never won a seat in successive general elections and by 1950 had faded away.

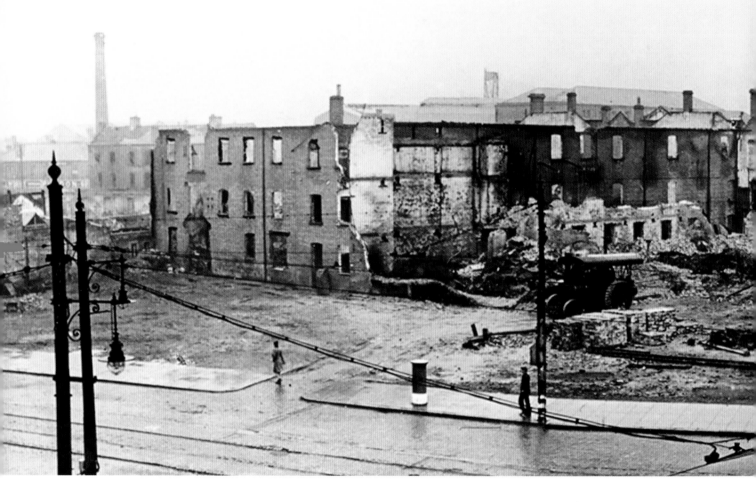

A panoramic view of the devastation in Belfast after the air-raids. The city had not been in a good place at the time of the outbreak of war in September 1939. Unemployment weighed heavily after the depression of the 1930s. Sectarian divisions continued to be deeply entrenched and one estimate was that at that time, over a third of the city was living in poverty. When war was declared, Belfast was reckoned to be beyond the reach of Luftwaffe bombers and complacency reigned. The situation was transformed after the Germans invaded France in May 1940 and established airbases near the Netherlands and French coasts. However, at the beginning of 1941, in and around the city there were few public air-raid shelters, a mere 21 anti-aircraft guns and no protective fighter squadrons. All was to change after the German attack (the first of four) on the night of 7 April 1941, when bombs were dropped on east Belfast.

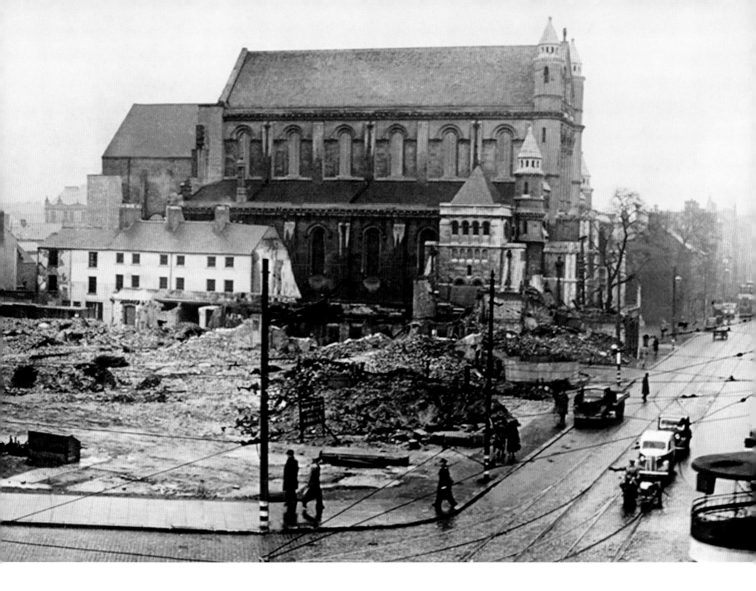

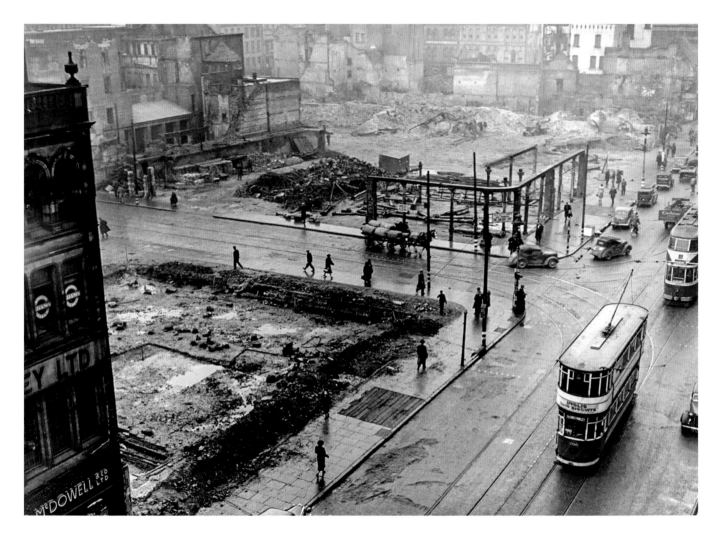

Heavily bombed – High Street and Bridge Street, while trams manage to operate despite the damage. The Germans had planned the raids on Belfast months before. In November 1940 a Luftwaffe reconnaissance aircraft had taken photographs of the target-rich city, including barracks, the Harland and Wolff shipyards, Short and Harland aircraft factory, the power station and the docks.

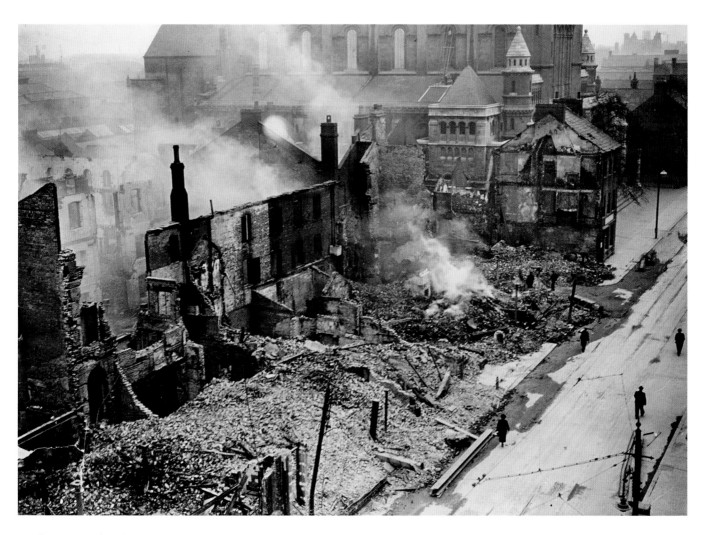

The corner of York and Lower Donegall Streets. Lord Haw-Haw had announced that it was to be 'Easter Eggs for Belfast'. At around 11 p.m. on Easter Tuesday, 15 April, the Germans delivered on their promise. In the most destructive raid of all, 200 Luftwaffe bombers dropped a mixture of incendiaries, high explosives and landmines on the city, continuing until about 5 a.m. An estimated 900 people were killed and 1,500 injured. This constituted the greatest loss of life from any night raid across the United Kingdom, outside of London, during the Blitz. Other raids followed on 4 May (when 150 more people were killed) and 5 May.

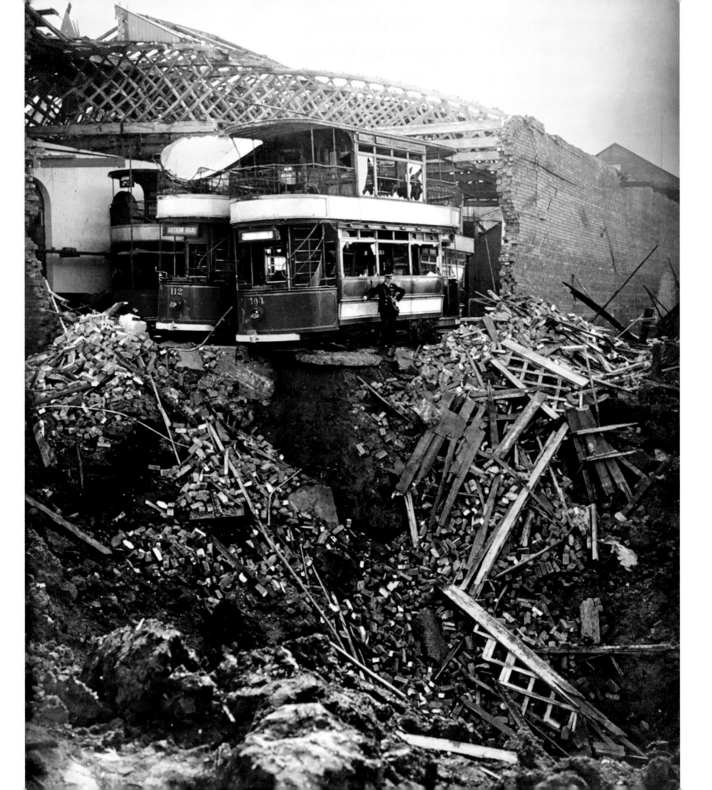

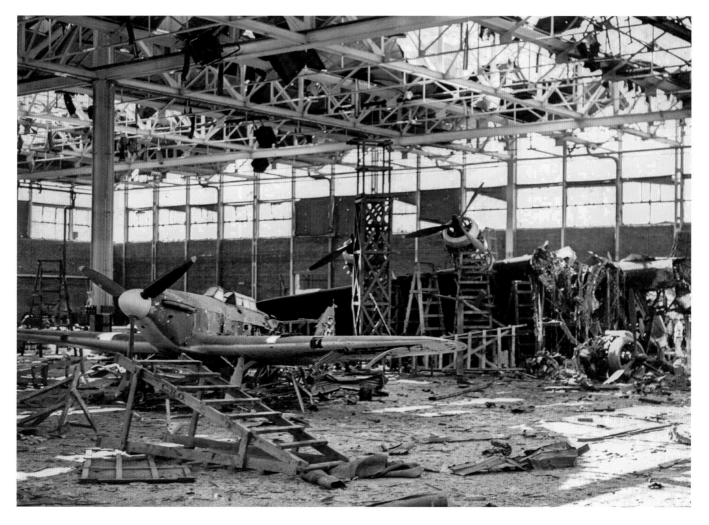

During the 7 April night raid, parachute mines floated down and the Short and Harland Aircraft Works was wrecked. Here, a Hurricane rests amidst the rubble, with a badly damaged Short Stirling bomber in the background.

Left: The scene on 16 April 1941, at the Tramway Depot on Antrim Road. At 4:35 a.m., John MacDermott, the Northern Ireland Minister of Public Security, asked Taoiseach Éamon de Valera for help using the railway telephone system, the only working link to Dublin. By 6 a.m., 13 fire tenders from Dublin and other centres were on the way to Belfast. They worked there for three days, before being sent back by the Northern Ireland government.

A jolly staged photograph at York Road on 16 April 1941, with the caption inferring that 'Land of Hope and Glory' was being played. The reality was somewhat different. There were desperate scenes at hospitals which were being overwhelmed by the casualties. In this, the most densely populated city of the UK, many thousands were homeless. One account says that half the population fled the city.

There were recriminations. Northern Ireland government ministers believed that the Germans could use the unblacked out lights of Dublin as guidance to the north. For Luftwaffe pilots, these lights and the east coast of Ireland with the large and unique indentation of Belfast Lough did provide convenient guideways.

Dublin was to suffer at the end of May, when it was on the return path for German bombers that went to raid the North.

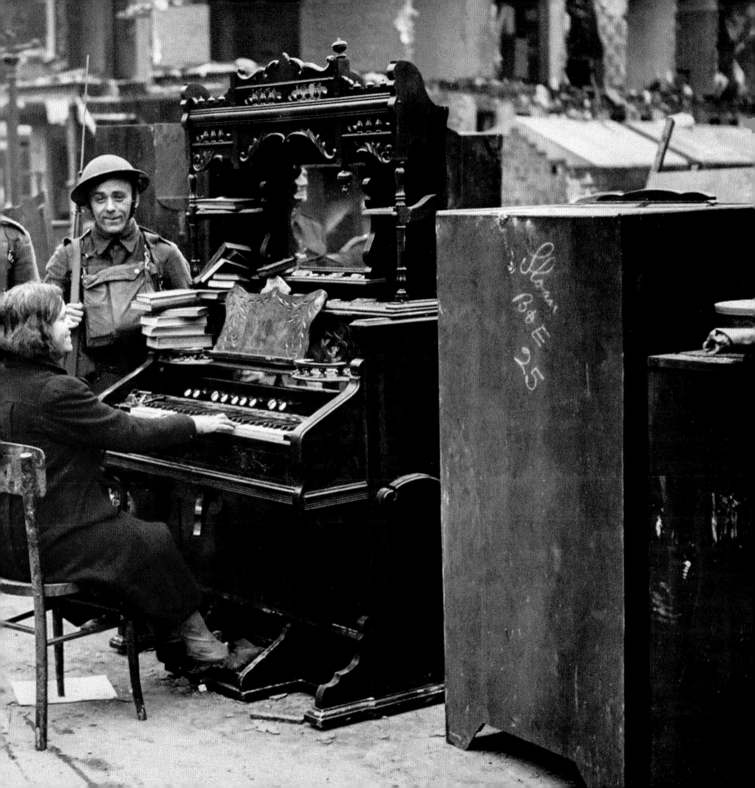

At the end of May 1941, it was Dublin's turn to be bombed, albeit on an infinitesimally smaller scale compared to Belfast. In the early morning hours of 31 May, two Luftwaffe bombers, part of a large group returning southwards from a sortie to Northern Ireland, dropped a total of four bombs. As planes milled around the Dublin skies, at 1:28 a.m. the first bomb, thought to weigh 250 pounds, fell at the junction of North Circular Road and North Richmond Street (near the O'Connell Schools). It demolished a nearby shop, whose occupants were injured. Immediately after, a second one fell, just around the corner at Summerhill. There were no fatalities. Minutes later, a third bomb dropped in soft ground near the Dog Pond by the Zoological Gardens in Phoenix Park, blowing out some windows in the adjacent Áras an Uachtaráin and, further away, the American Legation.

At around 2 a.m., one plane in particular was observed behaving erratically near Amiens Street Railway Station – searchlights were lit and anti-aircraft guns opened up. Shortly afterwards, the fourth bomb was dropped at North Strand Road, close to Newcomen Bridge. This bomb caused widespread damage and fatalities amongst the close-knit working class community there. The death toll was 28. 90 people were injured.

The Irish Chargé d'Affaires in Berlin was directed to protest in the strongest terms to the German government against the violation of Irish territory. The initial response of the German Minister to Ireland, Eduard Hempel, was to claim that it had been done by the British using captured German planes.

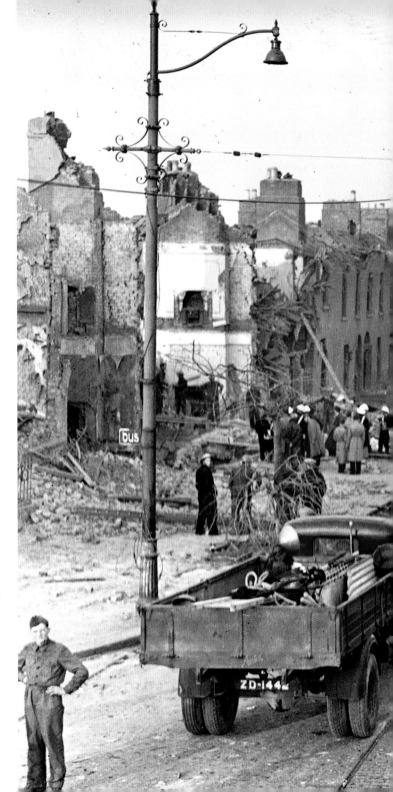

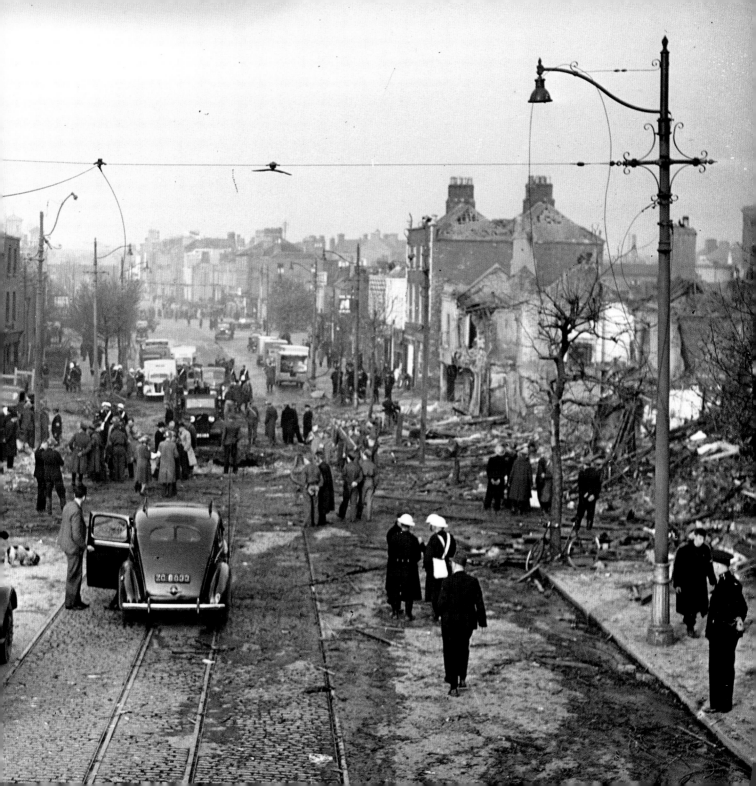

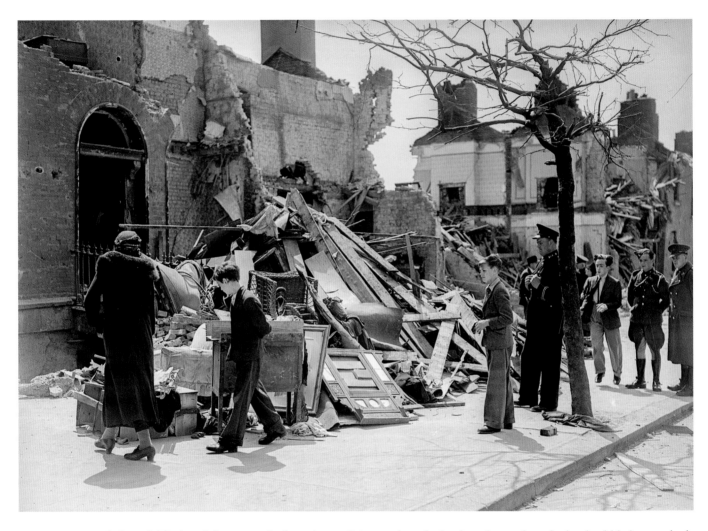

Damage at North Strand. The bomb here was a high-explosive 500 pounder, which when dropped on the hard cobbled street, had exploded on impact. A later military report said, 'the resulting cone of the blast [was] very flat and therefore had maximum effect'. A total of 2,250 buildings suffered some form of damage after the bombings. On 5 June, the taoiseach and government ministers attended the funerals of 12 of the victims.

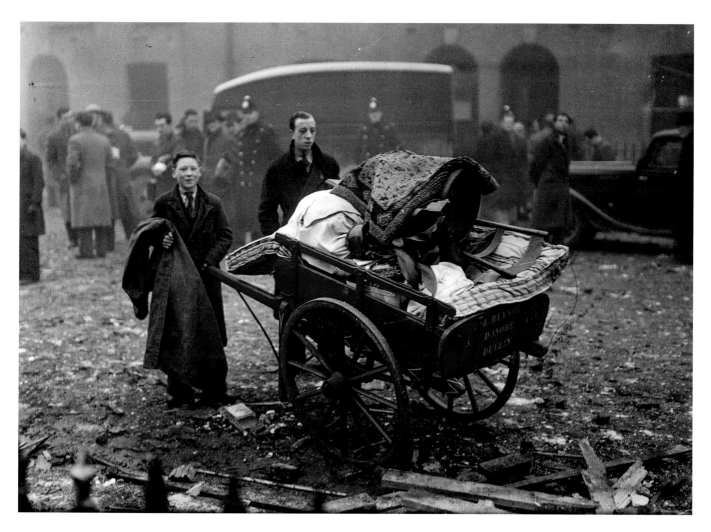

A hand cart is being piled with salvaged belongings. A conspiracy theory emerged saying that the bombing had been a warning to neutral Ireland after the government refused the previous December to allow a civilian plane land at Rineanna (Shannon) Airport that was carrying additional staff assigned to the German Legation. In reality, the most likely explanation was that the bombing was due to the reckless jettisoning of explosives by German bombers after an unsuccessful sortie against the North. After the war, the West German government accepted responsibility and by 1958 had paid out compensation of around one third of a million pounds.

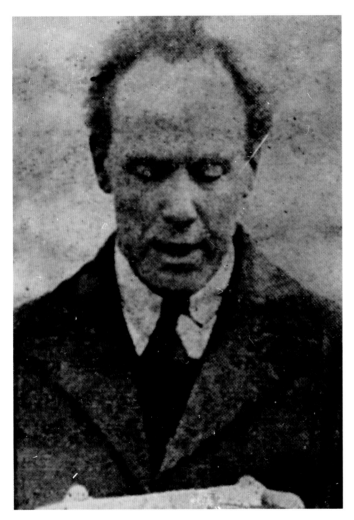

After the Magazine Fort raid in December 1939, the government cracked down on the IRA and passed draconian legislation. Seeing the organisation as one of the principal threats to public order and to Irish neutrality, harsh measures were taken over the course of the Emergency: six IRA men were executed and over 500 were interned without trial. In April 1940, Sean Russell, IRA Chief of Staff (above left) travelled to Germany to discuss support for IRA action against Britain, meeting Foreign Minister Joachim Ribbentrop in Berlin. In August 1940, he set out in a U-boat to return to Ireland, accompanied by Frank Ryan (above right), recently released, with the help of the Abwehr, from a Spanish jail. Russell died on board the submarine of a perforated ulcer and was buried at sea. Ryan returned to Germany, where, with his health in decline, he died at Dresden in June 1944.

The novelist, Francis Stuart, of Ulster Protestant stock, had taken the anti-Treaty side during the Irish Civil War. In early 1939, he was invited on a literary tour of Germany and was then offered a lectureship at Berlin University, a position he took up in December 1939. By 1942 he was working for German radio, writing scripts and giving talks in broadcasts aimed at Ireland. After the war, Stuart returned to Ireland. He died in February 2000.

German policy towards Éire was that it hoped that the country would maintain its neutrality and deny Britain the use of its ports. They were also interested in supporting the IRA in promoting an insurgency in Northern Ireland – thus diverting resources from other war fronts. During their planning for the invasion of Britain in 1940, the Germans had prepared Operation Green, whereby they would invade the south-east coast of Ireland as a diversionary attack, probably to draw off British troops in Northern Ireland who otherwise would have been sent to repel the invasion of Great Britain.

The Abwehr (German military intelligence) made secret contacts with the IRA before and during WWII. The IRA, on the basis that 'the enemy of my enemy is my friend', proved willing to collaborate with the Nazi regime. The Abwehr, who had a distorted view of Ireland, at one stage urged that the IRA ally with the de Valera government in mounting an invasion of Northern Ireland. The Germans sent a dozen spies to Éire during the war, usually by parachute or by U-boat. Most were soon captured and imprisoned. One, an Irishman called Joseph Lenihan, landed in Co. Meath by parachute in July 1941, and headed to Northern Ireland, where he gave himself up to the RUC.

Hermann Goertz (right), an experienced intelligence officer, proved to be the most successful German spy, managing to evade capture for 18 months. In May 1940, he landed at Ballivor, Co. Meath by parachute. He made it to the house of Iseult Stuart (Francis Stuart's estranged wife) in Co. Wicklow and then stayed with others in Dublin. He proceeded to gather information on Irish military arrangements including coastal defences. He soon discovered that the IRA were unreliable, in a state of disarray, and not capable of mounting any large scale action. While at large, Goertz managed to make some high-level political and military contacts. In November 1941 he was arrested and imprisoned for the rest of the war.

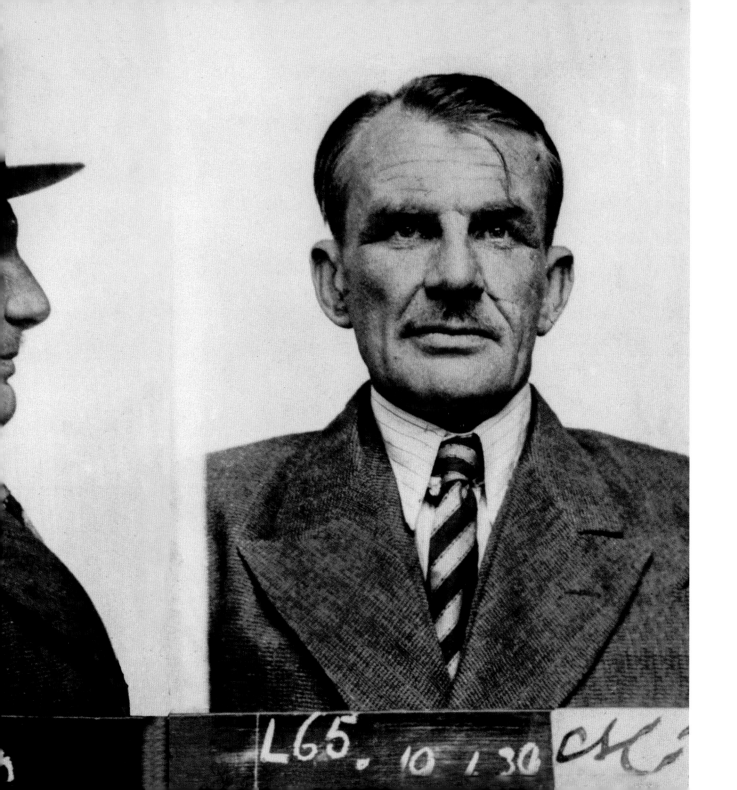

LG5. 10.1.30

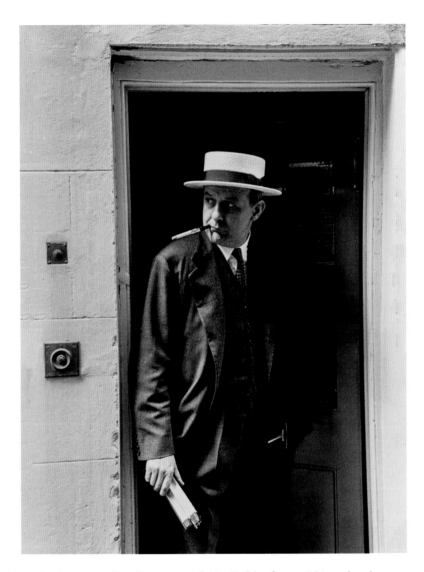

The avuncular John Betjeman, British press attaché in Dublin from 1941 – who also engaged in minor clandestine work. In mid-1940, worried about a supposed Fifth Column, British intelligence agencies flooded Éire with spies. This exercise was superseded when the Irish military cooperated fully with them, freely handing over details of Irish defences. In advance of D-Day, to stop leakage of information, the British sealed off Éire by controlling communications and restricting travel.

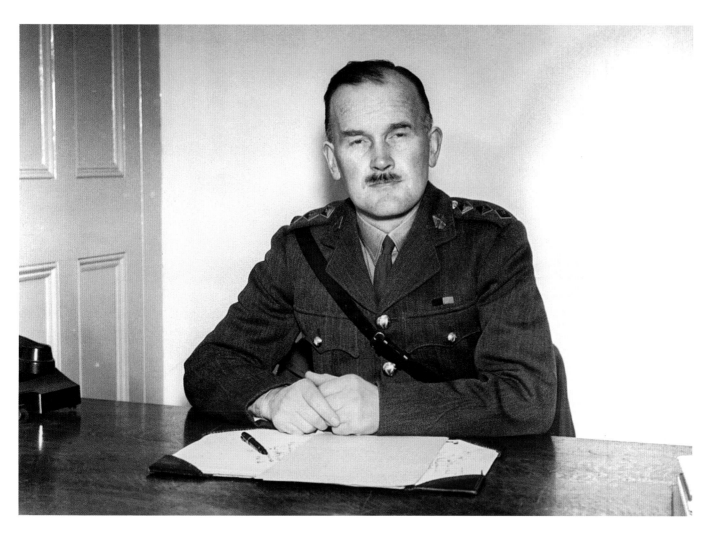

From July 1941, Colonel Dan Bryan, became head of G2, military intelligence, which held the primary responsibility for Irish security intelligence. From May 1940 onwards, close contact had been established with the British MI5, with G2 furnishing information on suspected German spies. It was open house in Éire where the Irish military authorities furnished the British with anything they requested, from operational intelligence, to the disposition of the Irish Army. Nevertheless, the British maintained a covert intelligence system in the country. Most of these networks were thoroughly penetrated by G2, but the Irish government chose to tolerate these and took no action against them.

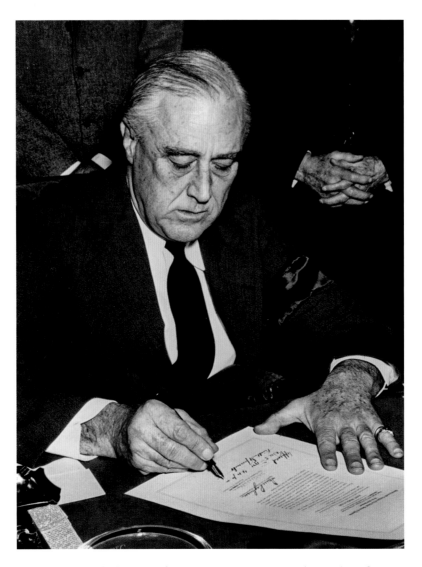

President Roosevelt signs the declaration of war on Japan on 8 December 1941. After September 1939, despite strong isolationist sentiment, Roosevelt had sought ways for the neutral US to assist the British cause and in 1940, 50 WWI destroyers were sent to Britain. As we have seen, the Anglophile president was not inclined to give any support to neutral Éire. In Asia, squeezed by a US oil embargo, the Japanese launched a surprise attack on Pearl Harbour on 7 December 1941.

3. EMERGENCY
1942-43

Just after the Pearl Harbour attack, Churchill sent a quixotic telegram to de Valera, once more urging Éire to enter the war: 'Now is your chance. Now or never – a Nation once again!' The taoiseach calmly decided to continue with Irish neutrality.

On 11 December 1941 Hitler made the colossal mistake of declaring war on the United States – which in turn declared war on the Germans. The great American economy, slumbering since the depression, was now set in motion and began to output ever increasing amounts of war matériel. The US immediately began to transport huge quantities of equipment to beleaguered Britain – and also shipped arms to its new ally, the Soviet Union, battling Hitler's armies since the previous June.

Churchill proposed to the president that the US immediately commit to winning the war in Europe by sending troops to support the British war effort. Divisions of American troops were rapidly sent to the United Kingdom, where Northern Ireland was to become an important staging post.

De Valera was not enamoured by the concept of American troops landing in Northern Ireland. In a statement which began with an outline of the history of partition, he said: 'The people of Ireland have no feelings of hostility ... towards the United States ... but it is our duty to make it clearly understood that no matter what troops occupy the Six Counties, the Irish people's claim for the union of the whole of the national territory ... will remain unabated.'

The first US forces to arrive in Europe were 4,500 soldiers of the 34th Infantry Regiment who docked at Belfast on 26 January 1942 (right).

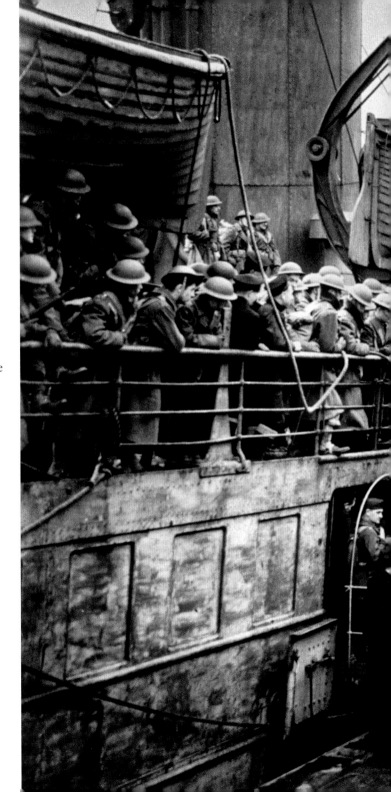

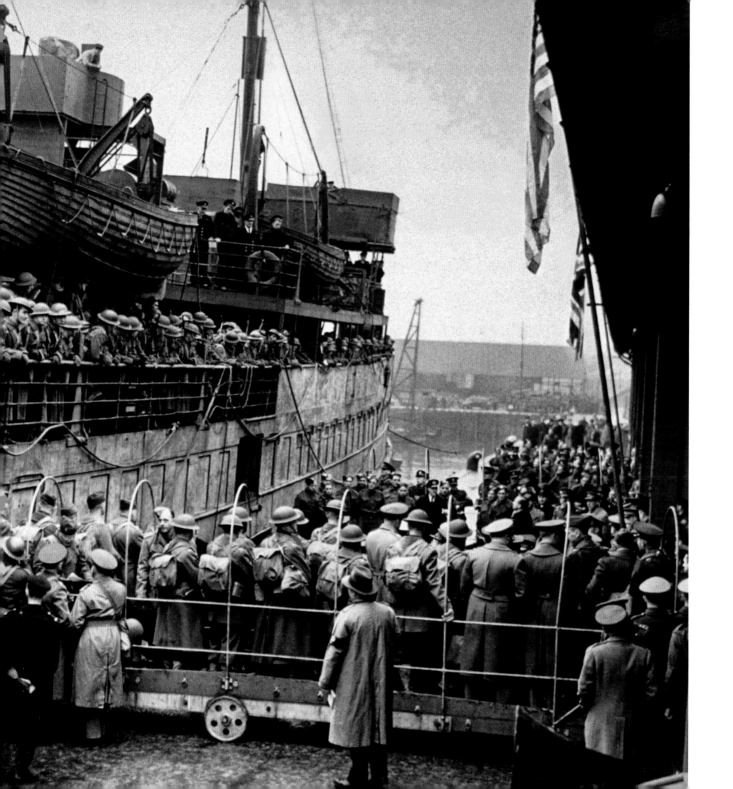

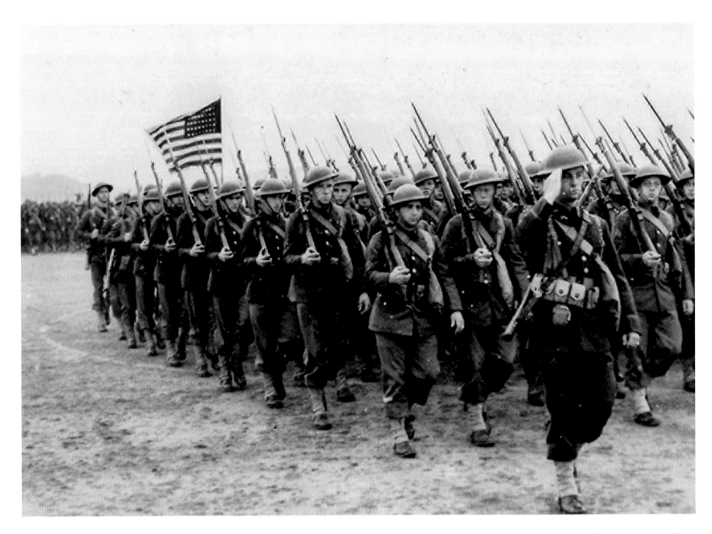

American troops, stationed in Northern Ireland, march past in a review. They are wearing the Brodie helmet. This was essentially a WWI design intended to protect the head from overhead shrapnel, and did not offer side protection. In 1942, the US Army introduced the M1 helmet, a slightly flanged model without a brim and which offered protection down the sides of a soldier's head. (Ironically, just the previous year, the Irish Army had adopted the Brodie helmet, see page 48.)

Right: Puzzling with pounds on his first payday in Northern Ireland. The troops received British currency and had to figure out the exchange rate, which was then around four dollars to a pound sterling.

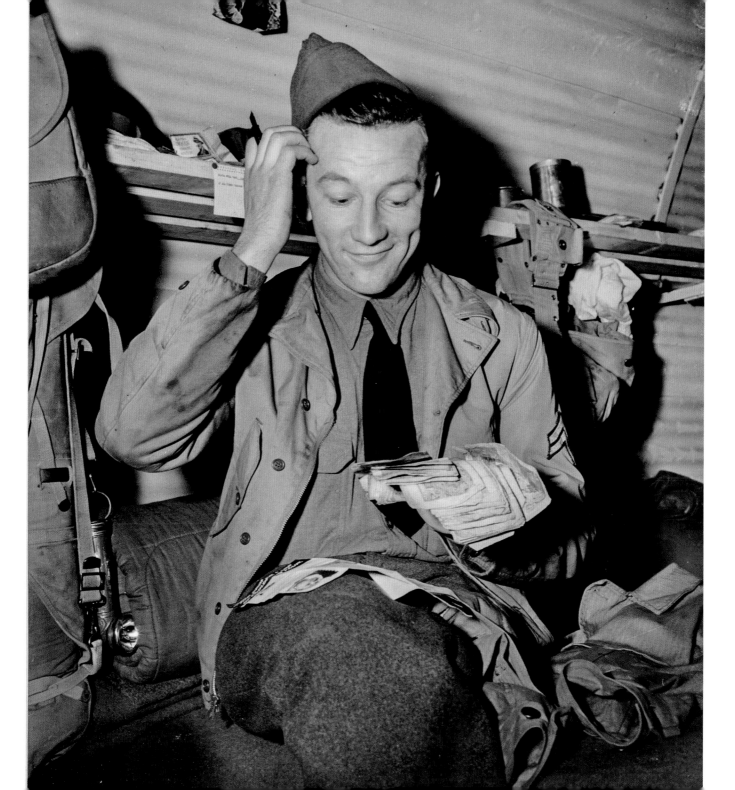

A sergeant of the Royal Artillery gives US soldiers training in the use of a light anti-aircraft gun. US troops, artillery and tanks were put through their paces in the fields, forests, mountains and beaches of the Six Counties, all in preparation for the combat to come.

Northern Ireland had become, in effect, a colossal US military camp. Over the course of WWII, more than 300,000 US military personnel passed through. The number peaked in early 1944 and diminished rapidly as most of the troops departed to take part in the D-Day landings and subsequent combat.

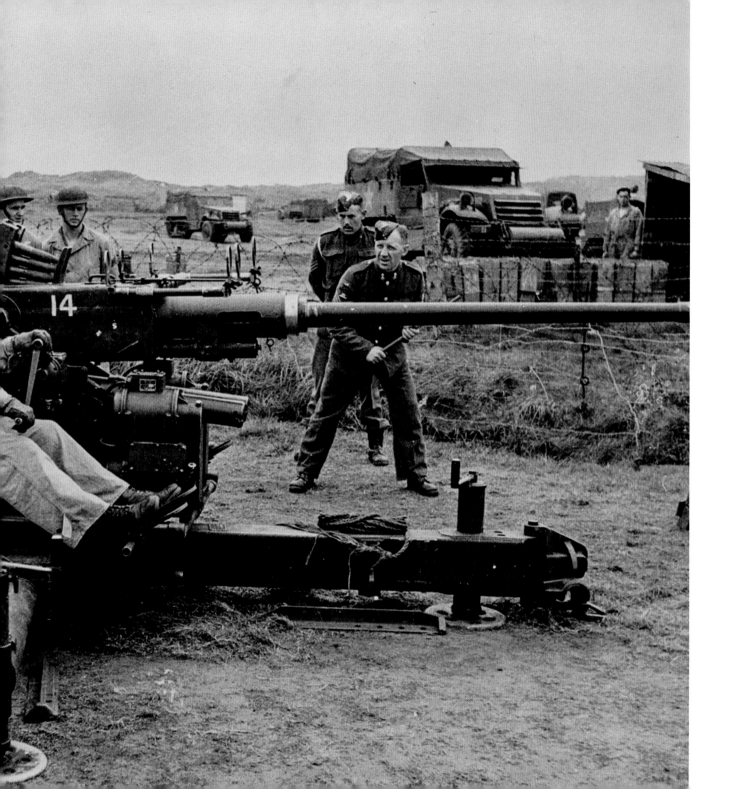

A training exercise in Northern Ireland. US infantrymen charge through the dust after the M3 Lee medium tanks which are surging ahead. This tank model had been introduced at the end of 1941 and the main armament was a 75mm gun which was unusually mounted, offset at the right side of the tank. Of the more than 6,000 M3s produced, several thousand were supplied to the British and Soviet armies. The M3 saw action in North Africa, and was eventually replaced by a better tank, the M4 Sherman.

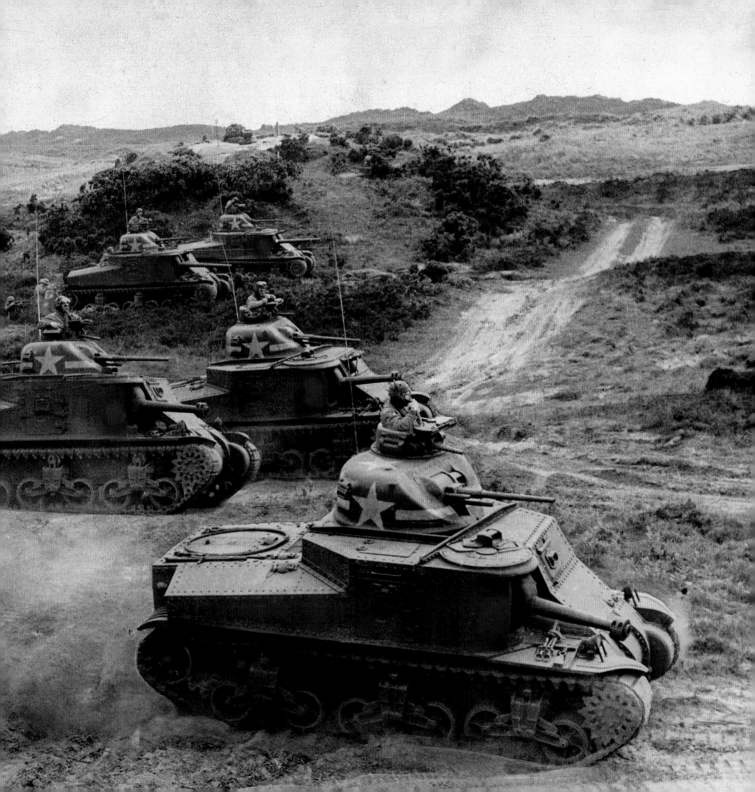

African-American troops draw rations at their base in Northern Ireland in August 1942. The first of these troops had arrived in the Six Counties the previous June. The US military enforced a de facto segregation, particularly for social events, intending to keep these soldiers and white GIs apart.

The African-American troops were popular with the local population and were pleased to be generally welcomed, irrespective of their skin colour, as American fighting men.

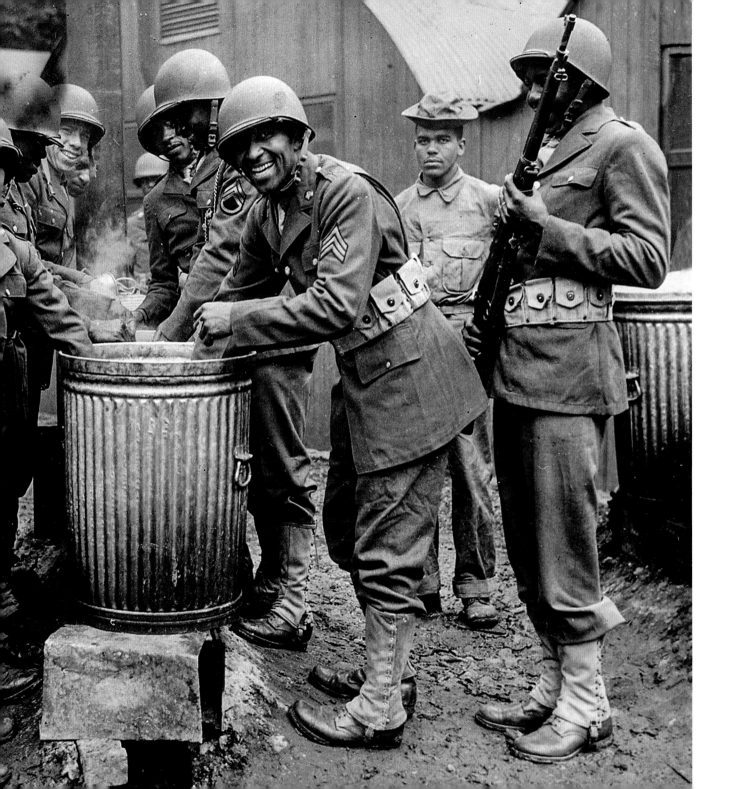

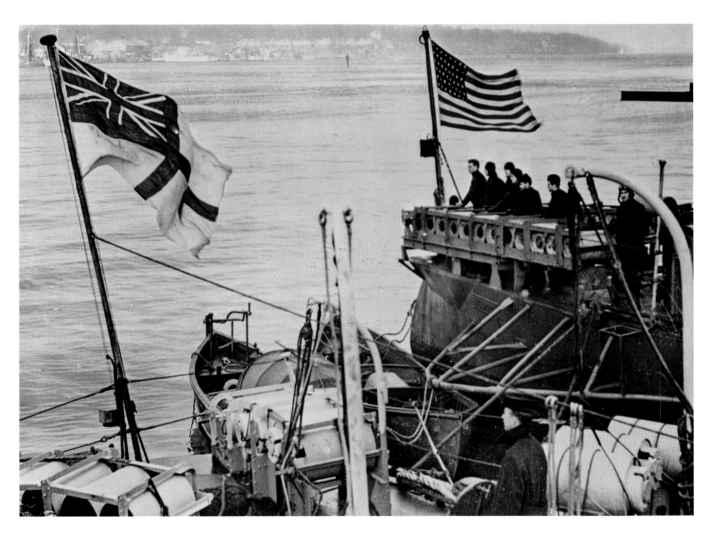

The White Ensign and the Stars and Stripes fly together at the newly inaugurated naval base at Derry. The first American warships arrived here at the beginning of 1942. Designated the US Naval Operating Base Londonderry, it was to be the US Navy's principal centre of operations in Europe until after the Normandy landings in June 1944. Work on the base had commenced in mid-1941 under Lend Lease arrangements. Around 800 American technicians together with over 2,000 local workers built the complex, which included docking and repair facilities, high-powered radio systems, a 200-bed hospital, and large stores and camps, spread across seven locations in the Foyle Valley.

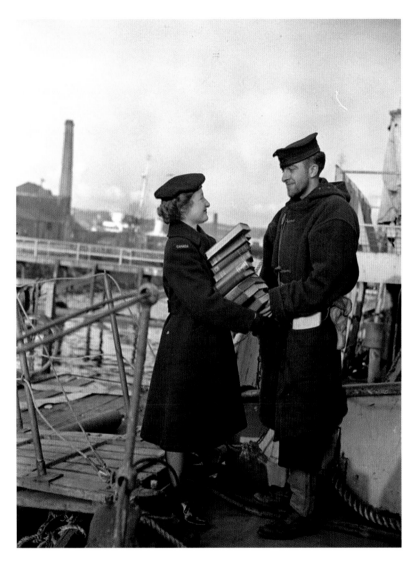

Ruth Church, part of the Women's Royal Canadian Naval Service (WRCNS), delivers a supply of library books to a Canadian sailor at Derry. Canada, like all the other British dominions except Éire, had entered the war in September 1939. Canada expanded its small navy to one amounting to over 400 ships and 95,000 men and women (including 6,000 of the WRCNS). Derry rivalled St. John's in Newfoundland as an importance port for Canadian ships and personnel.

It is July 1942 and four US sailors from the US Navy base at Derry chat with two girl hikers at a location near Dunluce Castle, Co. Derry. In the background is a poster for the Giant's Causeway Electric Tramway.

US personnel had been issued a pamphlet by the War Department called *Pocket Guide to Northern Ireland* to help them familiarise themselves with the place, dress, customs and culture. Although 'Irish girls are friendly', the pamphlet noted that traditional norms were common in rural areas where 'the old ideas still exist'. Sensibly, it warned to avoid 'arguing religion or politics'.

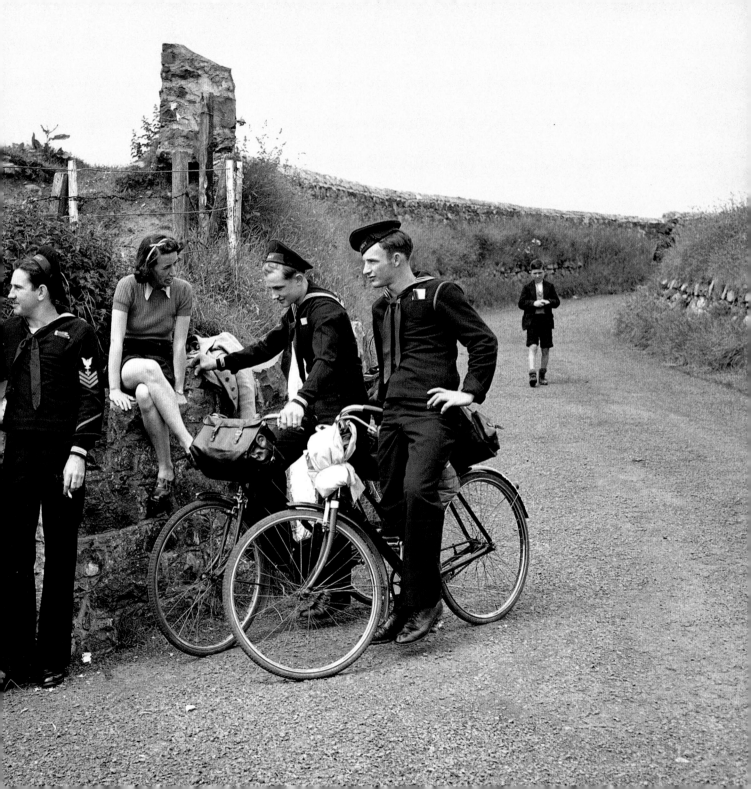

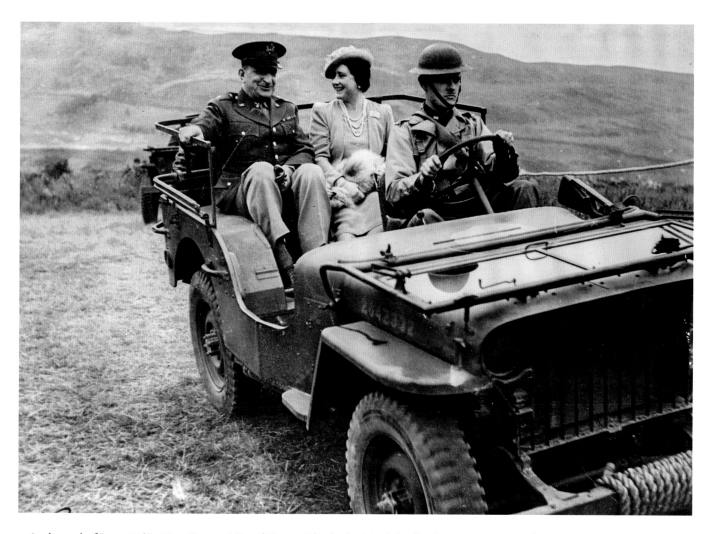

At the end of June 1942, King George VI and Queen Elizabeth visited the Six Counties to review the American troops stationed there. Here, Major-General Russell P. Hartle (commander of the first division of US troops to be shipped to Northern Ireland) converses with Queen Elizabeth as they travel in a jeep.

Left: The royal couple arrive at Belfast.

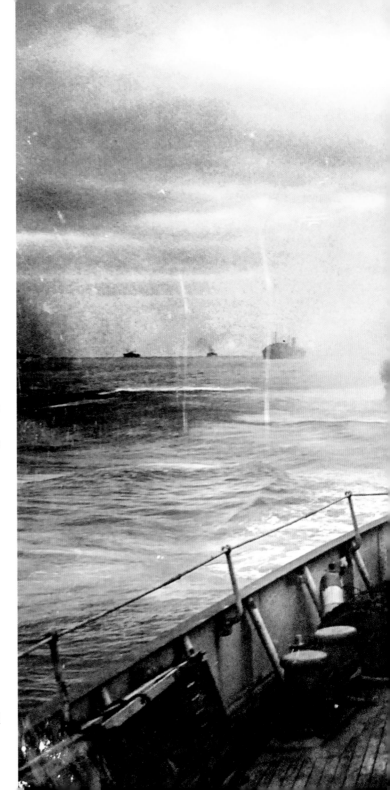

The view from the US Coast Guard cutter *Spencer*, as *U-175* is depth charged. In April 1943, the submarine, part of a pack, had been attacking a convoy to the southwest of Ireland. Escorting Coast Guard cutters launched salvoes of depth charges and *U-175* was forced to come to the surface. Hit by shellfire, it soon sank. By this stage of the war, the Allies were on the cusp of breaking the U-boat stranglehold on the Atlantic sea lanes.

After the war had started, the British requested to get back the Irish Treaty ports. One Admiralty report noted that if the warship escorts could be oiled and turned round at Berehaven rather than Plymouth, 'a great deal of unnecessary steaming … could be avoided'. Churchill, British Imperialist par excellence, believed that Éire was legally still British territory and was in favour of occupying the Treaty ports, but was restrained by his more rational cabinet colleagues. De Valera, wanting to maintain neutrality, continued to refuse to hand over the ports.

In the event, after the US entered the war, the need for the Treaty ports diminished. With better equipment and tactics, as well as facilities in Northern Ireland and Iceland, the Allies were better able to protect the convoys, many of which reached Britain by taking the northern route around Ireland.

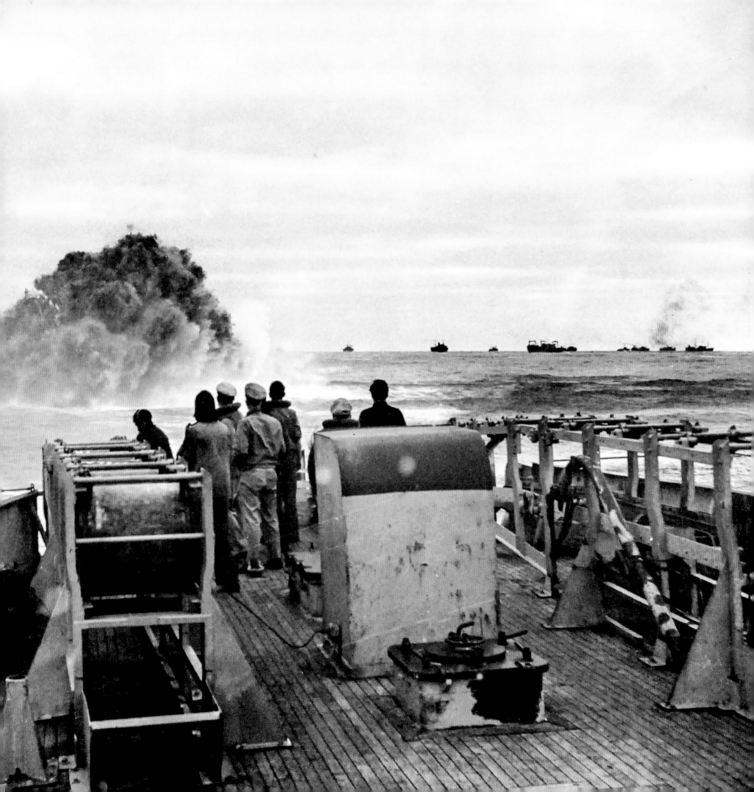

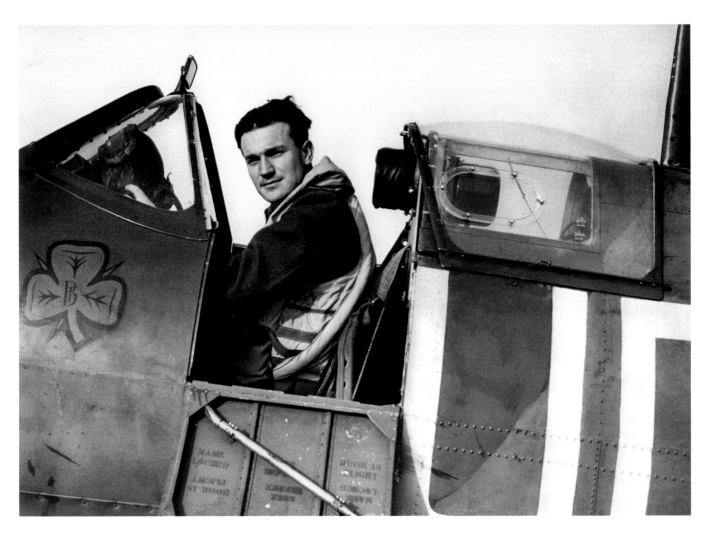

Wing Commander Brendan 'Paddy' Finucane had been a flying ace in the RAF. Having notched up 28 aerial victories, he was killed in July 1942 after he was forced to ditch in the English Channel. Finucane was born in Rathmines, Dublin and, even though he was the son of a veteran of the Easter Rising, had joined the RAF in 1938. Around 70,000 men from neutral Éire fought in the British forces during WWII. Motives included the need for adventure and good pay. Few gave their reason to fight as to defeat the Nazis or the struggle for democracy. Most approved of Ireland's policy of neutrality.

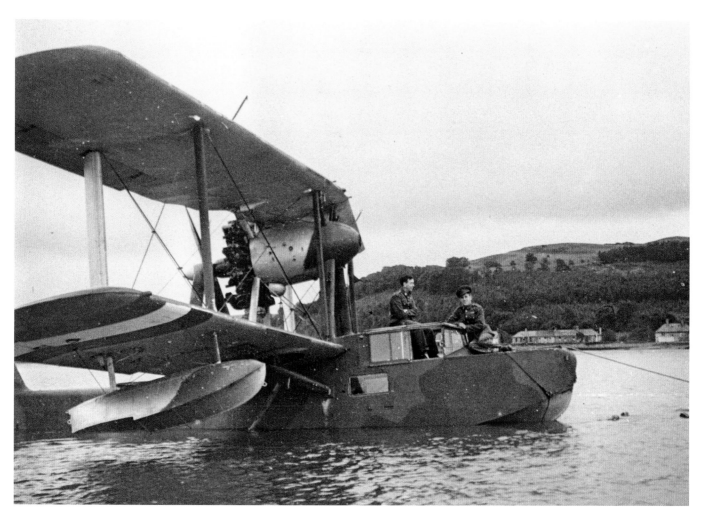

In March 1939, two Type 236 Supermarine Walrus flying boats entered service in the Air Corps, intended for coastal patrol duties. In August they were deployed to Rineanna Aerodrome to form part of a unit which carried out patrols of the south and west coasts, but the flights were soon reduced due to a shortage of aviation fuel. In January 1942, there was a bizarre incident – a pilot, Lieutenant Thornton, bored and fed up with the harsh conditions at bleak Rineanna, set off in a Walrus with three other Air Corps personnel. They were heading for the Channel Islands (then occupied by the Germans), with the intention of joining the Luftwaffe. The plane was forced to land at St Eval in Cornwall by RAF Spitfires, whose pilots were puzzled by the odd markings. Thornton was returned to Ireland under arrest. He was court-martialled at Cork and sentenced to 18 months' detention.

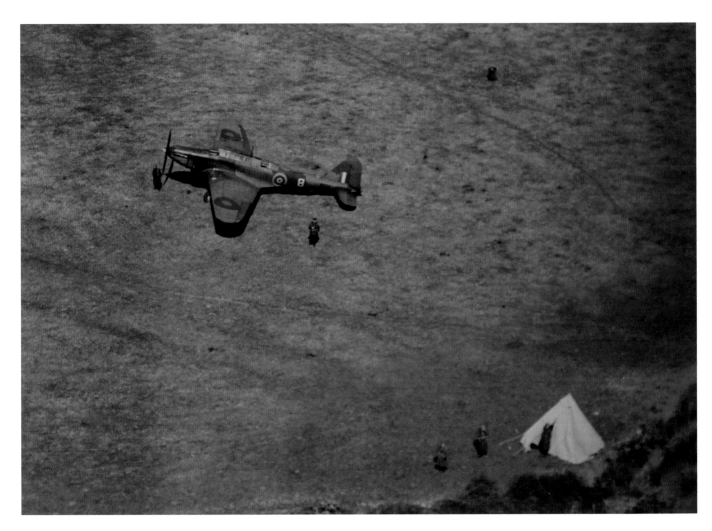

During the Emergency, there were around 180 crashes or emergency landings in Éire and along its coasts. In a few cases, aircraft landings resulted in a windfall for the Air Corps, allowing them to add the planes to their fleet. On 24 April 1941, this Fairey Battle TT1 light bomber took off from an airfield near Stranraer in Scotland on a navigational training exercise. Short of fuel, the pilot made a controlled landing at a field near Tramore, Co. Waterford, seen here afterwards. Four days later, an Air Corps pilot managed to take off and fly the plane to Baldonnel. The Department of Defence bought the plane from the British – during the war, other aircraft which had force landed were similarly purchased. After extensive overhaul by the Air Corps, the Fairey Battle entered service as a target-towing tug.

Another of the 'windfall' aircraft acquired by the Air Corps was this Lockheed Hudson L.214 reconnaissance and light bomber, seen here being loaded with bombs by an Air Corps ground crew. On 24 January 1941, operating in the RAF Coastal Command out of Aldergrove in Northern Ireland, it got lost while on a convoy escort mission off the coast of north-west Ireland. It made a forced landing in a field near Skreen, Co. Sligo. After much earthworks and removal of stone walls to create a temporary airstrip, the repaired aircraft was flown to Baldonnel. The Department of Defence purchased the bomber, along with a set of spare parts and the Lockheed Hudson was assigned to the No. 1 Reconnaissance and Medium Bombing Squadron at Rineanna. It was the first aircraft constructed in the USA to enter Air Corps service.

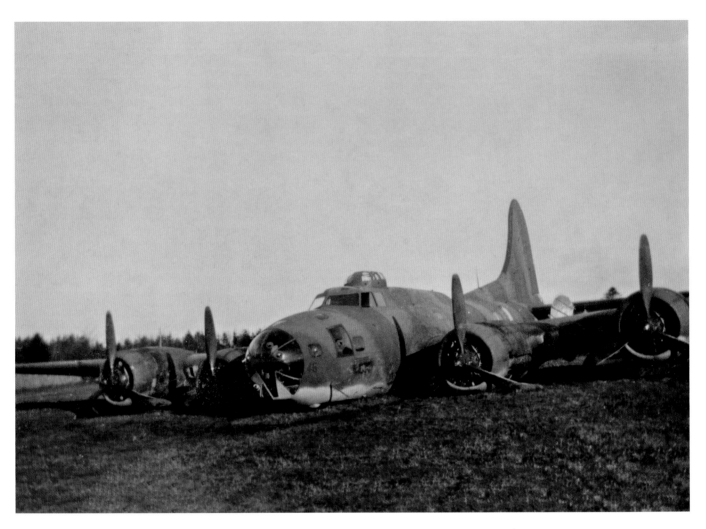

After the US entered the war, there were frequent crashes and landings by American aircraft in Éire. A particularly large intruder was this USAAF B-17E Flying Fortress which force landed at the Agricultural College at Athenry, Co. Galway on 15 January 1943. The plane had been flying from Gibraltar to the US when it went badly astray. Amongst those on board was one of the most senior American officers in Europe, Lieutenant-General Jacob Devers. In line with the practice adopted at this stage of the war, the 15 passengers and crew were allowed to transfer to Northern Ireland (in this case, after being treated to lunch at a local hotel).

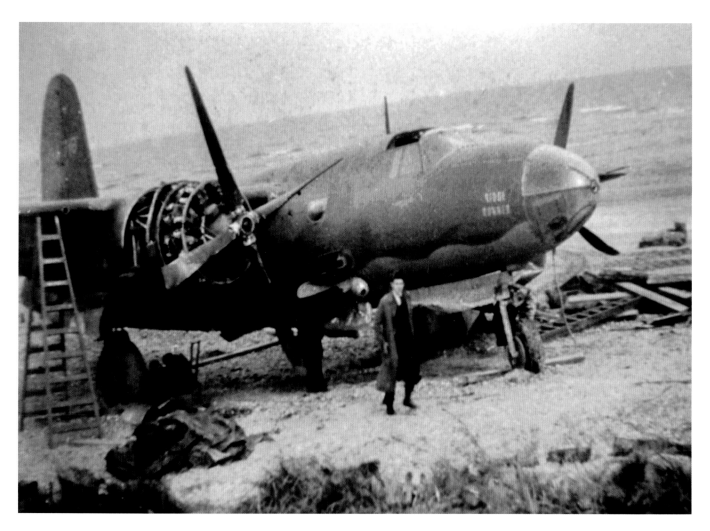

On 4 June 1943, a Martin B-26 Marauder medium bomber made an emergency belly landing on the beach at Termonfeckin, Co. Louth (seen here with its undercarriage dropped after being jacked up). The brand-new plane had been on a delivery flight from the US via Morocco, to Pembroke in Wales. With the help of the Air Corps, technicians from the Lockheed Overseas Corporation (then contracted to operate big installations in Northern Ireland) dismantled the plane. The aircrew, who had escaped injury, were allowed to quietly transfer to Northern Ireland. The policy adopted by the Irish government then was that serviceable or salvaged planes belonging to the Allies were returned to them – the remains of the Marauder were duly trucked across the border.

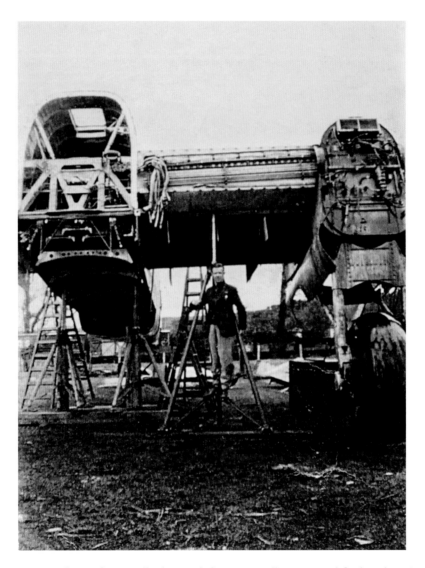

A local man poses in front of a partially dismantled RAF Handley Page Halifax bomber. On 21 April 1944, the aircraft had been on a weather reconnaissance flight over the Atlantic. After getting into difficulties it made a forced landing in a field at Skibbereen, Co. Cork. The only casualty was a grazing heifer, which was struck by the plane and later put down. The eight-man crew was transferred to Northern Ireland and the dismantled plane was later conveyed there.

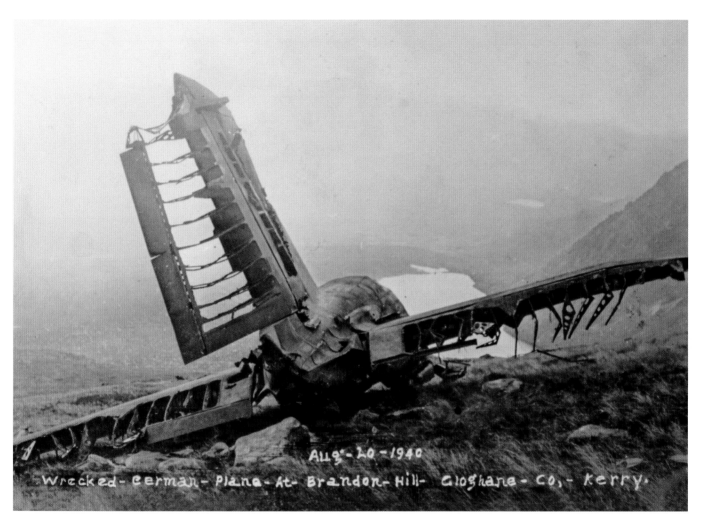

Aug^ 20 - 1940
Wrecked - German - Plane - At - Brandon - Hill - Cloghane - Co, - Kerry.

The first German crash in Ireland. The conquest of France by Germany in May 1940 allowed the Luftwaffe to deploy to air bases along the French Atlantic coast and mount offensive operations against Britain and its Atlantic convoys. On 20 August 1940, a Focke-Wulf Condor Fw 200 C-1 had taken off from an airbase near Bordeaux on a long-range anti-shipping and meteorological mission. Off course and in poor visibility, the aircraft crashed onto the slopes of the 950m-high Mount Brandon in Co. Kerry. All six crewmen survived, and to accommodate them the Irish government had to open an internment camp in the Curragh (see page 150).

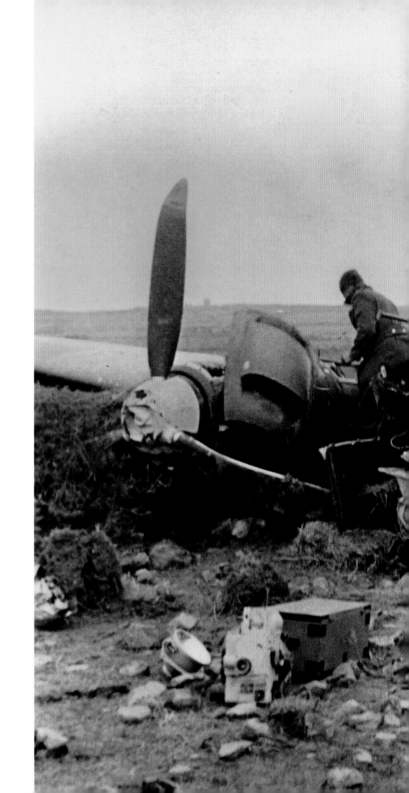

Buckled propellers. The wreck of a Heinkel He 111
bomber which crash-landed on 1 April 1941 at
Ballywristeen, Co. Waterford. The crew of five survived
and were brought to the Curragh for internment.

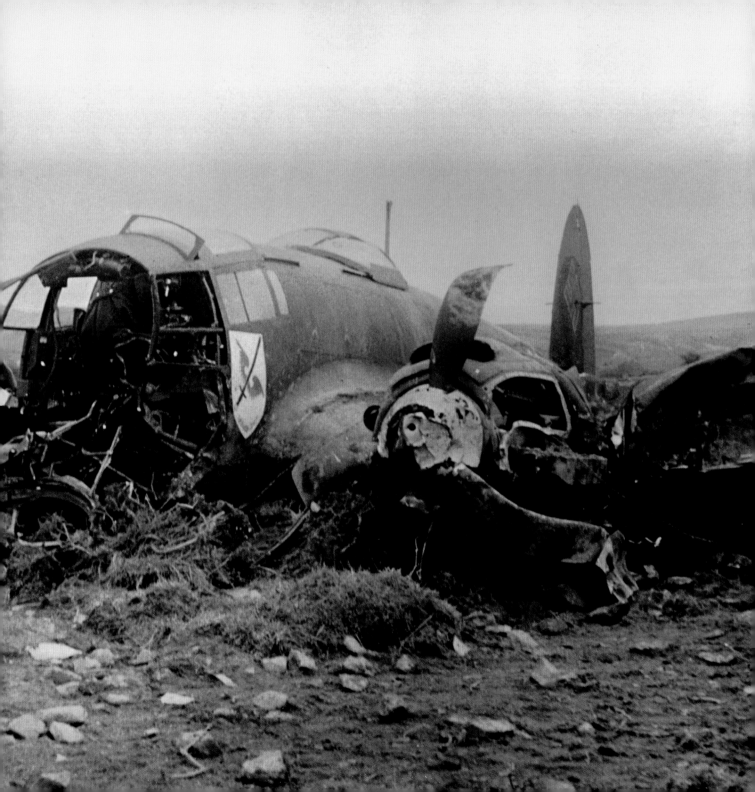

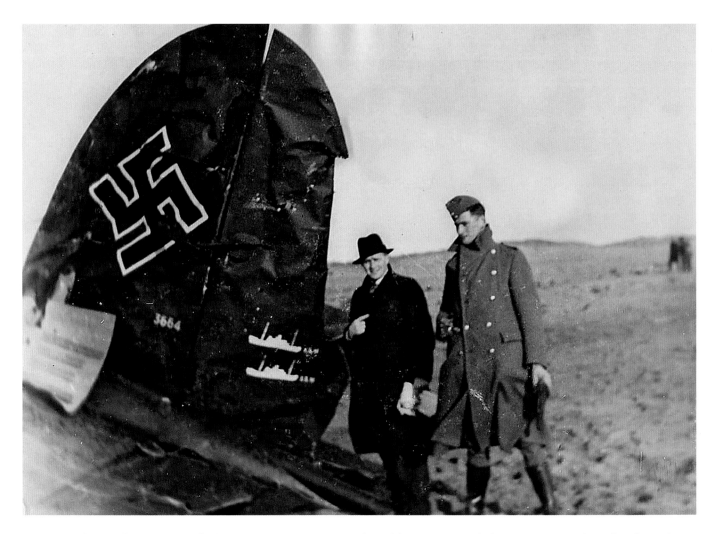

Coroner for South County Wexford Fintan O'Connor poses with a soldier near a Heinkel He 111 H-5 (with a tally of two ship 'kills' on its tail). On 3 March 1941, the bomber had taken off from a Luftwaffe airfield near Brest in France for an anti-shipping mission over the English Channel and the Irish Sea. While bombing a British merchant ship, the plane was hit by anti-aircraft fire and its port engine went on fire. The pilot made a forced landing, with undercarriage retracted, on a beach near Lady's Island, Co. Wexford. The gunner was killed, but the other four crew were uninjured. After removing their deceased crew member, they set fire to the plane, which exploded as a result. The four airmen were later escorted to the Curragh.

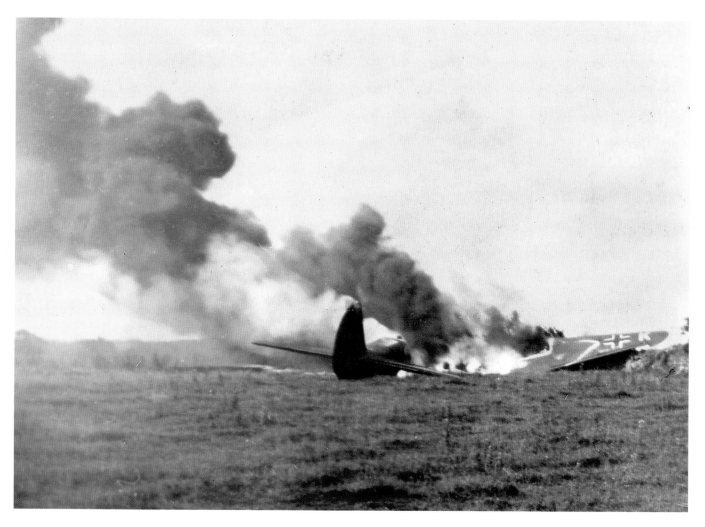

On 23 August 1942, a Junkers Ju 88D1, modified for long-range reconnaissance, took off from an airfield in the Brest peninsula, on a mission to photograph the Belfast area. As the aircraft flew north up the Irish sea, just skirting the Éire coast, it was being tracked by British radar. Spitfire squadrons from Wales and Northern Ireland were scrambled. As the Junkers was on its return journey, it was attacked by an RAF Polish squadron based at Anglesey. After an exchange of fire, Polish Flight Officer Sawiak had to crash-land his Spitfire near Rathoath, Co. Meath, and later died from his injuries. Spitfires continued to harry the Junkers, now operating on only one engine, as it flew south. The pilot made a forced landing, undercarriage retracted, in a field just north of Tramore, Co. Waterford. Here the Junkers burns, thought to be after a crew member had activated the installed incendiary device.

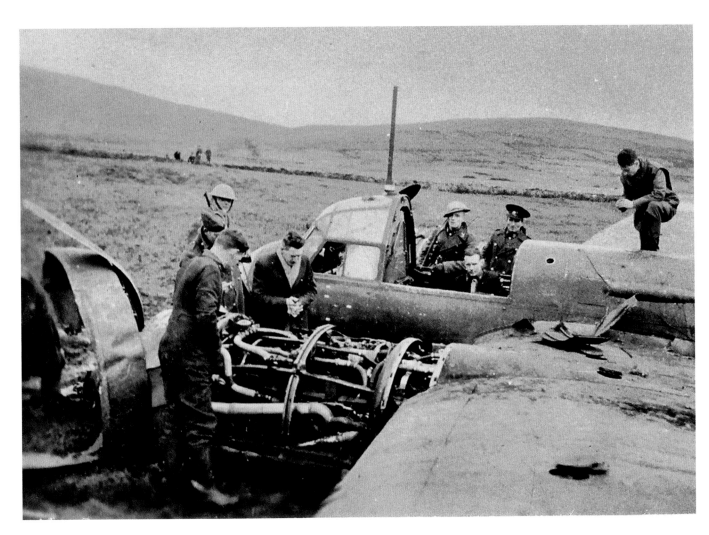

Air Corps technicians examine the wreck of a Junkers Ju 88A. On 26 December 1941, it had taken off from Rennes on a long-range mission to record meteorological data off the south-western and western coasts of Ireland. At around 13:45, after the oil and fuel pumps failed, the pilot made a forced landing, with the undercarriage up, in a field about 8km north-east of Waterville, Co. Kerry. The crew were uninjured, and subsequently made an unsuccessful attempt to set fire to the aircraft.

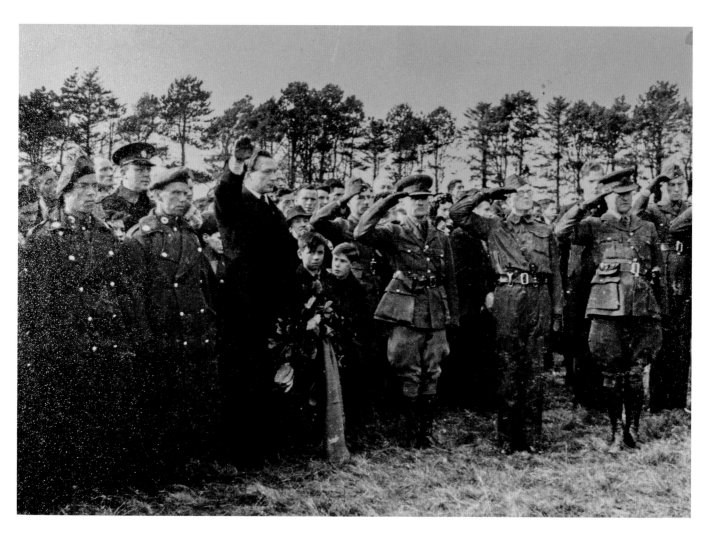

Those killed in air crashes were buried with dignity and full military honours. Here, at the graveside of five Luftwaffe airmen in Wexford, Counsellor of the German Legation in Dublin, Henning Thomsen (a committed Nazi, seen holding a wreath), gives the Nazi salute. To his left, members of the Irish military provide more conventional honours. The airmen were the crew of a Heinkel He 111, which had crashed onto a Wexford beach after an encounter with an RAF Hurricane. The Hurricane later ran low on fuel and had to force land near Kilmacthomas, Co. Waterford. The fighter was not badly damaged and was purchased by the Irish government and it entered Air Corps service (the second of three crashed Hurricanes thus acquired).

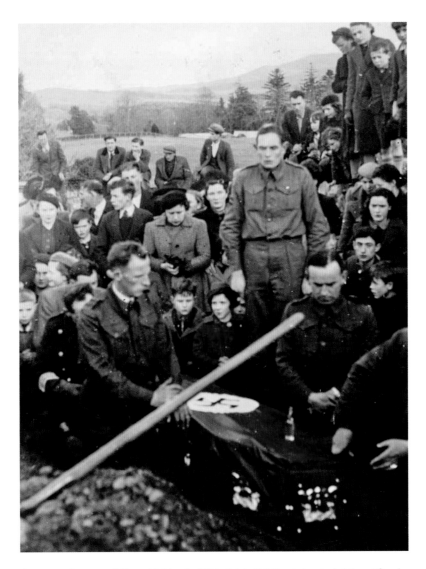

LDF members stand respectfully as Feldwebel Friedrich Schütz is buried, his coffin draped in his national flag. Full military honours were given during the large funeral at Kenmare, Co. Kerry. Schütz had been a crew member of a Heinkel He 111 that had been attacking British trawlers on 23 February 1941. Hit by anti-aircraft fire, the plane crashed into the sea near the Fastnet Rock. The airman's body was carried by strong tidal currents and drifted into Kenmare River.

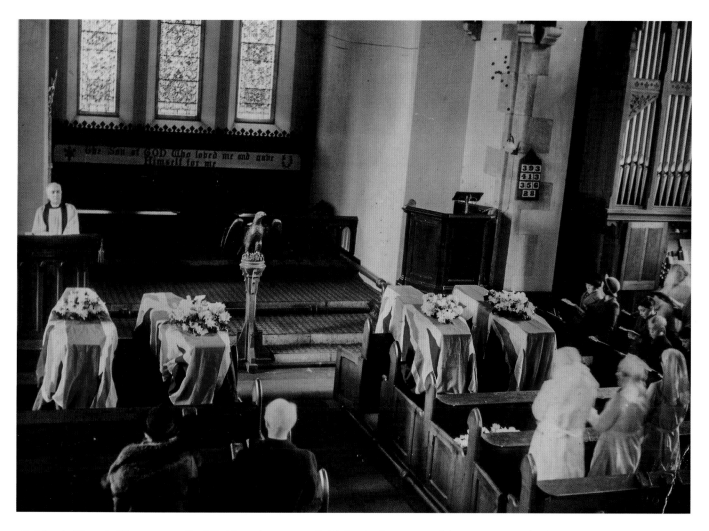

St Mary's Church, Blessington, Co. Wicklow. A service is held for the four crew of the RAF Hampden bomber which crashed into Black Hill, near Blessington, on 18 April 1941. The crash illustrates the inaccuracies of air navigation in those times – the bomber had lost its position whilst on the return journey after a raid on Berlin.

After a Luftwaffe Focke-Wulf Condor crashed in Co. Kerry in August 1940, the government decided to intern the surviving six belligerent airmen. A camp, popularly known as K-Lines, was built on the east side of the Curragh Camp (about 1.6km from Camp No. 1 which housed IRA internees). K-Lines was divided by a corrugated iron fence into two sections: G for Germans and B for the British. From the beginning of 1943 most of the British (and other Allied) internees were progressively and quietly released.

By the war's end, 54 members of the Luftwaffe and 210 members of the Kriegsmarine (navy) had been interned at the Curragh. Of the sailors, 164 were survivors of a German destroyer and two torpedo boats which had been sunk. They had been rescued by the Irish coaster, MV *Kerlogue* (which had been on passage from Lisbon to Dublin) on 29 December 1943. Their arrival at the Curragh led to overcrowding and a new camp (located near the IRA camp) was built within weeks. Here, German Air Force and Navy officers pose at the Curragh.

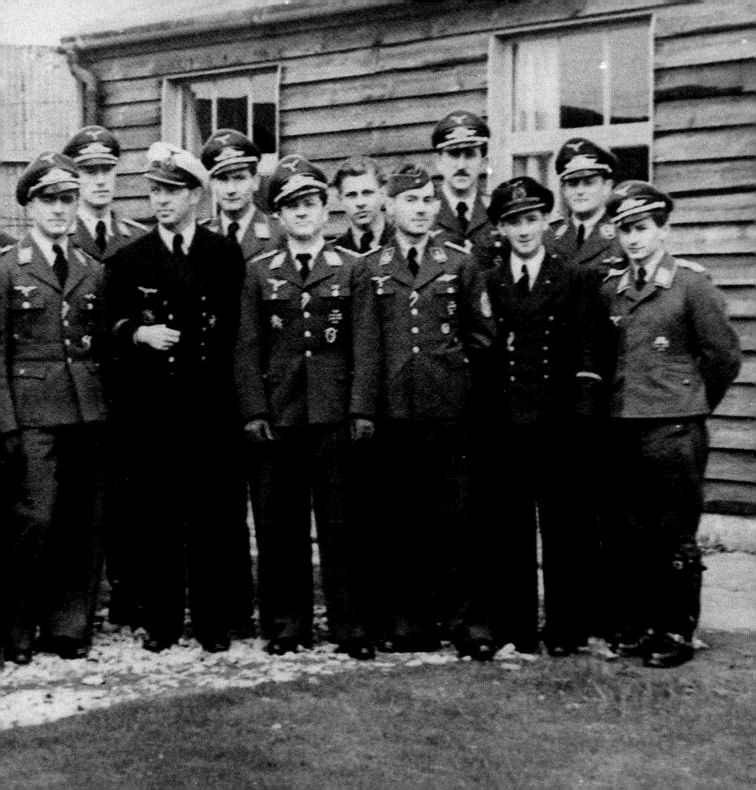

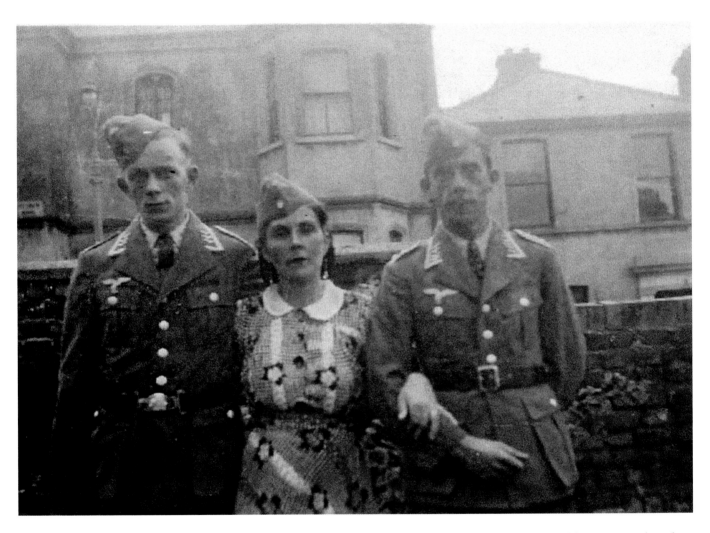

Surprisingly solemn on their day out, two Luftwaffe NCOs pose with an Irish friend at Newbridge, Co. Kildare. Against the rules, both airmen are wearing their uniforms outside the camp – the uniforms were smuggled out for the photograph. German internees were allowed leave their camp for several hours every day and were obliged to remain within a radius of around 12km. They had the use of the Irish Army's swimming pool two mornings a week. Life in general was good for the internees. They received their monthly service pay and cigarettes and alcoholic drinks were sold tax and duty free in both German and British canteens.

The niceties of mess life were observed in G Camp. Here Adolf Oelkers brings tea for the German officers. In the background, two internees, dressed for the warm summer temperatures, maintain their well-cultivated garden. By contrast, the grass in B Camp was overgrown. It was a reflection of the frustration that the Allied internees felt at their confinement, and discipline was sometimes poor.

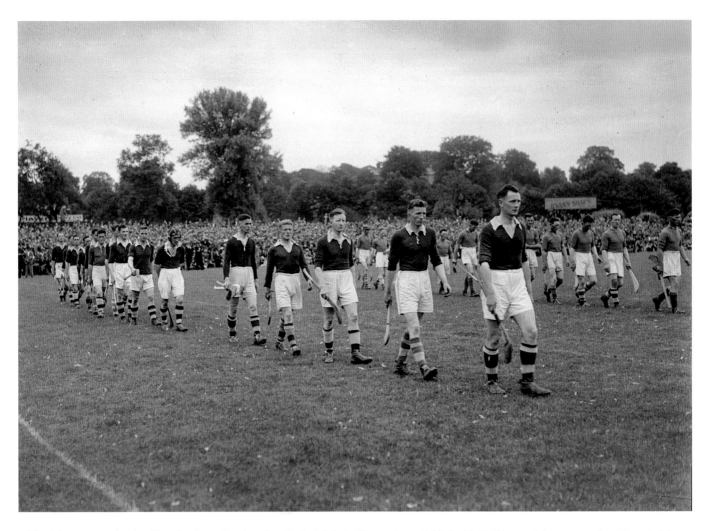

The Munster senior hurling final was held at the Cork Athletic Grounds on 12 July 1942. Pictured is a young Jack Lynch (the future taoiseach) leading the Cork team. The legendary Christy Ring, equally young, is seventh from the right. Cork won against Tipperary and went on to secure that year's All-Ireland Senior Hurling Championship.

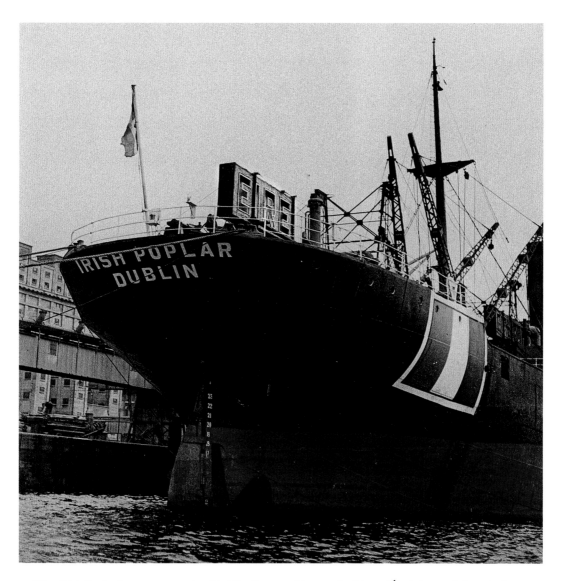

The *Irish Poplar* is seen moored at Dublin Port, emblazoned with an 'Éire' sign and the tricolour. In March 1941, the Irish government started Irish Shipping Limited. The new management had to scramble to acquire any available ships, scarce during the war. The *Irish Poplar* was the company's first vessel, sourced from Spain, having previously been a Greek-flagged ship which had been abandoned after being strafed by a German aircraft in the Bay of Biscay.

Discipline in the ranks – John Charles McQuaid inspects the troops. He was appointed Archbishop of Dublin at the age of 45, a young age for such an office. McQuaid ran his diocese with an almost military discipline. Charitable and shy in private, he was conservative in matters of the faith and particularly in sexual matters. His period of office (he retired in 1972) was a perplexing time for him, an era in which Ireland was going through a deep social and cultural transformation.

Members of the Army Nursing Service show off their new 'walking out' uniform which was introduced at the end of 1942. Including temporary appointees, there were about 400 members of the service during the Emergency.

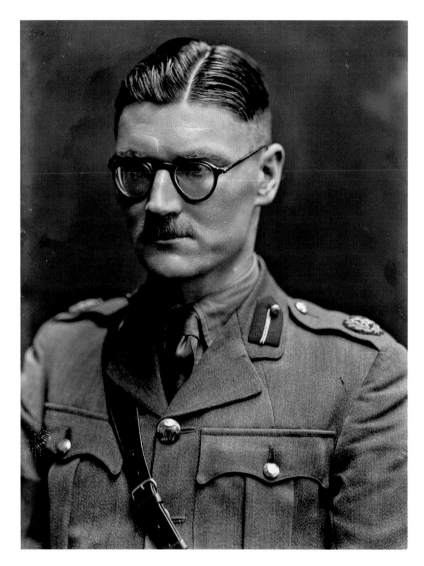

Major-General Hugo MacNeill (nephew of Eoin MacNeill, the Irish Volunteers leader) held senior positions in the army. In June 1941, he was appointed GOC 2nd (Spearhead) Division, tasked to repel an invasion from the Six Counties. In December 1940, in ambiguous circumstances, MacNeill contacted Henning Thomsen of the German Legation to discuss the possibility of German assistance in the event of a British invasion – he is also supposed to have met Goertz, the Abwehr agent.

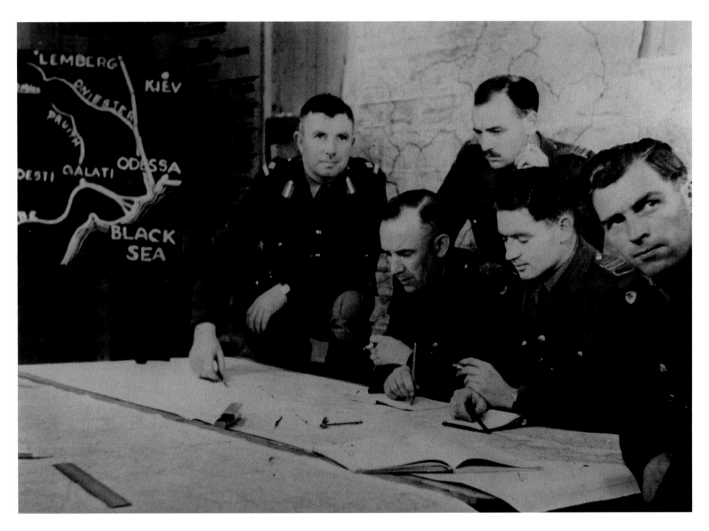

Major-General Michael Costello, like his colleague Hugo MacNeill, had been a member of the seminal Military Mission to the American Army in 1926. Here he is seen with his officers, with a chalked map of Ukraine in the background. Ukraine was part of the Soviet Union and had been recently invaded by the Germans. In mid-1941, Costello was appointed GOC 1st (Thunderbolt) Division, tasked to protect the southern coast, the area considered most under threat from a German invasion. In this instance, it is likely that Costello and his men are considering the River Blackwater, not the Dnieper.

Troops, participating in the Blackwater Exercises, take a break at Mitchelstown, Co. Cork. In September 1942, the Defence Forces carried out the largest exercises ever undertaken in Ireland. The 2nd Division (designated as being from 'Red Land') and the 1st Division ('Blue Land') faced each other along the valley of the River Blackwater.

Over the weeks, they carried out a series of simulated defence and attack manoeuvres incorporating the scenario of an invasion from the southern coast. Major-General Costello led the Blue Land forces while Major-General MacNeill commanded the Red Land forces, who had marched over 220km from Dublin to Cork.

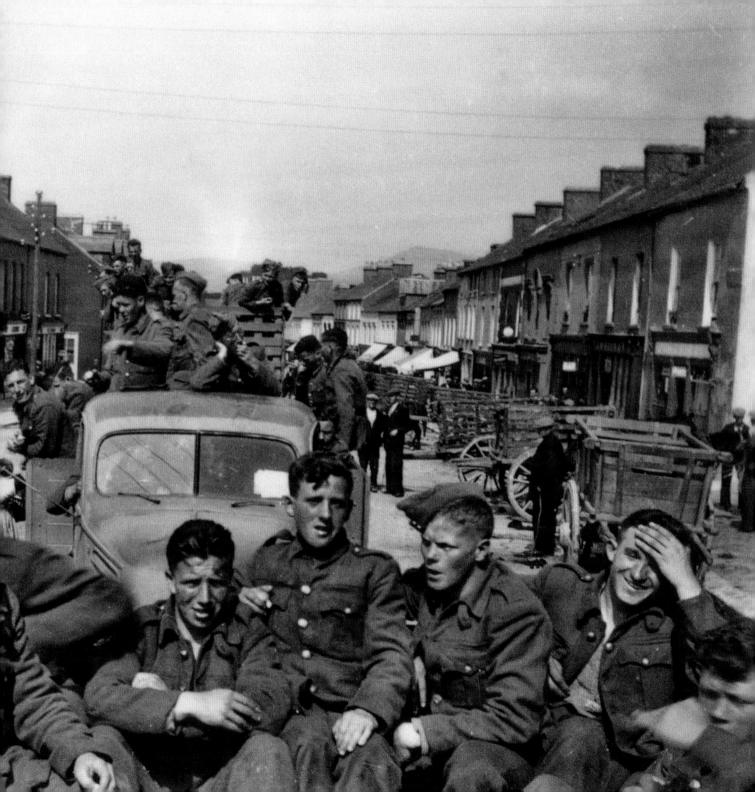

It is a measure of how important the Blackwater Exercises were to test Irish defences that Éamon de Valera paid a visit. Here he stands with the Chief of Staff, Lieutenant-General Daniel McKenna, and some umpires (with white bands on their hats), as Frank Aiken, Minister for the Co-ordination of Defensive Measures, converses with a captain, also an umpire.

A soldier out in the field grabs what rest he can. Here, this infantryman naps alongside his rifle, greatcoat, trenching tools and a box of .303 inch ammunition. His dog keeps a watchful eye on the cameraman.

Infantry, carrying rifles and Lewis guns, cross the River Blackwater. The troops link each other in the swift current. The river held dangers – an officer and three other ranks were drowned during the various fording exercises.

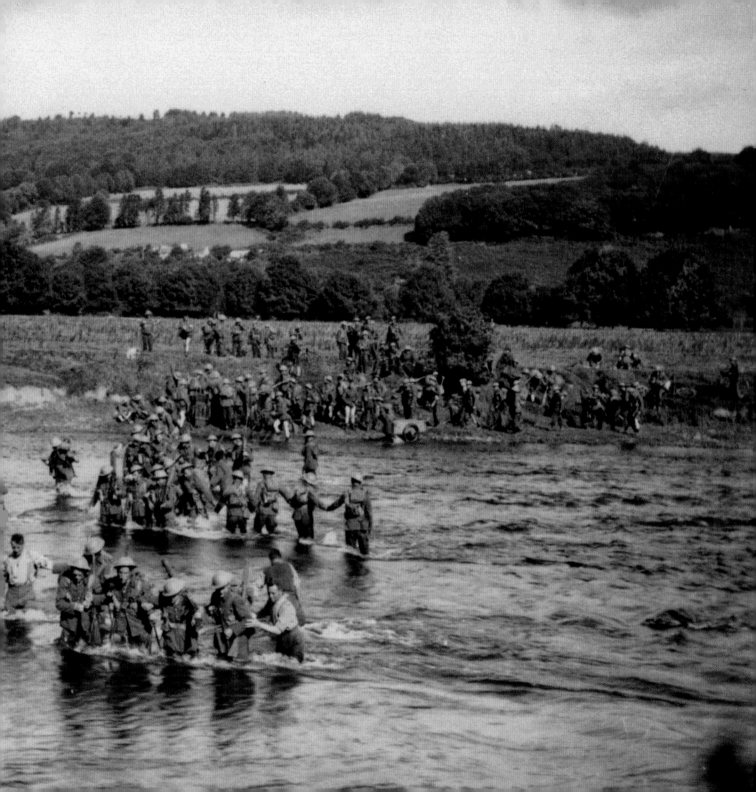

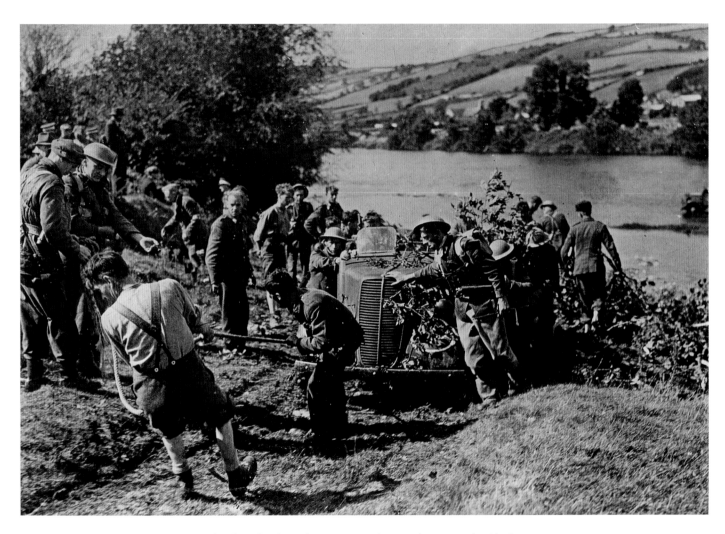

Heavy hauling for the 3rd Motor Squadron as they cross the Blackwater.

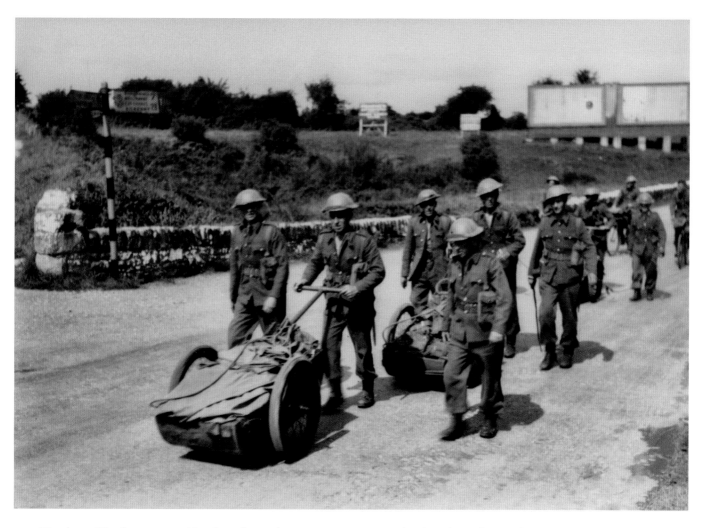

Handcarts like this were used by the infantry during exercises. Low-technology, but effective, they were used to haul heavy equipment like machine guns and ammunition.

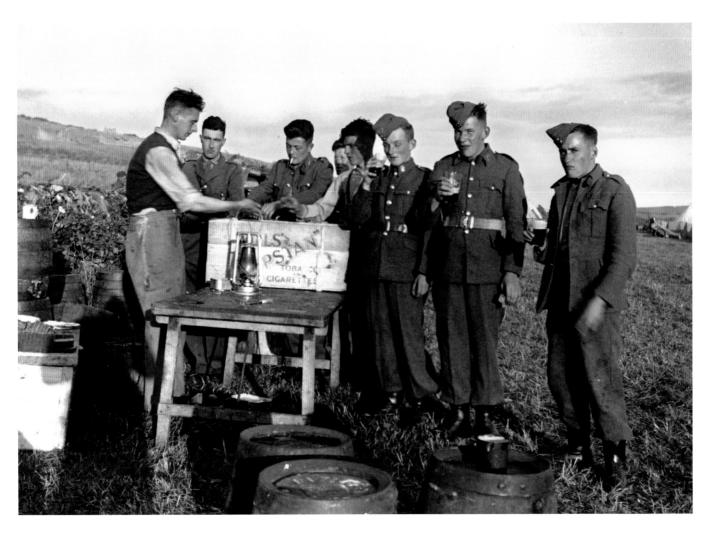

A pint of plain is much appreciated while in camp. It appears that more delights await these young soldiers in the large box of Wills's Capstan, a popular cigarette at the time, thought to have the highest nicotine content of any brand.

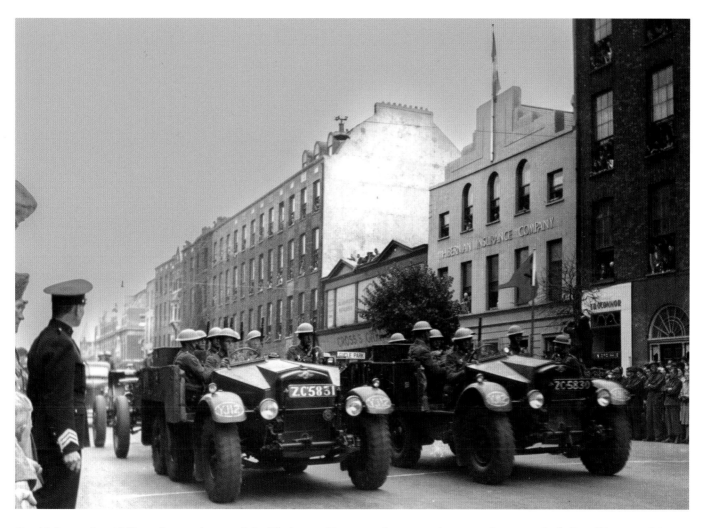

On 13 September 1942, at the conclusion of the Blackwater Exercises, there was a large march-past in Cork City. Here, two Morris-Commercial CDSW six-wheeled artillery tractors pull 4.5 inch howitzers along the South Mall.

The ceremonies in Cork, after the Blackwater Exercises, were the largest-ever military parade to take place in Ireland. Taoiseach Éamon de Valera took the salute at the march-past, with 200,000 people in attendance. Here, the Army Nursing Service parade along Patrick Street.

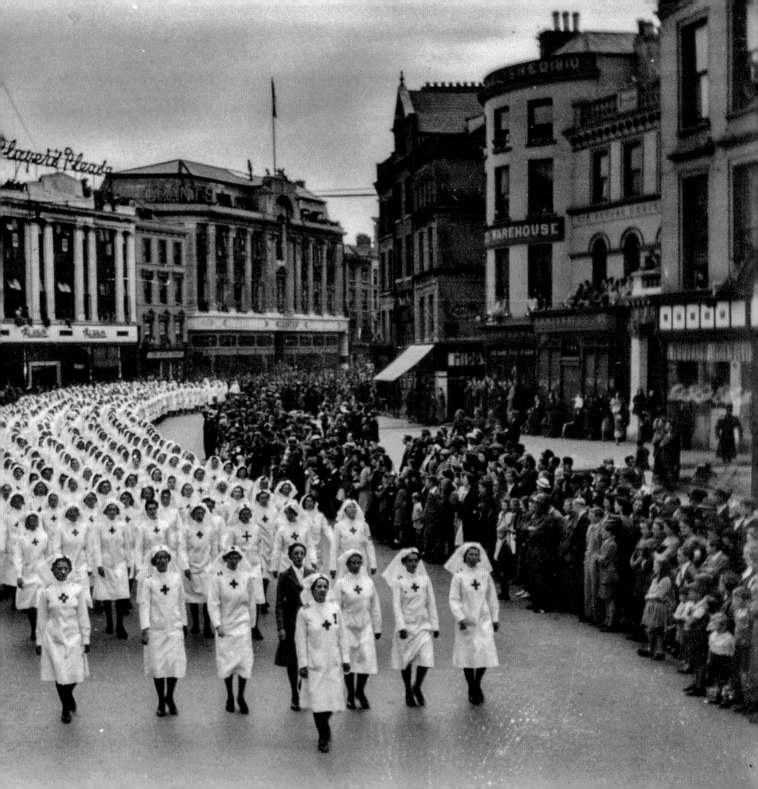

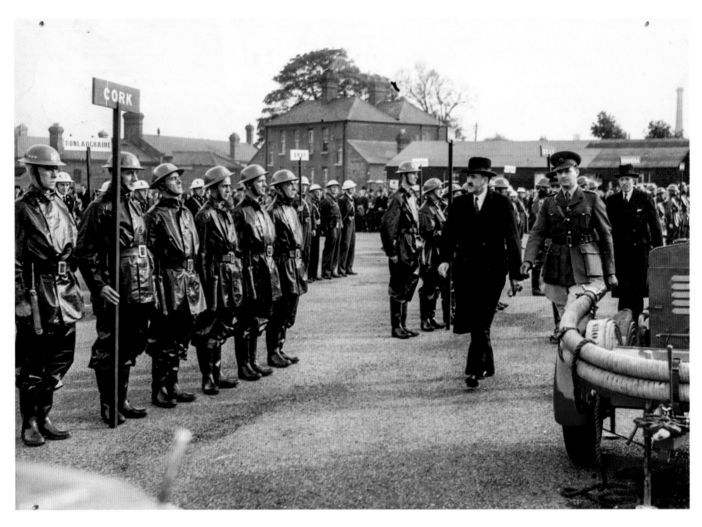

Frank Aiken, Minister for the Co-ordination of Defensive Measures, inspects the ranks of firemen during an Auxiliary Fire Service Competition at Cork in 1943. The team of the Cork Harbour Commissioners won.

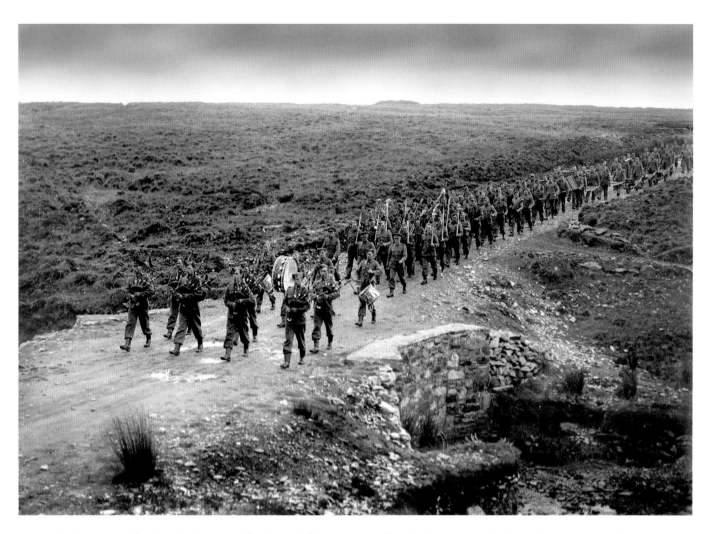

From the beginning of 1941, the shortage of coal (used for trains as well as for domestic and industrial consumption) began to bite. The British government had reduced exports of coal (as well as petrol) to Éire at the end of 1940. The Irish government's strategy had been to encourage turf production and now that policy was accelerated. A campaign was started which encouraged businesses and private individuals to cut turf. Local authorities were given powers to engage in turf cutting and by July 1941 they employed around 30,000. The Irish Army participated in the great turf-cutting operation. Here, led by a pipe band, soldiers march on the way to cut turf at Nadd Bog (*Nead an Fhiolair* – The Eagle's Nest) in North Cork.

Hard work at Nadd Bog. The soldiers dig their *sleáns* (special two-sided spades) to cut out the sods of turf. It was a huge enterprise for the army – over 2,000 soldiers participated, living in an area known as 'the Camps'. They had to first develop the vast bogland, creating drainage and roads, before they could get down to cutting the turf.

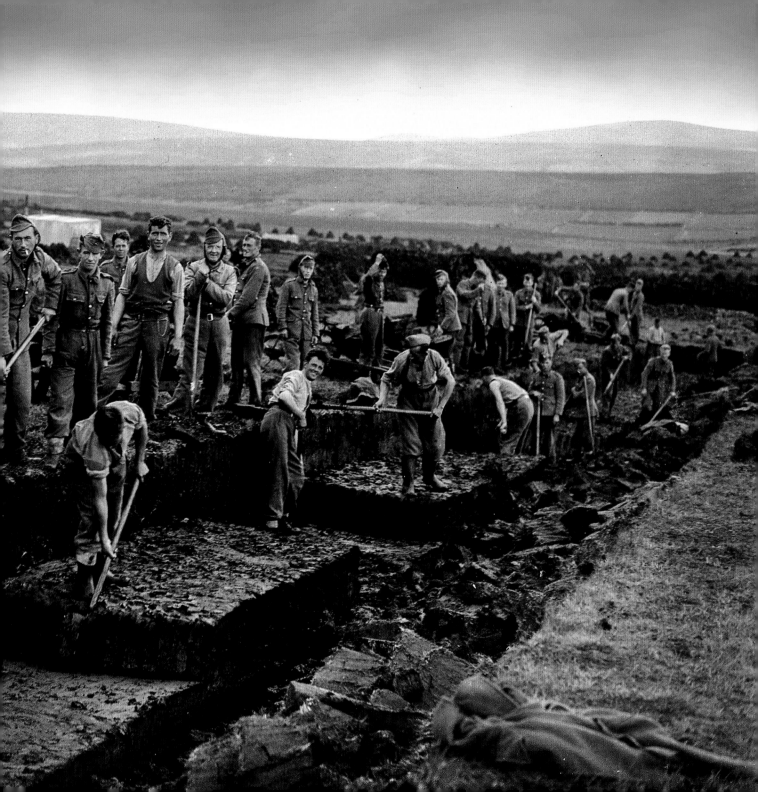

Trains specifically for transporting turf were organised to carry turf from rural areas in the west and the midlands to city areas. In the atmosphere of 'make do and mend' that pertained during the Emergency, former passenger coaches, as seen here, were converted into turf wagons. However, the lack of coal for locomotives meant that the quantity hauled began to tail off. In response, the government financed the building of 29 horse-drawn barges which could transport a 45-tonne load of turf along the canal system.

Turf was stored in giant ricks along Phoenix Park's main thoroughfare, Chesterfield Avenue. This became Dublin's main fuel stockpile, and was dubbed the 'New Bog Road'.

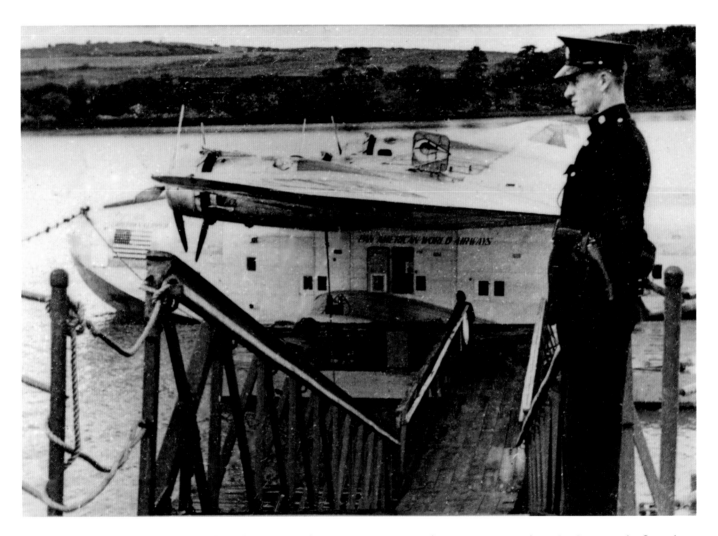

An armed Garda stands watch at the flying boat terminal at Foynes, Co. Limerick. From Spring 1941, BOAC operated a flying boat service to Lisbon and a year later, Pan American Airways operated flights to the United States with connecting flights to Britain. Foynes, although in neutral Éire, became a busy transport hub used by senior Allied military and government officials. From July 1942, the Irish authorities allowed an official British security representative to be based there.

Right: Laurence Olivier at the Powerscourt Estate, Co. Wicklow. In 1943, the British morale-boosting film, *Henry V*, was shot in Ireland, using the then innovative technique of Technicolor. Hundreds of extras were hired for the Agincourt battle scenes.

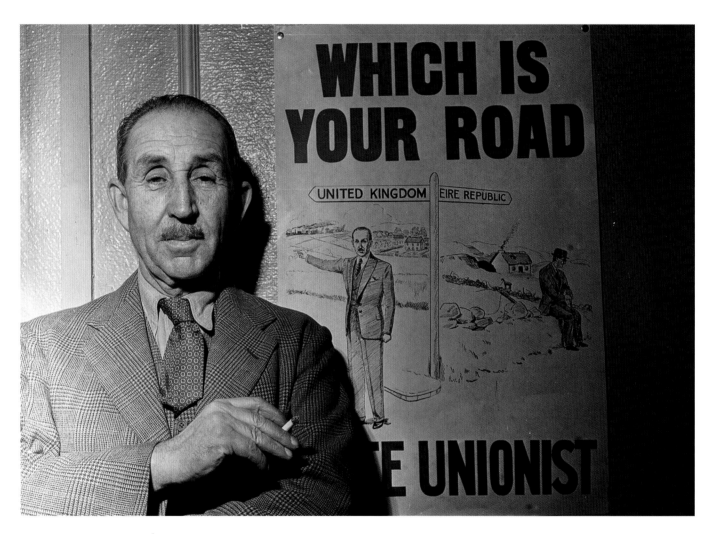

No danger of joining Éire with its thatched cottages and peasant poverty! Sir Basil Brooke became prime minister of Northern Ireland in May 1943, a position he was to hold for nearly 20 years. He presided over the Six Counties at a time when it had reached practically full employment, as its factories hummed, producing war matériel for the British war effort.

4. EMERGENCY
1944-45

The Germans suffered serious defeats during the course of 1943. By the beginning of 1944, confident that the tide had turned, Allied representatives felt able to increase the pressure on neutral Éire. In February 1944, the American envoy, David Gray (pictured here with his wife and, in the centre, her niece Eleanor Roosevelt, the president's wife) handed a note to the taoiseach demanding the expulsion of the Axis legations in Dublin, which was soon followed by a similar demand from the British. Known as the 'American Note', the exercise was a ploy to put de Valera in the wrong, to shame Ireland's neutrality and damn the country in the eyes of Irish-America. The note was opposed by the Allied intelligence agencies, who knew the Axis legations posed no security threat and the note would risk the cooperation they were receiving from the Irish.

A soldier on guard at Sliabh Coillte hill in south Co. Wexford. The 'American Note' did indeed generate stories in the American and British press that Dublin was a 'nest of spies'. However, de Valera chose to interpret the note as an ultimatum. He put the Irish Defence Forces on full alert and instructed the Chief of Staff to prepare for an Anglo-American invasion from Northern Ireland. The taoiseach published the American and British notes and condemned these as an attempt to deprive Ireland of her neutrality and sovereignty. This improved Fianna Fáil's popularity and helped secure them a majority when de Valera called a snap general election in May 1944, after the government lost a vote on the second reading of its transport bill.

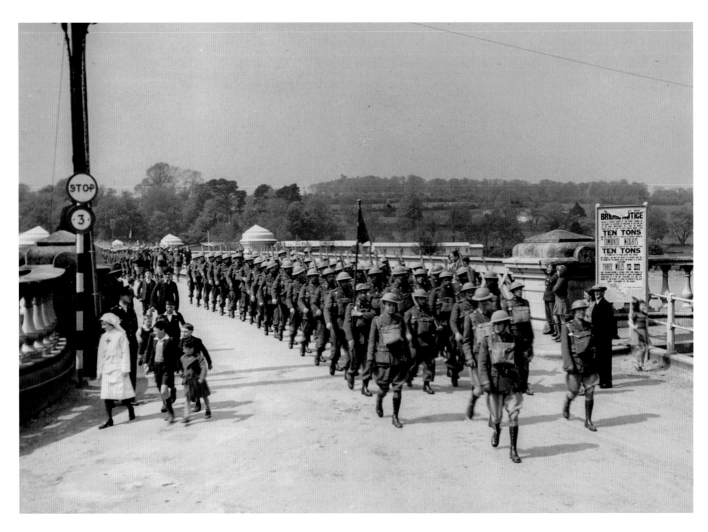

The army on the march at New Ross. Special military events were held in main towns which involved parades, concerts and sport events, all linked to an effort to increase recruitment, which had been tailing off since 1942. Desertions were a problem, particularly in units along the border, as many left to join the British forces, lured by the prospect of higher pay and a more exciting career. After the war, a list was compiled of 4,800 deserters. These deserters lost their rights to an army pension and were excluded from employment in the public sector for seven years.

Mass is being said at an improvised altar at a camp near New Ross. Surprisingly, the Catholic hierarchy were initially reluctant to allow chaplains to be assigned to units in the field, but they eventually agreed.

It was not all tedium out in the field. The arrival of the ice cream cart (operated by the Delicato family who ran a café in Waterford City) to Camp Mount Pleasant is appreciated by these soldiers.

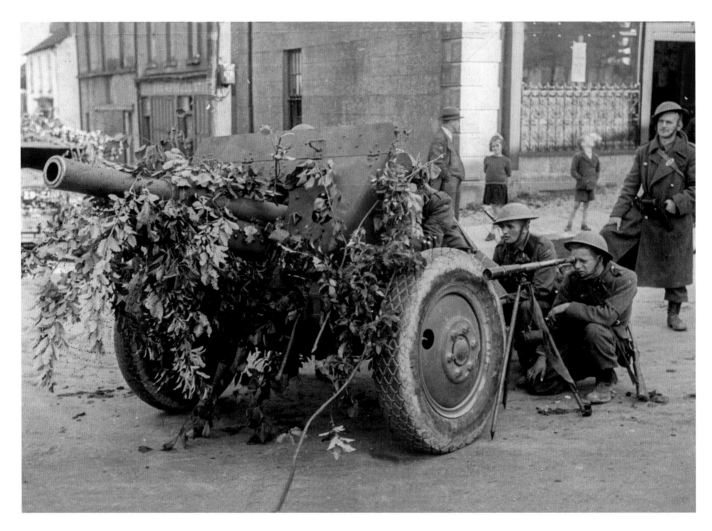

An 18-pounder is seen here at a street intersection in a town, while a member of the gun crew takes sight of a prospective target. It is most likely a posed photograph, as the muddy tyres and the tree branch camouflage suggest that the gun had just arrived from a field exercise. In April 1940, the Irish artillery inventory consisted of twenty-five 18-pounder field guns, four 3.7 inch and eight 4.5 howitzers together with a lone MkII 2-pounder anti-tank gun – the totality of which could have been snuffed out in the blink of an eye by an invading British or German Army.

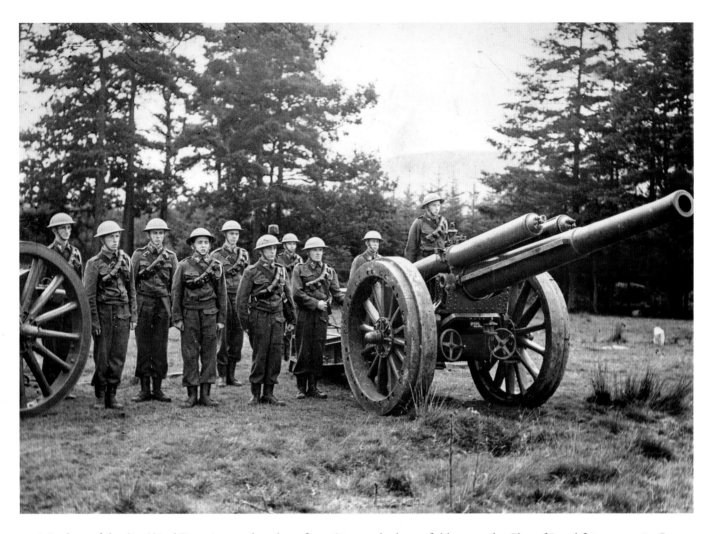

Members of the 41st/42nd Batteries stand ready to fire a 60-pounder heavy field gun at the Glen of Imaal firing range in Co. Wicklow. Over the period from 1942 to 1944, six of these obsolete guns (first developed in 1904) were obtained from the British. These were the largest field guns ever in Irish service. However, the solid tyres made transport of these heavy guns problematic and the intention then was that these would be placed on stationary defensive duty at harbours and bays.

Mortars were inexpensive weapons and relatively easy to transport and operate, giving added punch to infantry and artillery units. Here, in a live firing practice in the Comeragh Mountains in September 1944, camouflaged troops prepare to fire a Brandt 81mm mortar.

Despite years of under-investment and severe shortages of modern equipment, the Irish Army grew to a peak of around 45,000 and developed into a coherent force during the Emergency.

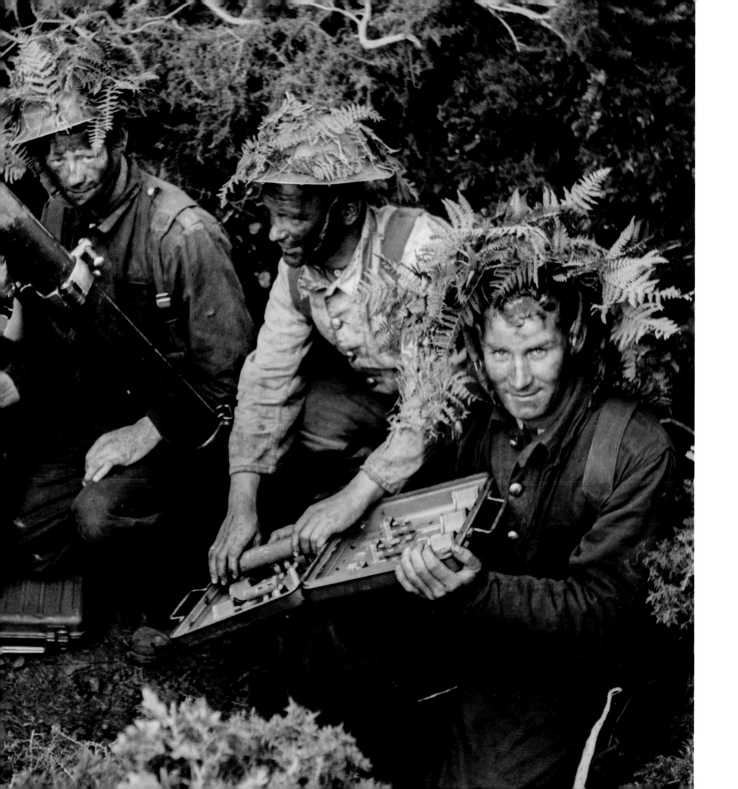

By early 1944, the immense United States economy was at full pitch churning out war matériel. In startling contrast to the small army south of the border that was starved of equipment, Northern Ireland was awash with advanced armament of all types, being a principal staging post for the build-up of American forces in readiness for the planned invasion of continental Europe. Here, a submarine chaser is being unloaded from the deck of a Liberty ship at Belfast docks.

Left: Great battleships – the USS *Nevada* (a survivor of Pearl Harbour) and, in the background, the USS *Texas* – lie anchored at Belfast Lough in May 1944. Both were greatly involved in bombarding German shore positions during the Normandy landings.

A tanker arrives at Belfast Harbour carrying Republic P-47 Thunderbolt fighter-bombers for the United States Army Air Force (USAAF) on its deck. The planes are well wrapped and secured for transport across the ocean. Demonstrating the meticulousness of American engineering and logistics planning, each of the fragile cockpits is stencilled with the word 'glass'. The Short and Harland Aircraft Works can also be seen in the right background.

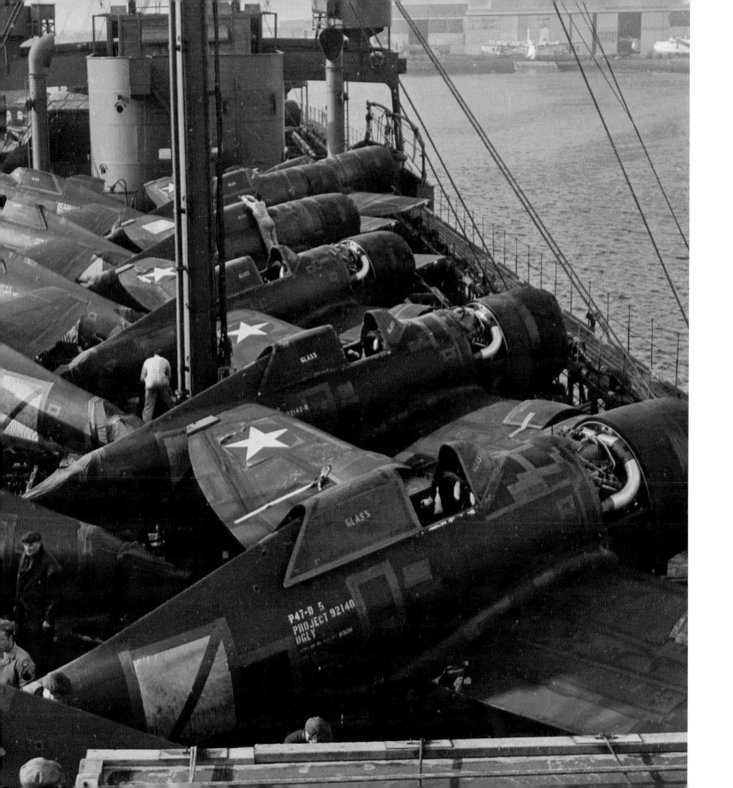

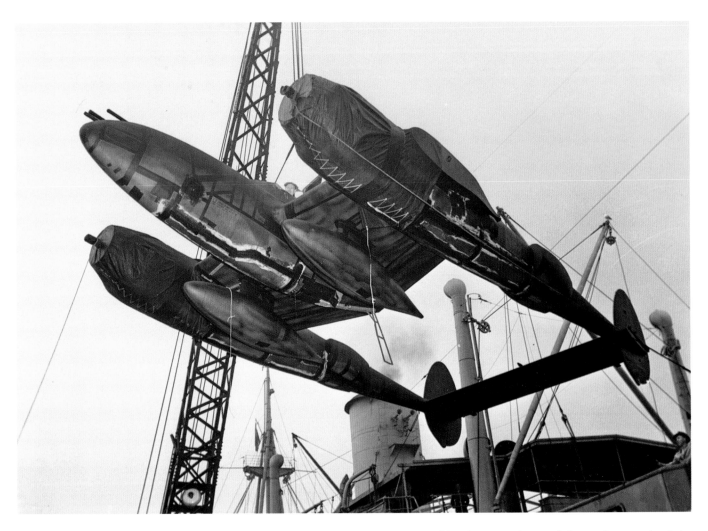

The planes kept coming, on the hazardous voyage across the Atlantic. Here, a Lockheed P-38 Lightning fighter is being unloaded from a ship at Dufferin Docks in Belfast on its way for final assembly at the Lockheed facility at Langford Lodge airbase. The twin-engined P-38 performed in many roles – it was an attack aircraft, a fighter-bomber and also used for aerial reconnaissance.

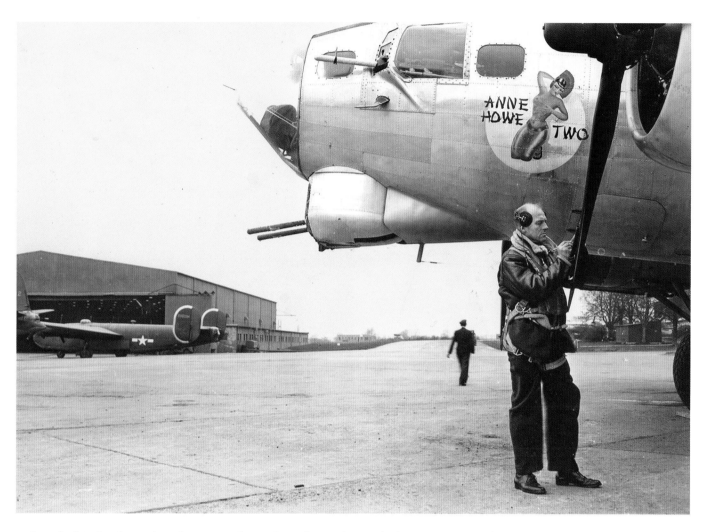

Langford Lodge, located on the eastern shore of Lough Neagh, was the biggest USAAF airbase to be built in Northern Ireland. Operation of the base was contracted to the Lockheed Overseas Corporation (LOC). At its peak, nearly 7,000 people worked at Langford Lodge, carrying out engineering work, aircraft servicing and assembly. The facility was a welcome generator of employment – as well as Lockheed and US military personnel, there were around 3,000 local civilian employees. Here, the LOC Chief Test Pilot, George Clark, stands next to a Lockheed B-17 heavy bomber.

The American bases across Northern Ireland became places where the awesome might of the US military-industrial complex was on display. Here is a line-up of B-17 Flying Fortresses, recently delivered from the United States. Made by Boeing, the B-17 was a four-engined long range bomber that could fly high and was relatively fast. It was referred to as the 'flying porcupine' by the Germans, as the aircraft was armed with 13 Browning .50 inch machine guns which pointed at the German fighters from virtually every direction. Over 12,000 B-17s were produced in different models over its service life.

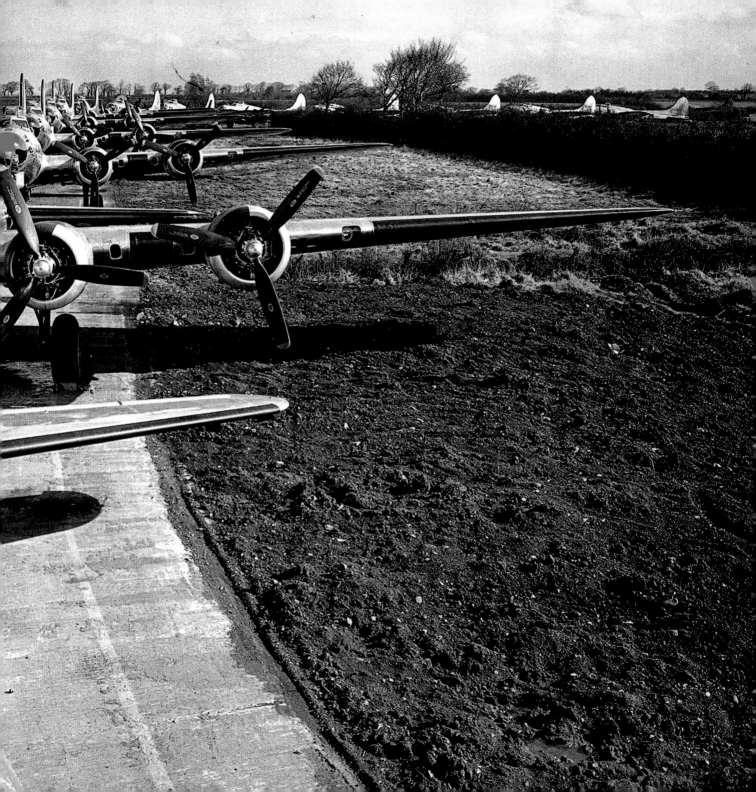

A Short Sunderland flying boat patrol bomber is refuelled at RAF Castle Archdale, Lower Lough Erne, Co. Fermanagh. Flying boats set out from here to patrol the North Atlantic in the search for German U-boats. These flights were facilitated by the 'nod and a wink' policy of the Éire government which quietly allowed the aircraft to fly over a short corridor over neutral territory, formed by south Donegal, north Sligo and north Leitrim, thus giving direct access to the Atlantic battleground. Another concession was to allow, from June 1941, an armed trawler manned by British personnel to carry out air-sea rescue duties, operating out of Killybegs, Co. Donegal.

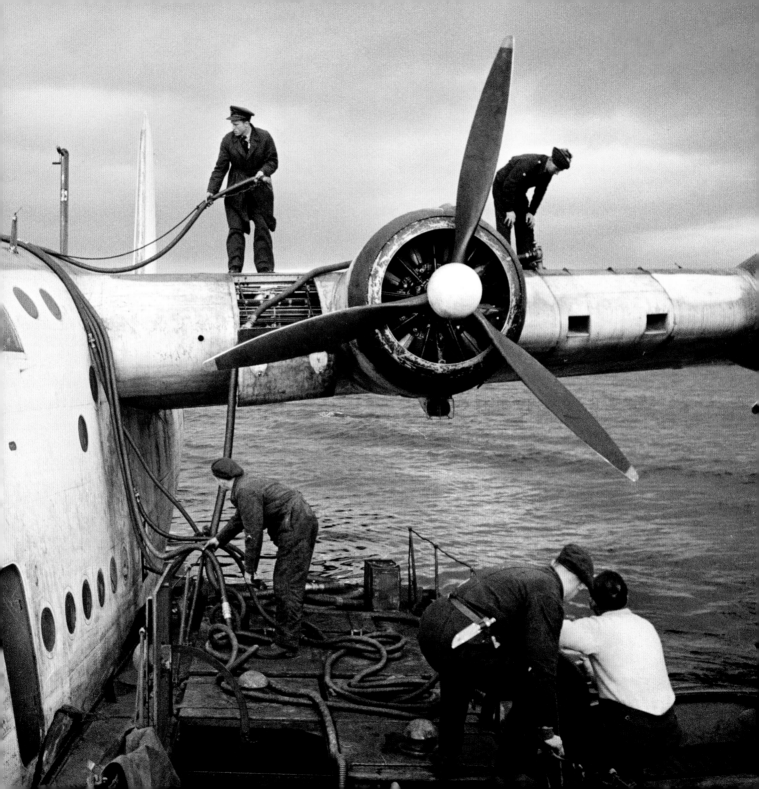

The scene in the cabin of a Short Sunderland of No. 201 Squadron at RAF Castle Archdale, Co. Fermanagh, as the crew prepare for the long flight from Lough Erne to their patrol area over the North Atlantic. The pilots sit in the cockpit while the radio operator adjusts his wireless instrument in the left foreground. Opposite him, the navigator formulates a flight plan.

The Short Sunderland S.25 had an endurance of 13 hours and could carry a payload of around 900kg of bombs, mines or depth charges. The aircraft, manned by a crew of up to 11, was well armed, with up to a dozen Browning machine guns located in the nose, tail and dorsal turrets.

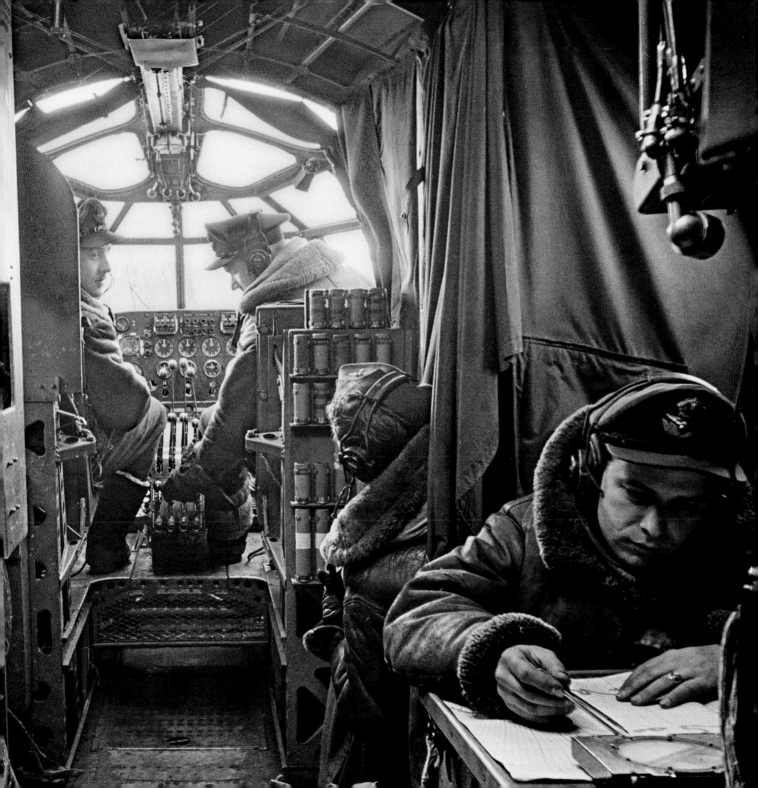

The woman from West Cork. Kay Summersby (born near Skibbereen), official driver to General Dwight Eisenhower, Supreme Commander of the Allied Expeditionary Force. A close relationship developed between the two during the war – opinion is divided as to whether they had an affair.

Left: General Eisenhower inspects the heavy cruiser USS *Quincy* at Belfast Lough on 18 May 1944.

Look Out Post (LOP) No. 16 at Hook Head, Co. Wexford. Eighty-three of these were constructed to keep Éire's seas and skies under observation. Members of the Coast Watching Service manned these LOPs, many located on remote cliffs and headlands. Initially, they watched out for invading forces but as the threat of invasion receded, they kept a general watch for sea and air activities of the belligerents. From mid-1943, an identification sign reading 'EIRE' was placed at each LOP. At the suggestion of US diplomats in Dublin, numbers were added. This allowed a list of LOP reference points to be exclusively handed over to the Allies – these points were then marked on maps used by Allied aircrew operating in the Atlantic and were an invaluable navigation guide, a facility that Axis aircrews did not have.

At the start of the war, with wild rumours circulating in Britain that U-boats were receiving succour along the Irish coast, the British SIS panicked and set up their own covert 'Dad's Army' of coast watchers in Éire. This mainly consisted of ex-British servicemen and Anglo-Irish loyalists, an arrangement that soon came to the notice of the Irish authorities. Over time, British fears were assuaged as, due to intelligence cooperation from the Irish, they received a steady stream of information on coastal sightings. The British naval attaché in Dublin arranged the supply of wireless transmitters to the Irish Coast Watching Service for better communication with their HQ, which speeded up the information that flowed to the Admiralty.

The Allies continued to benefit from the intelligence flow from 'neutral' Ireland. On 3 June 1944, the weather observations taken by Blacksod lighthouse keepers (located at the southern end of the Mullet Peninsula, Co. Mayo) were sent to the Metrological Office in Dublin and onto Britain, for ultimate relay to the Supreme Headquarters of the Allied Expeditionary Force. This information allowed General Eisenhower and his planners to forecast when there was the best chance of good weather – the data from Blacksod on approaching weather fronts led them to delay the Normandy invasion by 24 hours, and the landings occurred on 6 June 1944.

Hauling in the catch on the west coast of Ireland. The Irish fishing industry was small and had suffered from government neglect – at the beginning of the Emergency, there were only around 80 vessels over 15 tonnes in the entire fleet. Bigger tonnages were caught due to increased wartime demand, but began to decline after 1945. Two Irish trawlers were sunk due to belligerent action during the war, resulting in significant loss of life.

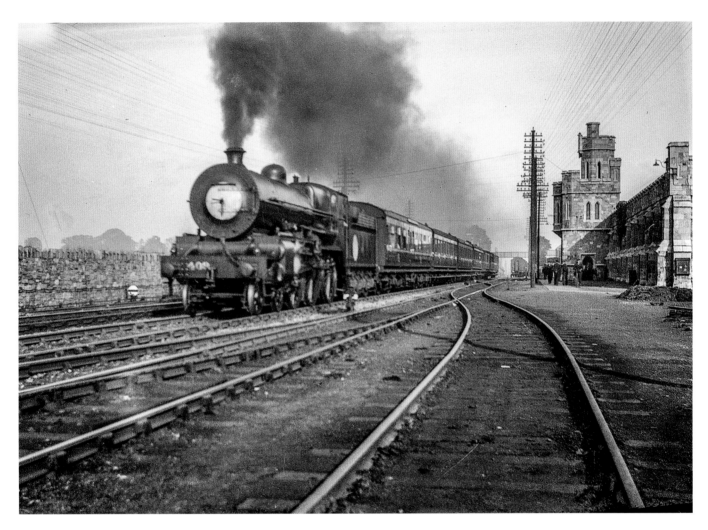

An oil-burning steam locomotive hauls a passenger train past the Inchicore Railway Works. Serious coal shortages during the Emergency resulted in the railways having to cut services. Some existing steam locomotives were retrofitted to burn oil, and rectangular oil tanks were fitted into the tenders – circles were painted on the side of the tenders to identify them as oil-burners. The government had called a general election in May 1944 after its transport bill had lost the vote. The victory by Fianna Fáil allowed the bill to be successfully reintroduced and on 1 January 1945, the new entity, Córas Iompair Éireann, came into being, which consolidated transport entities including Great Southern Railways and the DUTC (which had run Dublin's trams and buses).

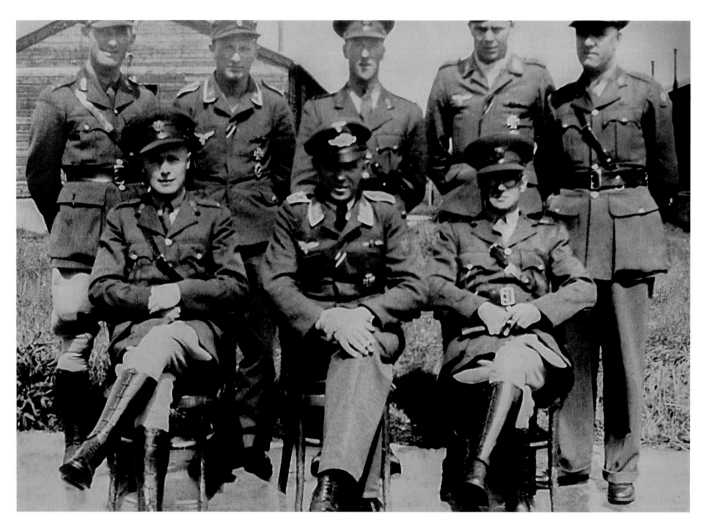

As the war ended, German forces were surrendering all over western Europe, and those in the Danish command surrendered at 8.00 a.m. on 5 May 1945. Earlier that morning, a Junkers 88 G-6c night fighter took off from the Danish airbase at Grove, destined for Prague, with the crew intending to escape possible retribution from the Danish resistance forces. The weather in the direction of Prague was bad so they turned towards neutral Ireland, where the weather forecast was favourable. Later that morning the aircraft arrived over the Air Corps aerodrome at Gormanston, Co. Meath, and landed there. The Germans were taken into custody and duly interrogated by a G2 officer. Here, the Luftwaffe men pose with Irish Army officers at Gormanston.

As it turned out, the RAF was very interested in acquiring the Junkers 88 for test and evaluation. Following negotiations, a party of British personnel landed at Gormanston on 1 June 1945. The Luftwaffe markings on the night fighter had been painted over with RAF roundels by Air Corps staff (seen here in progress). The following day, a Fleet Air Arm test pilot flew the Junkers to Farnborough, escorted by a flight of Supermarine Spitfires.

The naval base at Lisahally on Lough Foyle was assigned to be the principal base for the disposal of German U-boats that surrendered at the end of the war. The first U-boats arrived there in mid-May 1945. More submarines manned by skeleton German crews under the supervision of Royal Naval personnel subsequently arrived from other reception centres. The Allies agreed to retain 30 U-boats, to be divided equally between the UK, USA and the USSR – the rest were to be sunk.

Under 'Operation Deadlight', from 27 November 1945 to 12 February 1946, 116 submarines were towed to open sea, under escort by British and Polish Navy ships, where they were sunk in deep water off the north-west coast of Ireland.

Here we see a German submarine crew bringing their U-boat to the rendezvous point from which it was towed to be sunk. It is a Type XXIII, an advanced coastal submarine first introduced in 1944. This was more streamlined with an all-welded single hull, larger-capacity batteries and a snorkel, which allowed the diesel engines to run while submerged.

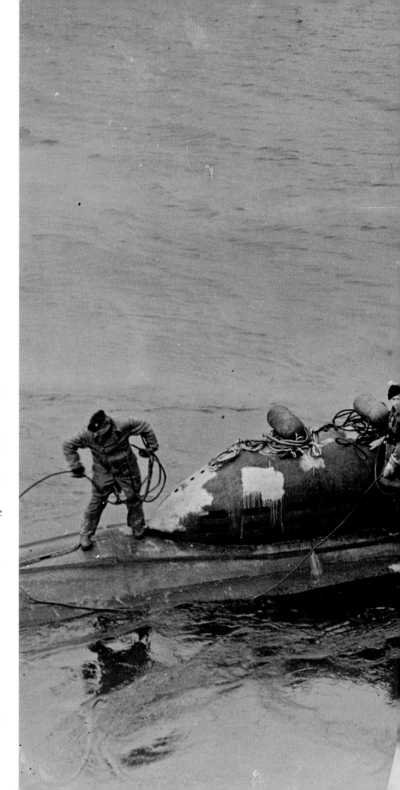

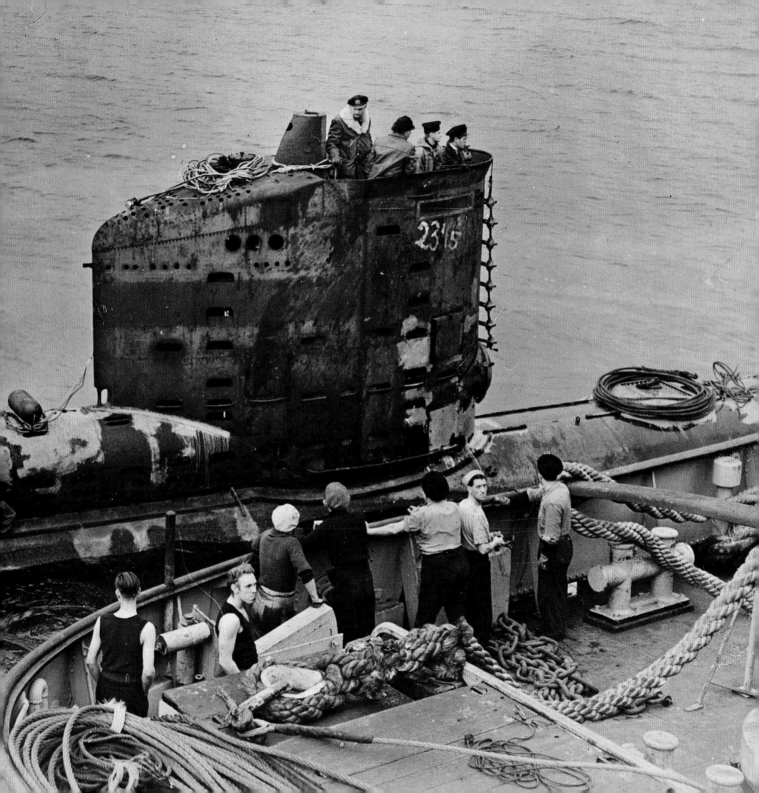

In this 1945 scene at College Green in Dublin, buses, a tram, horse transport and pedestrians predominate – there are few cars. On 2 May, the city was the scene of what became the most infamous event of the entire Emergency. After news came of Hitler's death, the taoiseach, Éamon de Valera, called on Dr Eduard Hempel, the German Minister to Ireland, to offer condolences on the death of his head of state. The visit attracted furious criticism in Britain and the United States. (A few weeks previously, after President Roosevelt's death, the taoiseach similarly had called on the American envoy, David Gray.)

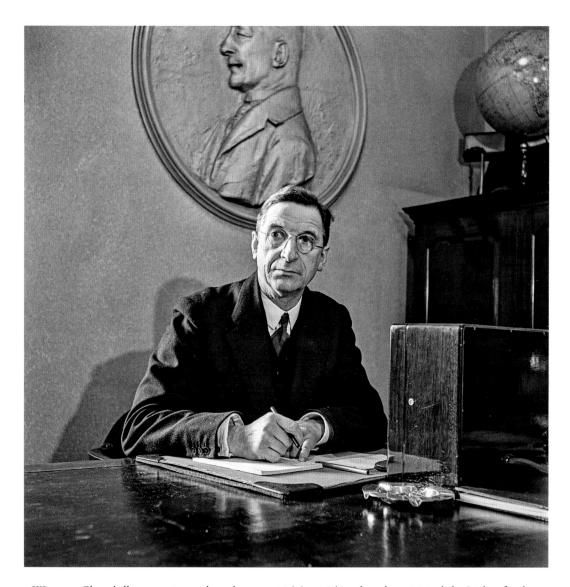

Winston Churchill gave a victory broadcast on 13 May 1945, where he criticised the Irish refusal to allow the British use of the ports and airfields, noting British restraint and how it 'left the de Valera government to frolic with the German [representatives]'. During the broadcast, the taoiseach gave a dignified reply noting how 'hard it was for the strong to be just to the weak' and reminding Churchill that 'there is a small nation that stood alone … for several hundred years against aggression'.

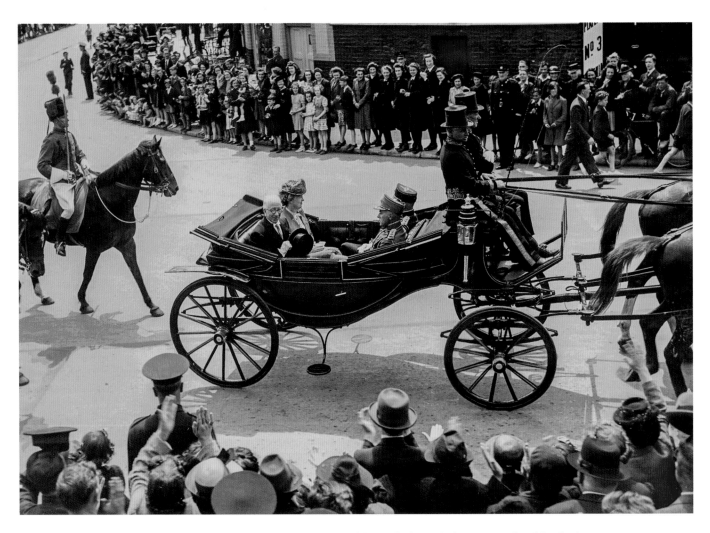

On 25 June 1945, the Blue Hussars escort Seán T. O'Kelly and his wife through the streets of Dublin for his inauguration as the second president of Ireland, demonstrating that a republican can also enjoy a touch of pomp. The horse-drawn landau had originally been Queen Alexandra's. The previous president, Douglas Hyde, had opted not to nominate himself for a second term, due to ill health. The election to succeed him was contested – O'Kelly, a 1916 veteran and a close friend of de Valera's, won, defeating two other veterans of the independence struggle, Seán Mac Eoin and Pat McCartan.

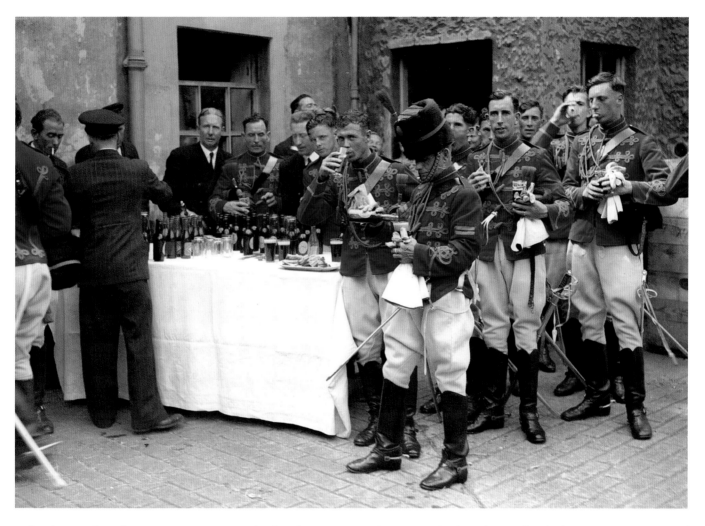

After the presidential ceremonies, it was time for the Blue Hussars to dismount, take their gloves off and relax. Here, they partake of some welcome bottles of stout and sandwiches.

A fortnight-long Military Tattoo, organised by the Defence Forces, was staged at the RDS in Ballsbridge, Dublin, at the end of August 1945. It was intended to mark the contribution of Ireland's soldiers, sailors and airmen to the state during the Emergency. Here, in a grand scene, soldiers form a geometrical tableau, while a massed army band plays in the background.

The Tattoo majored on Ireland's ancient history, with displays intended to show Irish martial tradition – ironic in a way, as Éire had desperately tried to remain neutral and avoid the military conflagration that was WWII. Here, the army demonstrates its flair for theatre with this scene of beards, spears and shields, as the kingly warriors man their chariot.

A centrepiece of the pageantry was a re-enactment of Eoin Ruadh O'Neill's victory at the Battle of Benburb in 1646. An *Irish Times* reporter cast a jaundiced eye on the event and was not impressed, calling the pageant 'confusing'.

The various branches of the Defence Forces had displays at the Tattoo. Here, in the Air Corps section of the main hall, a Hurricane fighter and a Miles Magister M.14a trainer are put on show.

No Military Tattoo was complete without the Blue Hussars. As part of their contribution, they performed a musical ride to the tune of 'Here Comes the Bride'. President Seán T. O'Kelly opened the Tattoo, and spoke of how the Defence Forces had spent the previous five years at lonely isolated outposts, separated from family and how 'by their untiring efforts … they have shielded the nation'. The event was held to raise funds for the Army Benevolent Fund. The Tattoo proved wildly popular, with 200,000 people attending.

The *Irish Times* reporter maintained his dyspeptic mood, observing that the so-called 'modern' heavy weaponry on display was no longer used by other European armies. The *Irish Independent* nonetheless concluded that the Tattoo had been a 'magnificent show'. The *Irish Press* took pride in the whole affair and marvelled that the 'Exhibition Has Everything But The Atomic Bomb'.

A young visitor explores the turret of a Leyland armoured car. Children enjoyed the Tattoo, and flocked to the weaponry on display. They swarmed over equipment and vehicles such as a Bren carrier, as well as holding and aiming machine guns and rifles. Particular favourites were the anti-aircraft guns, which they enjoyed pivoting rapidly to aim at the skies.

Right: A Corporal from the Corps of Engineers demonstrates mine detection equipment to a young woman.

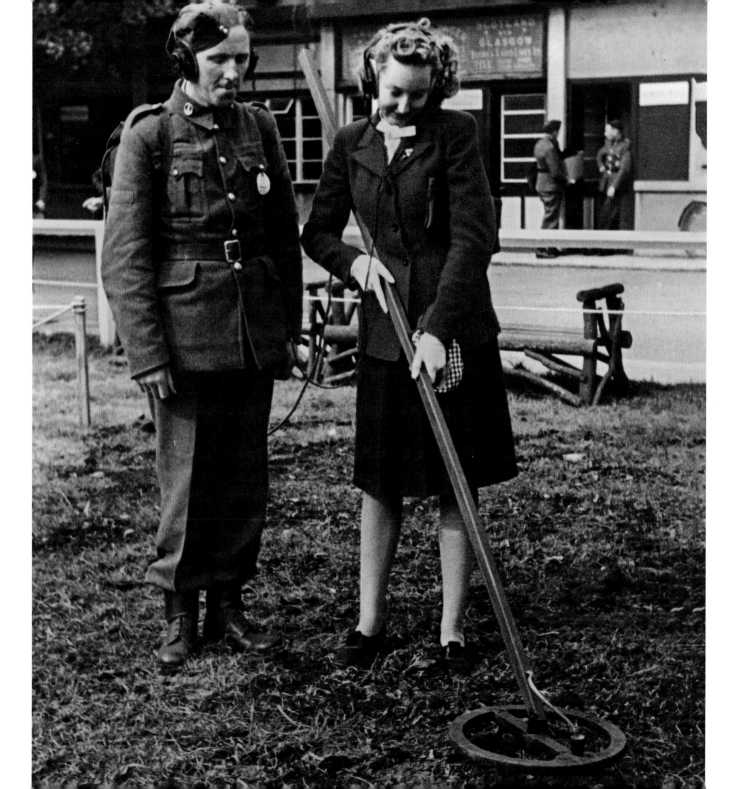

After 1945, the Irish Hospitals' Sweepstakes was able to return to pre-war profitability. Here, with ticket slips from all over the world, female workers sort boxes in Dublin. The company's activities had been seriously reduced during the Emergency. This was due to wartime complications including postal restrictions and censorship as well as the fact that major British horse races had been curtailed (many sweepstakes had been linked to these). However, there was some continuity as races could keep on running in neutral Éire. In late 1945, the Department of Justice, uneasy at the illegal sale of sweep tickets in Britain and the US and its subsequent impact on Ireland's reputation, raised the question of whether the Sweeps should be abolished. In the event, the issue was not raised at cabinet level and nothing was done.

Belfast-born Frank Murray, a doctor, enlisted in the Royal Army Medical Corps at the end of 1939 and was posted to Rawalpindi (now Pakistan). He was in Malaya in 1941. After the fall of Singapore (February 1942), he became a POW at Changi Prison. In May 1943 he was transferred to Hokkaido, the northernmost of Japan's main islands, where he spent the rest of the war in various POW camps, enduring starvation and harsh conditions. In addition to his medical role, by virtue of his rank, in 1944 he became officer commanding the prisoners. Here, on 3 September 1945, just after liberation, Major Murray (seated, second from left) poses with others at Raijo POW camp. Next to him, with his samurai sword, is the Japanese finance officer, Sergeant-Major Tsunezou.

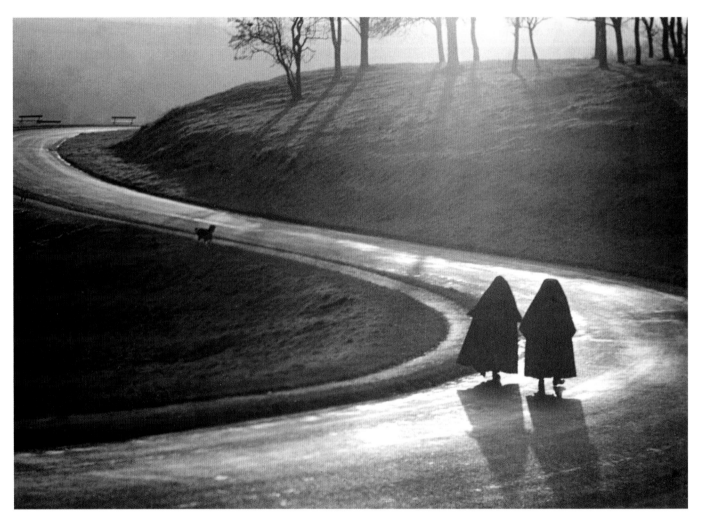

As 1945 ended, and the world was settling into an uneasy peace with a Cold War appearing over the horizon, these nuns take a leisurely walk through the calm of Phoenix Park in Dublin as the sun sets.

5. TO A REPUBLIC
1946–49

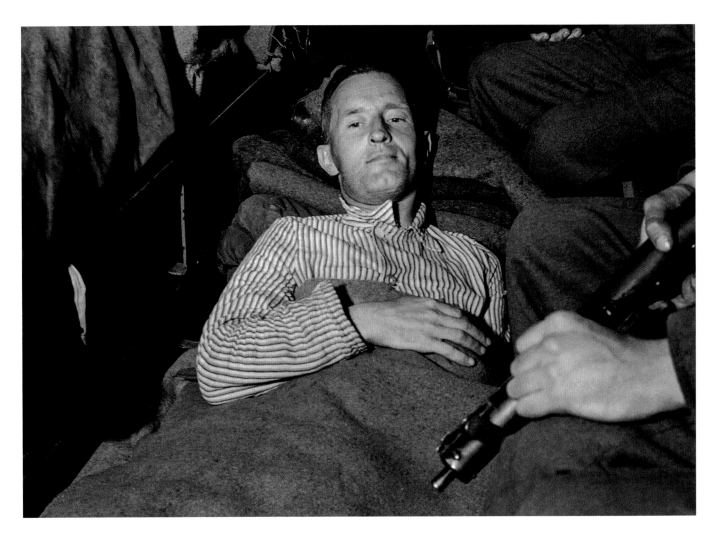

William Joyce, 'Lord Haw-Haw', lies wounded after being captured in Germany. Joyce was born in New York to an Irish father. His family returned to Ireland and Joyce was brought up in Galway. During the 1920s and 30s, he became involved in the British fascist movement. In August 1939, he left for Germany and was contracted to broadcast on the English-language service of the *Reichsrundfunk*. Over the course of the war, in his distinctive, gloating and all-knowing style, Joyce predicted and reported air-raids and read out lists of names of British POWs. Joyce was hanged for treason at Wandsworth prison on 3 January, 1946. At his trial, the court held that his illegally acquired British passport brought duties of allegiance, despite his American citizenship.

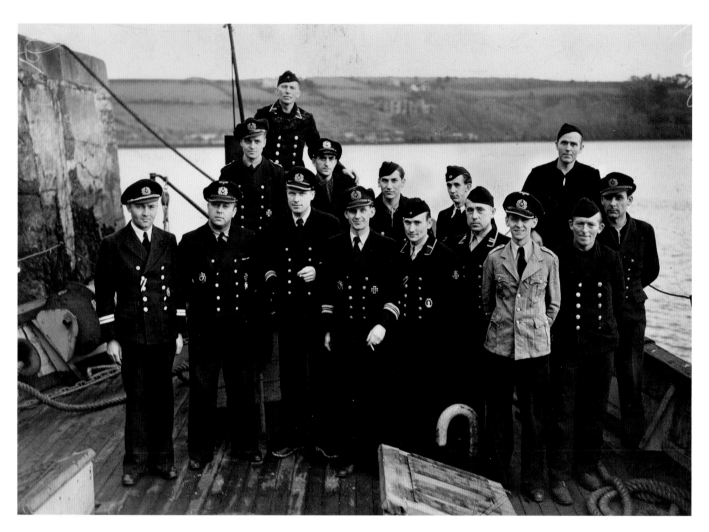

The war continued to reverberate when, on 19 January 1946, a French minesweeper sailed into Kinsale, Co. Cork, from St-Nazaire, carrying 15 German sailors, seen here. They had commandeered the vessel, having escaped from a French POW camp. The men were detained on the boat and watched over by the Gardaí. The Germans requested repatriation to their homes in Germany, or failing that, to be granted asylum in Ireland. The secretary of the Department of External Affairs warned that Ireland might become a refuge 'for every kind of "displaced person" who manages to get here from Europe'. The government decided, on dubious legal grounds, to expel the Germans, and a French corvette arrived at Cobh on 7 February to bring them back.

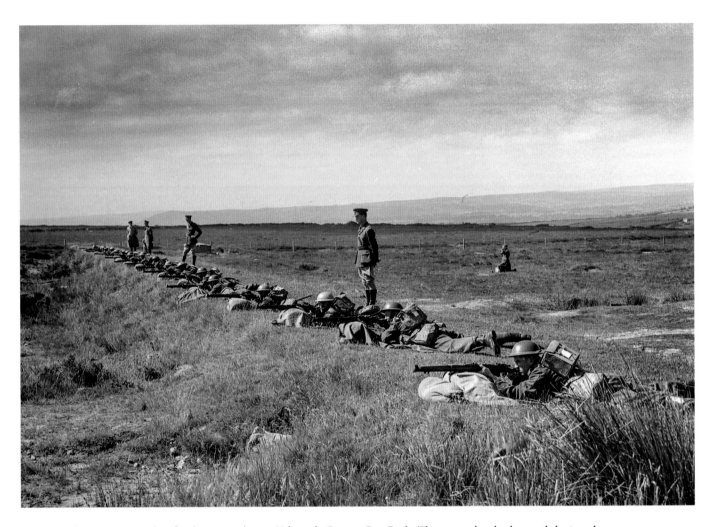

A Southern Command Rifle championship at Kilworth Camp, Co. Cork. The army that had served during the war years was soon dismantled. Once again an Irish government reverted to its stance of ill-defined neutrality and, forgetting the lessons of the Emergency, avoided the hard (and expensive) question of providing a defence force that could defend the country. A permanent force establishment of 12,500 was approved – a number that, in any case, proved to be totally aspirational.

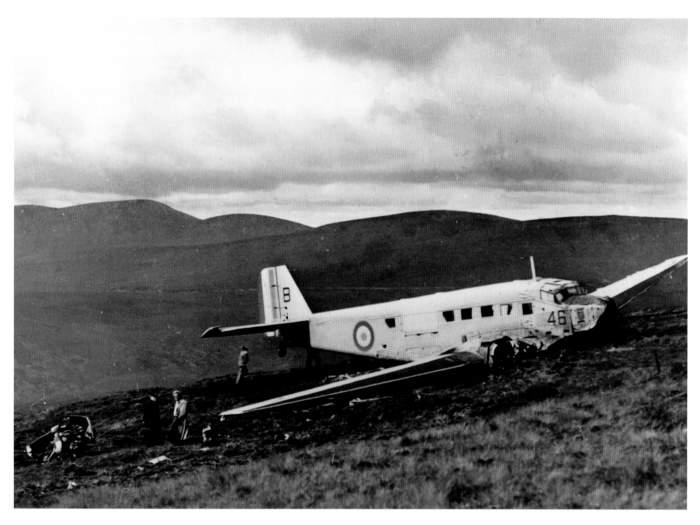

On 12 August 1946, a Junkers Ju 52 (the reliable transport workhorse of the Luftwaffe during WWII), chartered from the French Air Force, was flying from Le Bourget airport in Paris to Dublin, carrying a group of teenage girl guides. The plane encountered a violent storm on the Irish coast and the pilot became disoriented. As he broke cloud cover he saw the looming mass of a mountain and pulled back the control column. The plane hit the sloping, boggy surface at a similar angle, then it bounced, hit the ground a second time and slewed onwards for nearly 150m before coming to rest, with the engines and undercarriage ripped off. Luckily the corrugated aluminium fuselage of the plane remained intact, as seen here at the crash scene on the slopes of the southern side of Djouce Mountain in Co. Wicklow. All 27 on board survived, although eight of the girls sustained injuries.

Walt Disney signs autographs in Cork in November 1946. Disney, whose great grandfather had emigrated from Kilkenny, toured Ireland, ostensibly to research Irish folklore. He was welcomed by President O'Kelly and the Irish Folklore Commission was assigned to assist him. However, when they tried to interest Disney in the great heroic sagas, he was only interested in leprechauns. Thirteen years later, the result was the film *Darby O'Gill and the Little People*, featuring a leprechaun tribe.

Erecting the poles. By the end of the war, the ESB generating capacity comprised of the great hydro station at Ardnacrusha, several small hydro stations on the River Liffey and the thermal power station at the Pigeon House, which dated from 1903. As two out of three Irish homes had no electricity, an ambitious rural electrification scheme was commenced in 1946. By the time the scheme finished in 1964, one million poles had been erected and 80,000km of line had been strung. As the scheme rolled on, electricity was supplied to a sometimes sceptical populace, and it brought rural Ireland rapidly into the modern world.

Archbishop of St Louis, John Glennon, was born at Clonard in Co. Meath. On 18 February 1946, he was made cardinal in Rome by Pope Pius XII. Making his return journey to the United States, the new cardinal stopped off in Ireland where he received a warm welcome. Here on 5 March 1946, at a glittering reception at Áras an Uachtaráin, attended by the great and the good of Dublin, Cardinal Glennon is seated on the left, next to the Taoiseach Éamon de Valera. Standing from left are Archbishop McQuaid of Dublin, President Seán T. O'Kelly, a cleric and Mrs O'Kelly.

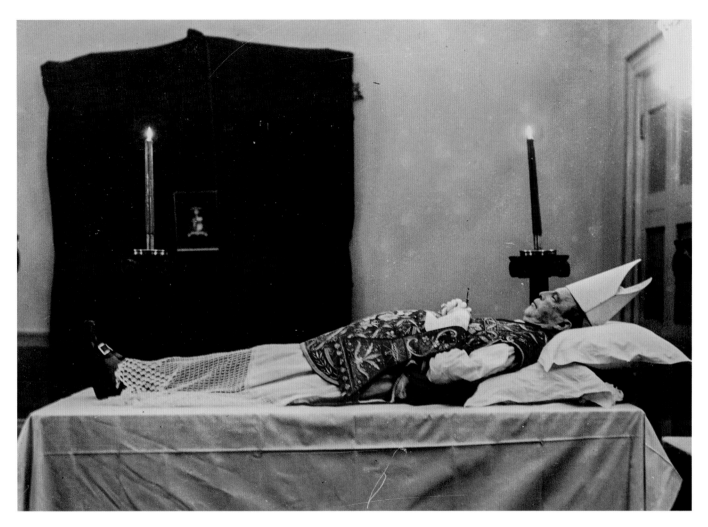

Cardinal Glennon had been staying at Áras an Uachtaráin. Four days after the reception there, the eighty-three-year-old Cardinal, who had been ailing with bronchitis, died. Pictured here, he is laid out at the Áras – his body was later flown to St Louis for burial in the crypt he had built for himself at his cathedral there.

A satisfied customer strides from a shop in March 1946 bearing her loaves of white bread. The ending of the war did not result in abundance or end shortages. In Ireland, the period 1945–8 was called the 'long Emergency'. Drought and war had caused a world-wide scarcity of wheat and in January 1947, the Irish government introduced rationing of flour and bread.

In mid-May 1945, as the war ended in Europe, the government had secured a Dáil vote sanctioning the substantial amount of £3,000,000 for the relief of distress in Europe, despite Éire's limited resources. For the taoiseach, after the years of isolation and neutrality, the measure also offered the prospect of good international publicity and countered allegations that Ireland was concerned only for itself. Food aid, made up of the commodities that Ireland did have, such as meat, sugar, butter and condensed milk, were sent to the devastated Continent. It encompassed the countries of the defeated powers, as well as the countries of their victims. One fifth of the relief budget was allocated to the International Red Cross for aid in Central and Eastern Europe.

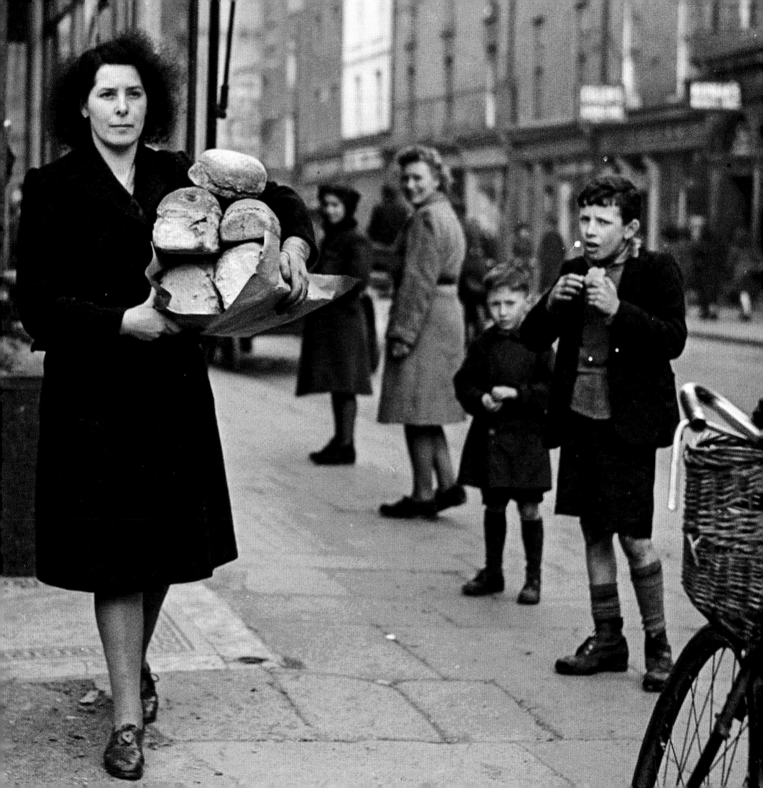

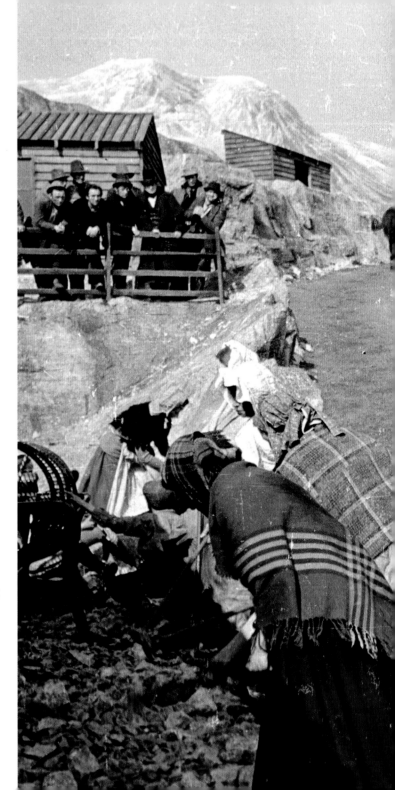

Filming *Hungry Hill* near Glengarriff in West Cork in July 1946. The male lead, Dennis Price (left), as John Brodrick, walks with his father (Cecil Parker) past the rocky terrain, which had been made of wire netting and canvas. The film, set in Ireland, told the story of a feud between two families, the Brodricks and the Donovans, over the sinking of a copper mine at Hungry Hill.

The film was adapted from the novel of the same name by Daphne du Maurier, in turn loosely based on the Anglo-Irish Puxley family, who owned copper mines at Allihies on the Beara Peninsula (near Glengarriff) – Hungry Hill, at 685m altitude, is the highest of the Caha Mountain range. The film did not receive good reviews and only managed to recover half of the production costs.

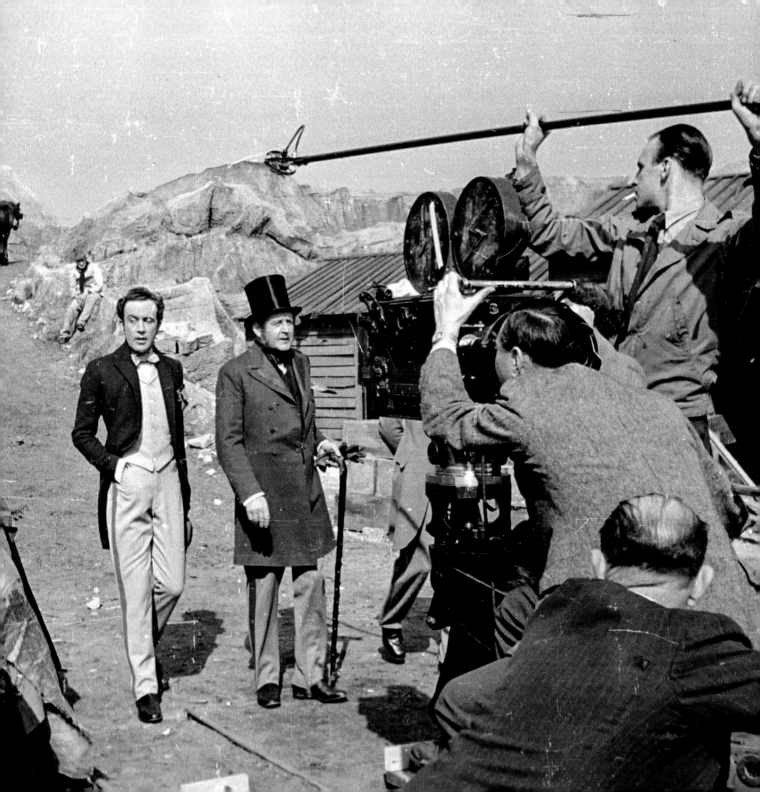

A Great Northern Railway (Ireland) rail bus at Goraghwood, just to the north of Newry. Irish railways struggled after the war years, not least due to the severe scarcity of British coal. In addition, with the inexorable (if uneven, due to petrol shortages) emergence of better cars, trucks, buses and improved roads, the railways continued to lose traffic. Railway companies adapted and innovated as best they could. On low-density traffic routes such as branch lines, the GNR(I) introduced rail buses, converted at their works in Dundalk, to run on rail. Across the Irish network, as the balance sheet began to worsen, the death-knell rang for the more minor lines, both narrow-gauge and standard Irish-gauge, starting a process of closures that was accelerated during the 1950s.

Petrol rationing continued into 1947. Here, in May of that year, cars queue at a garage in Washington Street, Cork, during a shortage. There was also a shortage of other fuels – the winter of 1947, with heavy snow and freezing conditions, proved to be one of the most severe in living memory. With no British coal available and low turf stocks, people struggled to keep warm in their houses.

As we have seen in Chapter 2, Hermann Goertz had been the most competent and effective of all the Abwehr agents operating in Éire. During his time at large, he succeeded in developing high-level political and military contacts. He was arrested in November 1941 and spent most of his detention at Custume Barracks, Athlone. He was released on parole in 1946, along with other German agents. In April 1947 the former agents were informed that they were going to be deported to Germany. Goertz fell into depression – he was aware of the dire living conditions in Germany. He had also become increasingly paranoid – with the Nuremburg trials recently concluded, he over-estimated his own importance and believed that he would be put on trial in Germany and executed.

On 23 May 1947, as instructed, he arrived at the Aliens Registration Office at Dublin Castle to be served with a deportation order. Goertz, sitting in an outer office, bit into a cyanide phial and died.

Many were in attendance at his funeral (seen here) held at Deansgrange Cemetery four days later. Goertz was buried in a Luftwaffe uniform and his coffin was draped in the Swastika flag. Mourners included Dan Breen, Fianna Fáil TD and veteran republican, whose action at Soloheadbeg had marked the start of the War of Independence in 1919 – the white-haired Breen can be seen in the middle background.

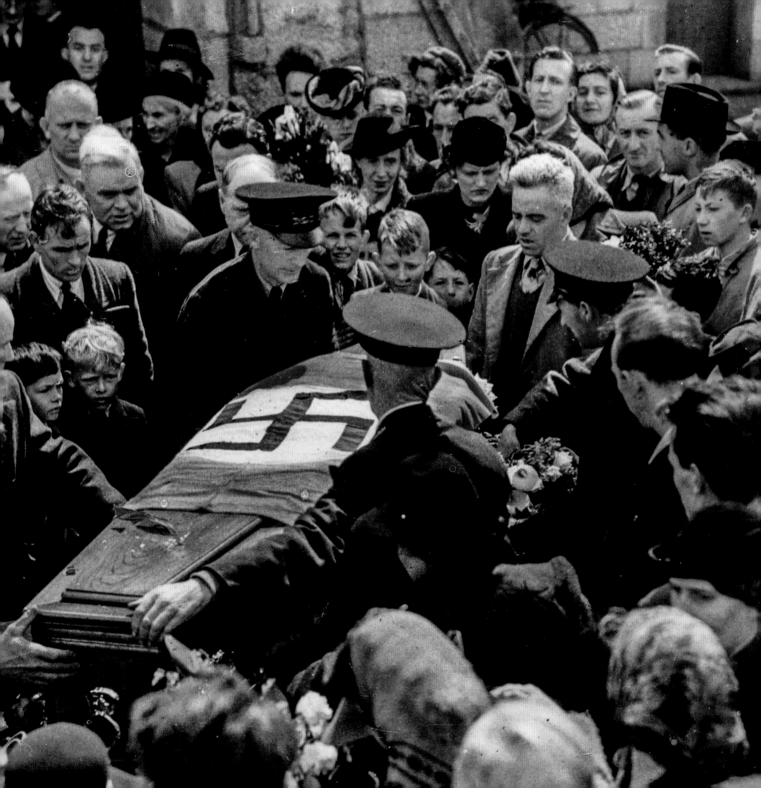

Torches at the crossroads – a Fianna Fáil election procession at Roscommon, with a guard of honour formed by old IRA men. Éamon de Valera had been alarmed at the rise of the new party, Clann na Poblachta, led by Seán MacBride (son of John MacBride and Maud Gonne, and briefly Chief of Staff of the IRA in the mid-1930s) – a party which threatened to steal de Valera's republican mantle. In an attempt to thwart them, the taoiseach called a general election for the beginning of February 1948.

After a gruelling election campaign held in bad weather, Fianna Fáil lost nine seats and MacBride's new party gained 10. It was time for a new government, this time a coalition made up of five minority parties. The leader of Fine Gael, the largest party of the new government, Richard Mulcahy, aware of his controversial Civil War record stepped back and the relatively unknown John A. Costello, a barrister who had been Attorney General from 1926 to 1932, became taoiseach. MacBride was appointed as Minister for External Affairs.

The government, a curious mix of the left and right, Free Staters and republicans, managed to last for around 40 months. It is mainly remembered for two things – the declaration of the Republic, and the Mother and Child scheme. The latter was a socially advanced programme initiated by the new Minister for Health, Dr Noël Browne of Clann na Poblachta, which would introduce free ante- and post-natal care for pregnant women and extend free healthcare to children under the age of 16. The scheme was strongly opposed by the Irish Medical Association and the Catholic bishops, led by the Archbishop of Dublin, John Charles McQuaid. Isolated in cabinet, Browne resigned in April 1951.

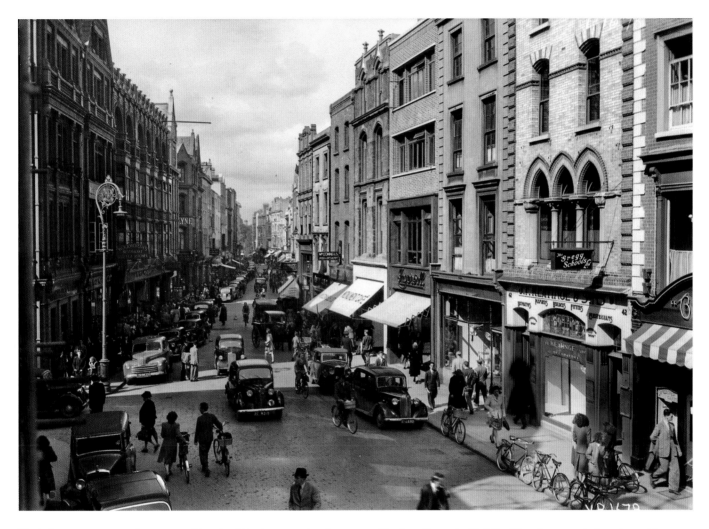

Fuel shortages or not, the car was king in this photograph of post-war Grafton Street in Dublin. The shops are brimming with wares for the middle classes who thronged the footpaths. Clearly the rigours of the Emergency had disappeared.

Left: Since 1908, a statue of Queen Victoria had been located in the forecourt of Leinster House in Dublin. This outsized likeness of a British monarch was an incongruous presence near the parliament of a state still trying to assert its independence from Britain. As we see here in July 1948, work is underway in removing the statue which was then placed in storage. In 1986, the statue was shipped to be put on display at Sydney in Australia, another former dominion, yet to shake off all imperial links.

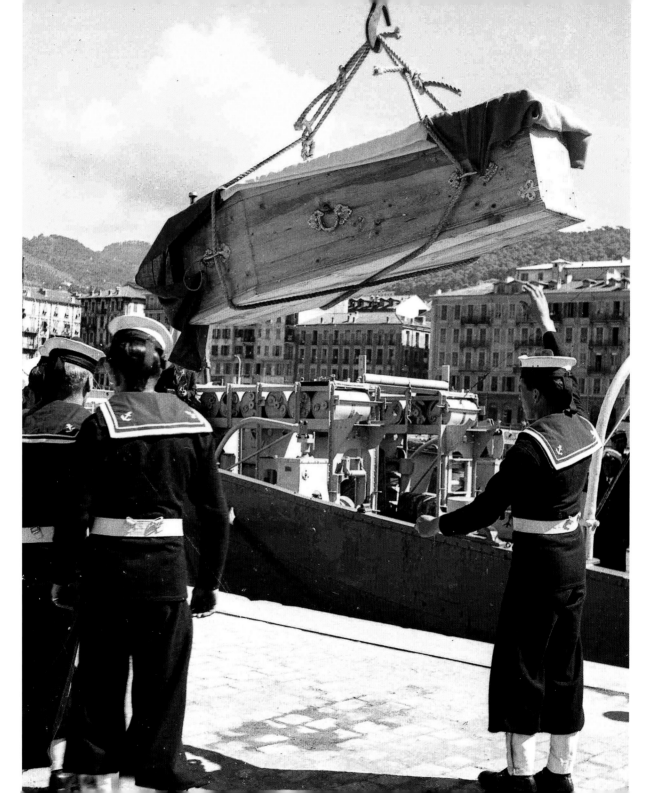

A Guinness barge sails down the Liffey, carrying barrels destined for loading on cross-channel ships at Dublin Port.

Left: In 1948 the LE *Macha* sailed to Nice to bring what were then considered to be the remains of W.B. Yeats, who had died in France, back to Ireland – the first overseas deployment of the Irish Naval Service. Here, we see the coffin being lifted onto the ship. The LE *Macha* arrived at Galway on 17 September where the remains were transferred for burial at Drumcliffe graveyard in Co. Sligo.

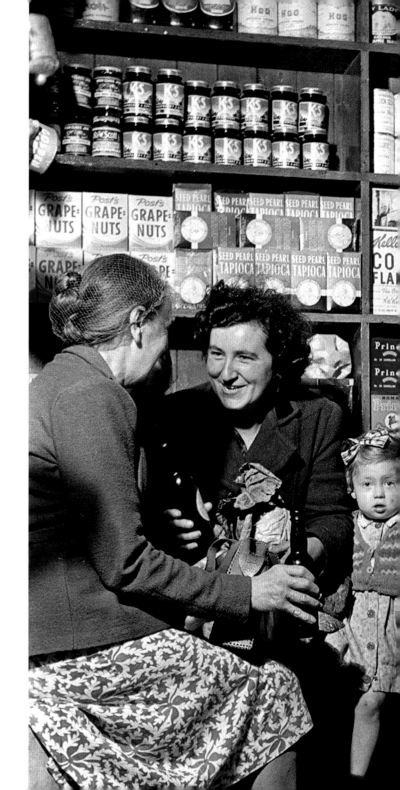

Pints and cornflakes. A 1948 photograph of a group of customers in Francis Stafford's public house in Laytown, Co. Meath. Like many other premises in Irish towns, it sold groceries in one part and alcohol in another.

The shelves are amply stocked and display a wide variety of food products, mainly produced by companies set up to manufacture in Ireland during the Economic War of the mid-1930s, protected by tariffs. While many of these brands are still to be found today, few are manufactured in Ireland now, due to the advent of free trade from the 1960s onwards.

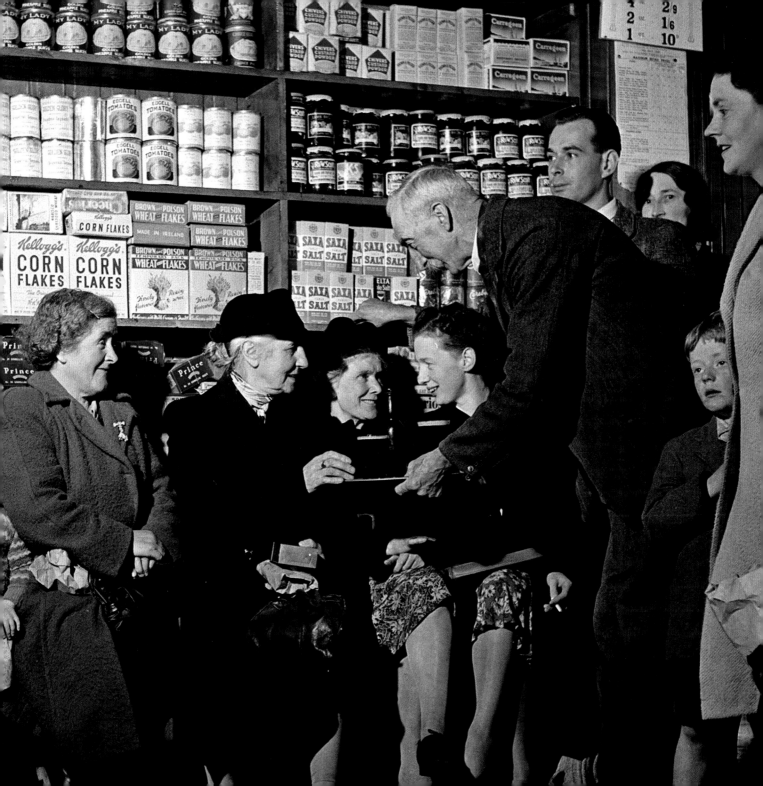

This publicity photograph of bikini-clad young women posing at the pool at Butlin's holiday camp in August 1948 shows that the tectonic plates of an Ireland, kept within strict principles of sexual morality by the Catholic Church, were on the move. The camp had opened the previous month, and was located at Mosney, Co. Meath – tellingly, outside the jurisdiction of Archbishop John Charles McQuaid in Dublin. Butlin's camps were very popular in Britain and this was the first Butlin's to be built outside that country.

It was a new concept, offering an 'all-in' holiday, with swimming pools, nurseries for children and variety shows. Butlin's also intended to entice British visitors, attracted by the rich array of food on offer in Éire in comparison to the strict rationing in place at home

The regimented entertainment on offer at the camp led to a columnist in the *Irish Times* sniffily observing that it was aimed at 'the frayed collar worker' social class.

The camp engendered controversy – the local Fine Gael TD fulminated in the *Catholic Standard*: 'Holiday camps are an English idea and are alien and undesirable in an Irish Catholic country – outside influences are bad and dangerous.' In response, Billy Butlin adapted to local mores – he built a Catholic church within the camp grounds.

In September 1948, Taoiseach John A. Costello, on a visit to Ottawa, made the surprise announcement of the government's intention to declare Ireland a republic. It was all the more surprising because this had been decided by a Fine Gael taoiseach, whose precursor party had accepted the Treaty, under which Ireland had become a dominion of the British Empire whose members of parliament had to swear allegiance to a British monarch. Costello, a lawyer, had disliked the ambiguities and untidiness of de Valera's External Relations Act of 1936, wherein Ireland effectively was a republic in its internal affairs, while in external relations it was an associate member of the British Commonwealth and the credentials of Irish diplomats still had to be authorised by the British king.

Great ceremonies were held in Dublin to mark the promulgation of the Republic of Ireland Act (passed by the Dáil in December 1948). The events began with a 21-gun salute at O'Connell Bridge at midnight on Sunday 17 April 1949. The following day, Easter Monday, massed units of the Irish Defence Forces (seen here) paraded down O'Connell Street where President Seán T. O'Kelly took the salute at the GPO. It was symbolic that the centrepiece of the ceremony was the running up of the tricolour at the GPO, where, thirty-three years earlier, the flag had flown for a few days just after an Irish Republic had been first proclaimed.

The British government responded to the declaration of the Republic by the passing of the Ireland Act in June 1949, which asserted that 'in no event will Northern Ireland … cease to be part … of the United Kingdom without the consent of the Parliament of Northern Ireland'. It was a reaffirmation of the present situation, but the act further copper-fastened partition, to the satisfaction of the Ulster Unionists.

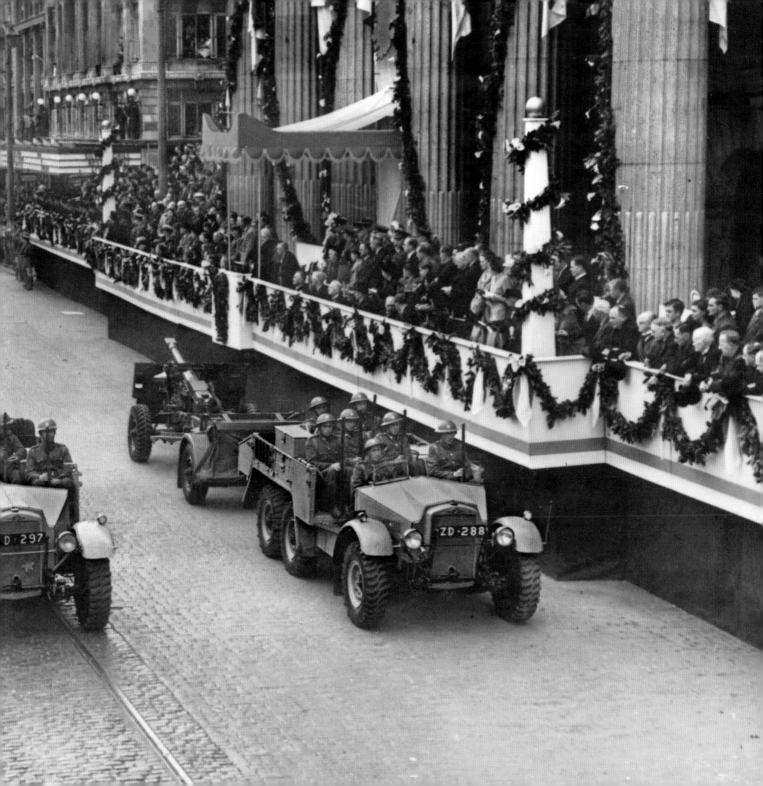

The American filmmaker Robert Flaherty has been called the 'father of the documentary'. Having made a film about the Inuit people, *Nanook of the North*, he went on to direct the acclaimed *Man of Aran* in 1934, which again depicted life at the edge, this time in the Aran Islands off the west coast of Ireland. He is seen here in 1949, on a return visit to the islands, rowing a currach.

Left: The *Amerigo Vespucci*, a sail-training vessel of the *Marina Mare*, the Italian Navy, is pictured here, berthed at Dublin Port in 1949. The three-masted steel-hulled vessel, launched at Naples in 1931, is still in Italian naval service. (Her twin, the sail-training vessel, the *Regina Marina*, had previously been handed over to the USSR as part of war reparations.)

Young refugees in Cork, whose parents had fled from the annexation of their country by the USSR.

Left: In September 1949, former landing craft, the *Victory*, arrived in Cork from Sweden, overloaded with 374 refugees (mostly Estonian). The ship, en route to Canada, had been damaged and docked at Cork. After negotiations, most of the refugees were allowed to enter Canada, travelling there by liner.

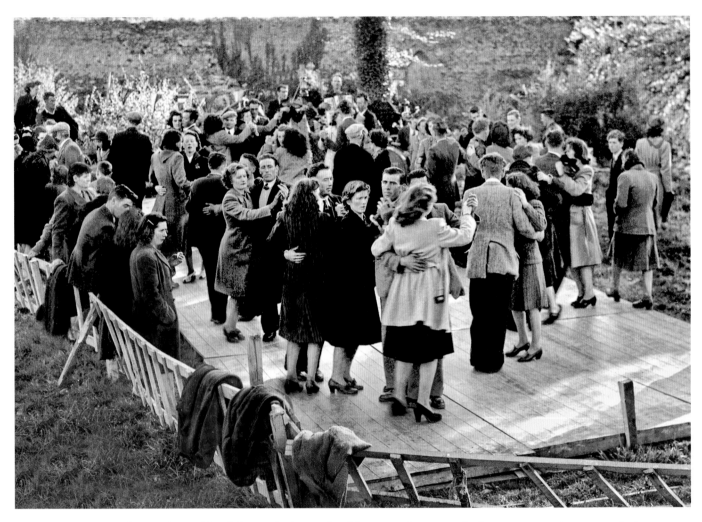

Entertainment of the traditional kind during the late 1940s. This scene shows people dancing, not at the crossroads, but at Glenbower, Killeagh, Co. Cork. These outdoor events were called 'pattern dances' – all one needed was a wooden dance floor with a bit of spring, together with a fiddle and an accordion or two.

In 1949, Charles McAlester Butchers of Moore Street in Dublin entices British visitors with the message: 'Cross Channel Visitors – we specialise in packing choice meat parcels to bring home with you'. Despite being the victors of WWII, Britain was a grim place during the immediate post-war period, being heavily in debt and with an unbalanced economy. Rationing of foods such as butter, tea, sugar and meat continued into the early 1950s. Some visitors came to Ireland as 'ration tourists' to enjoy the relatively plentiful food. Food parcels with fresh food could be sent speedily to Britain, by a postal service that was much faster than today. In one example, a parcel put in the 3:15 p.m. collection at Cork would be in London by 11 the following morning.

The first scheduled transatlantic passenger flight from the United States using a land plane, a DC-4 of American Overseas Airlines (on the New York-Gander-Shannon-London route), landed at Shannon Airport, Rineanna, Co. Clare, in October 1945.

Previously, transatlantic air travel had been dominated by flying boats – whose terminal was at Foynes on the south side of the Shannon Estuary. During the war, land planes, both military and passenger, had been developed into new levels of sophistication. These new passenger planes allowed the era of comfortable and relatively swift transatlantic flight to begin. Shannon Airport, closest to North America, became the gateway to Europe and entered a decades-long period of success until the advent of modern long-distance passenger jets. In 1947, the world's first duty-free shop was established at this airport.

Shannon Airport did not just handle passengers. Here, six thoroughbred horses, all two- or three-year-old colts, are being prepared for a pioneering flight to North America. In today's values, the horses would have cost a total of €2m. The first leg of the horses's journey, on the chartered American Airlines DC-4, was to Newark, New Jersey, and then on to Burbank, California. Despite these horses having enjoyed success in Ireland, only one of this group subsequently had a triumph in the United States.

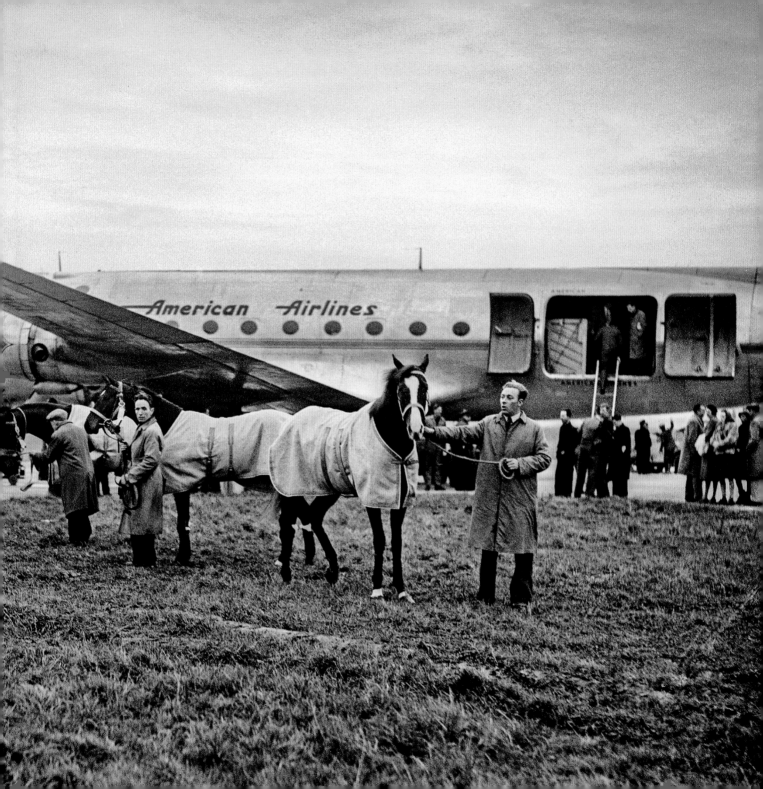

There was an air of sophistication and exclusiveness enveloping post-war air travel. Here, Aer Lingus hostesses, wearing the elegant 1948 uniform designed by Sybil Connolly, pose in front of a Viscount 700 airliner visiting Dublin Airport on a demonstration flight. By 1950, the number of passengers at the airport had increased to 150,000 (around 0.5 per cent of today's figure). Ireland's aviation industry was initially modest, but has since grown to be a major player in the global aviation sector.

IMAGE CREDITS

GLOSSARY

Abwehr	The German military intelligence agency during WWII.
BOAC	British Overseas Airways Corporation, a state-owned airline which operated overseas services from 1939–74.
Córas Iompair Éireann	Established in 1945, a state-owned corporation that was responsible for most land transport operations in the Republic of Ireland.
Curragh Camp	In the early years of the 20th century the Curragh was the principal base of the British Army in Ireland. It is now the main training centre for the Irish Defence Forces.
Dominion	A self-governing nation within the British Empire (later known as the British Commonwealth). The British monarch was head of state. In December 1922 the Irish Free State became a dominion, joining the other white-ruled nations of the Empire.
Éire	The 1937 Constitution of Ireland describes the 26-county state as 'Éire' in Irish and 'Ireland' in English, and this still applies. During WWII, British and other international commentators chose to use the term 'Éire' as a means to distinguish the Irish state from Northern Ireland and to reflect its separate identity and neutrality.
Emergency	How the Second World War period was referred to in Éire, a time during which the state remained neutral.
ESB	A state-owned company established in 1927 to provide and manage Ireland's electricity supply.
Fianna Fáil	The party was founded in May 1926 by Éamon de Valera, who had recently split from Sinn Féin. It entered government in March 1932 and, slightly left of centre, this party for all seasons enjoyed power for 61 of the 79 years up to 2011. It still is one of Ireland's principal parties.
Fine Gael	Founded in September 1933, an amalgamation of the pro-Treaty Cumann na nGaedheal, the Centre Party and, controversially, the Blueshirts (then known as the National Guard). Centre-right, it is still one of Ireland's principal parties.
G2	The intelligence section of the Irish Defence Forces.
Garda Síochána	The national police service, the Civic Guard was founded in September 1922. This unarmed force was renamed as An Garda Síochána in August 1923.
Great Northern Railway (Ireland)	Formed in 1876 by a merger of northern railway companies. It operated across Northern Ireland, and also had principal and secondary lines running between there and Éire.
GSR	Great Southern Railways, which was in operation from 1925 up to the creation of CIÉ in 1945 – it had been an amalgamation of all the railway companies that lay wholly within the Irish Free State.
IRA	Irish Republican Army, a title which has had many claimants over the last hundred years. It had its origins in the Irish Volunteers established in November 1913. In the aftermath of the founding of the Irish Free State and the Civil War of 1922–3, it had been a paramilitary organisation advocating for a republic and the reunification of Ireland. After the Good Friday Agreement in 1998, the IRA formally disbanded, but dissident factions persist, rejecting the peace process.
Ireland Act 1949	An act passed by the Westminster Parliament, recognising that the 26 counties had ceased to be a British dominion and declaring that Northern Ireland would continue as part of the United Kingdom unless the Parliament of Northern Ireland consented otherwise.
Local Security Force (LSF)	Formed in May 1940, intended for local defence in the event of invasion, it was under Garda control. In January 1941 most members were transferred to the Local Defence Force (LDF), now under army control.
Lord Haw-Haw	The nickname given to William Joyce (born in the US and brought up in Ireland) who made English-language broadcasts on German radio during WWII.
Northern Ireland	A constituent unit of the United Kingdom of Great Britain and Northern Ireland. It comprises six Irish counties – Antrim, Armagh, Down, Fermanagh, Derry (shired as Londonderry) and Tyrone.
Marshall Plan	Called the European Recovery Programme, it was an American plan enacted in 1948 to provide financial aid to war-shattered Western Europe.
MTB	Motor Torpedo Boat.
President	Ireland's head of state, with mainly ceremonial duties – an elected post, with a seven-year term.
Republic of Ireland	Ireland declared itself a republic under the Republic of Ireland Act 1948.
SIS	The UK Secret Intelligence Service, also known as MI6.
Taoiseach	The head of government, or prime minister, of Ireland.
TD	Teachta Dála (member of parliament, Dáil Éireann).
Treaty Ports	Irish deep-water ports retained by the United Kingdom under the terms of the Anglo-Irish Treaty of 1921 – Berehaven, Spike Island (in Cork Harbour) and Lough Swilly. They were transferred to the Irish government in 1938.
Unionism	In the Irish context, it is an ideology which supports political union between Ireland and Great Britain.
WWII	Second World War, the global conflict that lasted from 1939 until 1945.

BIBLIOGRAPHY

Archives Consulted:
Capuchin Archives, Dublin; Cork Public Museum; Military Archives, Dublin; Library of Congress; National Library of Ireland, Dublin; National Museum of Ireland, Public Record Office of Northern Ireland, Belfast; UCD Archives, Dublin; US National Archives and Records Administration; US Naval History and Heritage Command.

Periodicals:
General Irish and British newspapers; *History Ireland*; *Irish Historical Studies*; Journal of the *Irish Railway Record Society*; *The Irish Sword*.

Books:
Aan de Wiel, J., *Ireland's Helping Hand to Europe*, 1945-1950, Central European University Press, 2021.
Allen, T., *The Storm Passed By, Ireland and the Battle of the Atlantic*, 1940-41, Irish Academic Press, Dublin, 1996.
Ayiotis, D., Gibney, J, Kennedy, M., *The Emergency, A Visual History of the Irish Defence Forces*, Eastwood, Dublin, 2019.
Barnes, S., *When our Plane hit the Mountain*, New Island, Dublin, 2005.
Bartlett, J., *A Military History of Ireland*, Cambridge University Press, 2008.
Blake, J., *Northern Ireland in the Second World War*, Blackstaff Press, Belfast, 2000.
Bowyer Bell, J., *The Secret Army*, Poolbeg, Dublin, 1990.
Carroll, J., *Ireland in the War Years*, David & Charles, Newton Abbot, 1975.
Coleman, M., *The Irish Sweep*, UCD Press, Dublin, 2009.
Cromie, E., Warner, G., *Military Aviation in Northern Ireland: An Illustrated History – 1913 to the Present Day*, Colourpoint Books, 2012.
Cronin, S., *Frank Ryan, the Search for the Republic*, Repsol Publishing, Dublin, 1980.
Doherty, R., *Irish Volunteers in the Second World War*, Four Courts Press, 2002.
Douds, S., *The Belfast Blitz*, Blackstaff Press, Belfast, 2011.
Duggan, J., *A History of the Irish Army*, Gill & Macmillan, 1991.
Duggan, J., *Herr Hempel at the German Legation*, Irish Academic Press, Dublin, 2003.
Duggan, J., *Neutral Ireland and the Third Reich*, The Lilliput Press, Dublin, 1981.
Ferris, T., *Irish Railways*, Gill & Macmillan, Dublin, 2008.
Ferriter, D., *The Transformation of Ireland 1900-2000*, Profile Books, London, 2004.
Fisk, R., *In Time of War, Ireland, Ulster and the Price of Neutrality*, Paladin, London, 1983.
Forde, F., *The Long Watch*, Gill & Macmillan, 1981.
Girvan, B., *The Emergency, Neutral Ireland 1939-45*, Pan Macmillan, London, 2007.
Gray, T., *Ireland this Century*, Little Brown and Company, London, 1994.
Gray, T., *The Lost Years*, Little Brown and Company, London, 1997.
Hanley, B., *The IRA, a Documentary History 1916-2005*, Gill & Macmillan, Dublin, 2010.
Horgan, J., Cummins, P., *Luftwaffe Eagles over Ireland, the story of German Air Crashes over Neutral Ireland, 1940-1945*, Horgan Press, Kerry, 2016.
Kennedy, M., *Guarding Neutral Ireland, the Coast Watching Service and Military Intelligence, 1939-1945*, Four Courts Press, 2008.
Kinsella, E., *The Irish Defence Forces, 1922-2022*, Four Courts Press, Dublin, 2023.
Lee, J., *Ireland 1912-1985*, Cambridge University Press, 1989.
Lyons, F., *Ireland Since the Famine*, Fontana, London, 1979.
MacCarron, D., *Landfall Ireland*, Colourpoint Book, 2003.
MacCarron, D., *Wings over Ireland, The Story of the Irish Air Corps*, Midland Publishing,1996.
MacGinty, T., *The Irish Navy*, Kerryman, 1995.
Martin, K., *Irish Army Vehicles since 1922*, Karl Martin, 2002.
Maxwell, J., Cummins, P., T*he Irish Air Corps, An Illustrated Guide*, Max Decals Publications, Dublin, 2009.
Mc Menamin, M., *Ireland's Secret War*, Gill Books, Dublin, 2022.
McCullagh, D., *De Valera: Rule*, Gill Books, Dublin, 2018.
McIvor, A., *A History of the Irish Naval Service*, Irish Academic Press, Dublin, 1994.
McMahon, P., *British Spies & Irish Rebels*, Boydell Press, Suffolk, 2008.
McMahon, S., *Bombs over Dublin*, Currach Press, Dublin, 2009.
McShane, M., *Neutral Shores, Ireland and the Battle of the Atlantic*, Mercier Press Cork, 2012.
Meenan, J., *The Irish Economy since 1922*, Liverpool University Press, 1970.
Ó Gráda, C., *A Rocky Road: the Irish Economy since the 1920s*, Redwood Books, Trowbridge, 1997.
O'Byrne, J., Barry, M., *A Nation is Born*, Gill Books, Dublin, 2023.
O'Halpin, E., *Defending Ireland, the Irish State and its Enemies since 1922*, Oxford University Press, 2001.
O'Halpin, E., *Spying on Ireland, British Intelligence and Irish Neutrality during the Second World War*, Oxford University Press, 2008.
Quinn, J., *Down in a Free State*, IWG, 1999.
Riccio, R., *AFVs in Irish Service since 1922: From the National Army to the Defence Forces*, MMP, 2011.
Riccio, R., *The Irish Artillery Corps since 1922*, MMP, 2012.
Richardson, C., *Smyllie's Ireland*, Indiana University Press, 2019.
Rigney, P., *Trains, Turf and Coal, Transport in Emergency Ireland*, Irish Academic Press, Dublin, 2010.
Ryle Dwyer, T., *Behind the Green Curtain, Ireland's Phoney Neutrality during World War II*, Gill & Macmillan, Dublin, 2010.
Ryle Dwyer, T., *Guests of the State*, Brandon, Kerry, 1998.
Share, B., *The Emergency*, Gill and Macmillan, Dublin, 1978.
Whelan, B., *Ireland's Revolutionary Diplomat, a Biography of Leopold Kerney*, University of Notre Dame Press, 2019.
Wills, C., *That Neutral Island: a Cultural History of Ireland during the Second World War*, Harvard University Press, 2007.

INDEX